Schoolgirl pregnancy, motherhood and education: dealing with difference

Schoolgirl pregnancy, motherhood and education: dealing with difference

Kerry Vincent

Trentham Books

Stoke-on-Trent, UK and Sterling, USA

Trentham Books Limited
Westview House 22883 Quicksilver Drive
734 London Road Sterling
Oakhill VA 20166-2012
Stoke on Trent USA
Staffordshire
England ST4 5NP

First published 2011

British Library Cataloguing-in-Publication Data
A catalogue record for this book is available from the
British Library

ISBN 978-1-85856-494-4

Designed and typeset by Trentham Books Ltd
Printed and bound in Great Britain by 4edge Limited, Hockley

Contents

Acknowledgements

I am especially grateful to the 14 young women who welcomed me into their lives and their homes and who provided the experiences and insights on which this book is based. I was moved by their warmth and good humour, their resilience and courage, and their insightfulness and candour. I also wish to thank the 18 professionals who made time in their busy schedules to speak with me and to share their thoughts and understandings. A special thanks goes to the headteacher at Phoenix pupil referral unit, and the local authority Teenage Pregnancy Co-ordinator, for initially encouraging my endeavour. A big thank-you to Professor Pat Thomson whose encouragement and guidance was instrumental to both the research process and the writing of this book. And I am grateful to the friends, colleagues and family members who supported me in so many ways over an extended period, and to Nicola and Chris who provided feedback on earlier drafts of sections of this book. Finally, I wish to thank Gillian Klein at Trentham Books for her interest in publishing this work and for her invaluable editorial guidance.

Acronyms and abbreviations

ALANs	Adult Literacy and Numeracy awards
DCSF	Department for Children Schools and Families
DfE	Department for Education
DfES	Department for Education and Skills
DH	Department of Health
e2e	Entry to Employment
EET	education, employment or training
GCSE	General Certificate of Secondary Education
GP	general practitioner
HDA	Health Development Agency
LGBT	lesbian, gay, bisexual, transgender
NEET	not in education, employment or training
NVQ	National Vocational Qualification
OCN	Open College Network
ONS	Office for National Statistics
PRU	Pupil Referral Unit
PSED	personal, social and emotional development
SEU	Social Exclusion Unit
SRE	sex and relationship education
TPS	Teenage Pregnancy Strategy
TPU	Teenage Pregnancy Unit
US	United States
UK	United Kingdom

It is not difference which immobilises us, but silence.
And there are so many silences to be broken
(Audre Lorde, 1984, *Sister Outsider*)

1

Schoolgirl pregnancy, motherhood and education

Pregnant schoolgirls and educational inclusion

The swollen belly of a uniform-clad pregnant schoolgirl is a powerful and uncomfortable image – a visual oxymoron to which people are unaccustomed. These young women inhabit an ambiguous and contradictory space. On one hand they have not reached legal adult status, yet on the other, they are about to embark upon one of the key signifiers of adulthood – becoming a mother. They also create discomfort and wariness through their embodied confirmation of uncontained and unconstrained adolescent sexuality.

In the past, schools have not had to deal with this uncomfortable image. Such young women have been ushered quickly and quietly out of sight and out of mind (Carabine, 2001). Prompted possibly by the stigma and shame associated with out-of-wedlock childbearing, or a belief that education is neither important nor appropriate for a young woman about to embark upon motherhood, there has been, until quite recently, no clear expectation for education to continue.

These days however, a global inclusion movement means that schools across the developed world are expected to accommodate a much wider range of pupil differences than in the past. Underpinned by a human rights agenda (Ballard, 1999), the well documented links between educational exclusion and subsequent social exclusion (SEU, 1998) along with citizenship curricula aimed at promoting greater res-

1

pect for diversity, there are strong government imperatives to develop more inclusive schools and to support marginalised and vulnerable pupils. In the UK, particular attention has been directed at pupils with special educational needs, looked after children, Gypsies and Travellers, and some ethnic minority pupils, all of whom are over-represented in official exclusion statistics and under-represented amongst those who do well in national examinations (DfE, 2011a;b). Although under-represented in official exclusion statistics, pregnant schoolgirls and schoolgirl mothers have also been identified as a group that is particularly vulnerable in terms of poor educational outcomes (Audit Commission, 1999).

There appears to be a sound basis for this view of educational vulnerability. Teenage mothers are more likely than their peers to leave school early and less likely to leave with qualifications (Kiernan, 1995; Wiggins *et al*, 2005). Education authorities place low priority on supporting pregnant and mothering teenagers back into education (Audit Commission, 1999; Coleman and Dennison, 1998) and some teenagers have reported being excluded from school or strongly discouraged from attending because of pregnancy, while others stop attending because of bullying (Dawson and Hosie, 2005; Osler and Vincent, 2003). The combination of lack of educational qualifications and the demands of motherhood is believed to restrict education and employment opportunities still further, increasing the likelihood of the young mother and her child living in poverty (DCSF, 2007). This is part of the 'problem' of teenage pregnancy.

The wider policy context: problems and solutions

In order to make sense of the accounts and analyses that follow, it is necessary to understand something of the wider socio-political context within which schools and other educational institutions operate. The ways in which the difference of teenage pregnancy is represented within policy contributes to and helps justify particular solutions. It is these constructions of difference that influence how pregnant and mothering teenagers become recognised and, as I argue later, it is these that need some rethinking so that policies and practices become more constructive.

The problem

For several decades now, teenage pregnancy has been seen as a serious public health issue, and reducing teenage conceptions has remained on the policy agenda of successive British governments. This mirrors policy in the US, New Zealand, Canada and Australia – other English-speaking countries where teenage conception rates are considered to be problematic. The 'problem' is generally said to be that teenage pregnancy is costly both to the individuals concerned and to wider society (see for example DfES, 2006). This representation is based primarily on the increased risk of a range of negative health, educational and economic outcomes for both mother and child. The large-scale epidemiological studies upon which this view is based show that compared to their peers, teenage mothers are less likely to finish their education, less likely to be employed or in well-paying jobs, more likely to be homeless, more likely to experience poor mental and physical health, and more likely to be bringing their children up in poverty (Hobcraft and Kiernan, 1999; Wellings *et al*, 1996). Teenage pregnancy is thus seen to be both a cause and a consequence of social exclusion. Despite the research evidence that points to social inequality rather than the mother's age being the problem (Hawkes, 2010; Lawlor and Shaw, 2002), government publications continue to spotlight the latter, thus implying a causal link between youthfulness and the adverse outcomes highlighted in research.

Interestingly, the 'problem' is not that current teenage birth rates in the UK are higher than in the past. They are not. As noted by a number of commentators (Duncan, 2007; Selman, 2003) and as can be seen by figures provided by the Office for National Statistics (ONS, 2011), under-18 conception rates in the UK are lower today than they were in the 1960s. Since the 1970s, rates have been relatively stable – fluctuating between 40 and 50 per 1000 women. What has changed though, and the factor that has fed the current moral panic over teenage pregnancy, is that during the 1980s and early 1990s, teenage pregnancy rates in other Western European countries decreased while those in the UK stayed the same. The UK's 'shameful record' (SEU, 1999:4) could no longer be ignored; this source of political embarrassment now required a political solution.

The causes

The putative causes of the crisis are clearly laid out in *Teenage Pregnancy*, the Social Exclusion Unit (SEU) report that was used to launch the official UK response to the problem. This report states early on that there is no single explanation for the UK's relatively high teenage pregnancy rate but three factors stand out: low expectations, ignorance and mixed messages. Teenagers who become pregnant are expected to have low educational and employment aspirations, to believe that they will end up on benefit anyway, and to have little hope or expectation of a better future. That is, they are constructed as having the wrong ambitions, motivation and aspirations.

Young people are represented as ignorant, lacking knowledge about sexual matters, contraception and what it is like to be a parent. This view is typified in the early pages of the SEU (1999) report: 'There are no good reasons why teenagers should be as ignorant as they are about the facts of life and the role of contraception' (SEU, 1999:7).

Finally, 'mixed messages' refers to the way in which issues of sexuality are viewed and managed within wider society – that young people are constantly exposed through the media to sexually explicit messages but at the same time are expected to remain sexually innocent and inexperienced. Adolescent sexuality is marginalised and demonised within a wider culture that celebrates, promotes and gives high status to adult sexuality. As some scholars have pointed out, what is left untouched and unquestioned in these explanations of teenage pregnancy are the more challenging issues of social inequality related to class, gender and race as well as those of teenage sexuality and relationships (Hoffman, 1998; Kehily, 2005; Phoenix, 1991).

Policy solutions

These representations of the main causes and consequences of teenage pregnancy have shaped policy solutions. In the UK, 1999 marked the launch of a national Teenage Pregnancy Strategy. This ten-year campaign to reduce conception rates and increase participation of teenage parents in education, training or employment was comprised of four main cornerstones: a national campaign; joined-up working; better prevention; and better support. The first two strategies were generic and focused on setting up the structures to support implementation of

4

the strategy; for example, the appointment of a teenage pregnancy co-ordinator within each local authority and the expectation that all government departments would work together on achieving the Strategy's targets. The third cornerstone, better prevention, focused primarily on improving sex and relationship education (SRE) and improving access to sexual health services. This part of policy was seen to address the 'ignorance' cause of teenage pregnancy and links to the aim of halving teenage conception rates. The final cornerstone, 'better support', relates to the 'low expectation' cause and to the second main aim of the strategy – getting 60 per cent of pregnant teenagers and teenage mothers into education, employment or training (EET). This national campaign aimed to break the cycle of social exclusion by preventing teenage pregnancies occurring in the first place but if they did occur, to support young women into education, training or employment so that they could become socially included.

Policy for pregnant schoolgirls and school-aged parents

In support of the national strategy, local authorities in the UK were from 2001 required to provide a somewhat ambiguous 'suitable' education for all pupils for whom they are responsible, *including* pupils of compulsory school age who are pregnant or become parents. The guidance for schools specifies that pregnancy is not a reason for exclusion and that health and safety reasons should not be used to prevent a pupil from attending. It also states that 'The school should ensure that the young woman continues learning as long as possible up until the birth by exploring all opportunities for curriculum support available' (DfES, 2001:5). This is far less ambiguous and makes it clear that schools are expected to support the on-going education of a pregnant pupil. When mainstream education is considered unsuitable, other options should be considered. For example schools can refer a pregnant pupil to an educational alternative such as a pupil referral unit (PRU), or give her work to do at home when she cannot attend. In these cases, the guidance states that the pupil is to remain on the roll of her mainstream school and links are to be maintained, with the aim of subsequent re-integration.

The 2001 guidance was thus intended to address the low priority afforded by schools and local authorities to the education of pregnant

and mothering pupils. Four years after its introduction however, the mid-term evaluation of the Teenage Pregnancy Strategy reported that the educational lot of the pregnant schoolgirl seemed not to have improved (TPU, 2005). More than one third of the young mothers who participated in this evaluation were found to have left school before the statutory school leaving age and to experience difficulties in returning to education. The evaluation concluded that many pregnant schoolgirls continue to face barriers to completing their education and in balancing the demands of parenting with study.

It seems, then, that some differences are more easily catered for than others and that despite inclusive intent and clear policy guidance, teenage pregnancy is a difference that schools find difficult to accommodate yet little seems to be understood about why this is the case or how this situation might be improved. This is the terrain of this book.

Focus and aims of the book

This book is about how educational institutions deal with pupil difference; both the obvious differences that become contentious focal points, and the less obvious ones that are often sidelined within policy debates or seen as irrelevant in the day-to-day practices of educational professionals. It focuses on one particular group of pupils; those who become pregnant while still of statutory school age. Through an in-depth exploration of the connection between education and the broader, everyday lives of pregnant schoolgirls and schoolgirl mothers, and using students' own words and stories, the book aims to provide greater insight into the lived experiences of a marginalised group of young women who continue to get the short end of the educational stick.

My principle concern is to provide more holistic and situated understandings of the ways in which pregnant and mothering teenagers create, modify and interpret the world in which they find themselves than we can find in the research literature on teenage pregnancy. I am interested in deepening understanding about their educational experiences, their perspectives on their own lives, and how they negotiate the social contexts in which they find themselves. I hope to shift attention away from the pregnant teenager herself to the institutional barriers that she and others like her face. Accordingly, I juxtapose young women's experiences and understandings with the representations and

assumptions about pregnant and mothering teenagers within policy and I explore where resulting practice is more helpful or less so. I believe that a deeper understanding of these processes might evoke more constructive and socially just responses to pregnant and mothering teenagers.

Specifically, the book explores how the difference of teenage pregnancy is represented within policy, how it is responded to by educational institutions and individuals within those institutions, and with what effect. By highlighting young women's experiences in schools and analysing why things are as they are, I aim to contribute to a change in the way policy-makers and practitioners view pregnant teenagers and teenage mothers, and therefore how they respond when a pregnancy occurs.

Although I focus on one specific group of vulnerable pupils – those who became pregnant while still of statutory school age – my views and understandings have been shaped by my previous work with a wide range of children and young people and my frequent frustration with unnecessary, and certainly unhelpful, constructions of pupil difference. These were often simplistic, negative constructions which ignored important dimensions of a pupil's wider context and experience. By illustrating how institutional responses to the many differences pupils bring with them into schools create exclusionary or inclusionary schooling experiences, and by presenting an analytic model that I believe has wider application, this book aims to contribute also to general debates about inclusive education.

Working with teenage mothers
The research
The book draws extensively on my doctoral studies of the educational experiences of pregnant schoolgirls and schoolgirl mothers. The fieldwork took place over an 18-month period spanning 2007/2008 and involved three in-depth, semi-structured repeat interviews with fourteen pregnant or mothering teenagers in one local authority in England. Those who took part in my study were accessed, with the support of teenage pregnancy workers, through various educational institutions and support services. Ranging in age from 15 to 18 years, most of them were 16 or 17 years old when I first met them. One was 18

and two were 15. Nine were already mothers, while the remaining five were pregnant. Twelve of them had still been of statutory school age when they first became pregnant and had attended nine different secondary schools across the city. Their EET (education, employment or training) status changed several times over the course of the study, but when I first met them, six were still completing Year 10 or Year 11 (the final two years of secondary school), six were engaged in post-secondary education and two were NEET (not in education, employ-ment or training). Through interviews I also ascertained the views of 18 different professionals with an interest in educational outcomes for pregnant and mothering teenagers. While this book is based primarily on the data collected from the young women, I also draw on the views of these professionals in developing some of my points.

The text

I use illustrative excerpts from my interviews because I want to fore-ground the views and perspectives of the young women themselves – not just because their words often speak more powerfully than mine but also because their voices are generally absent or muted in much of the published research. During the research process I became acutely aware that there is no typical teenage mother experience and certainly no single representation of 'the pregnant teenager'. I viewed the stories of the young women I worked with and came to know as a window through which I might come to see and understand something of their lives, but a window that was opaque rather than transparent, affording only a glimpse. I chose excerpts which would highlight similarities and differences in their experiences and allow me to explore apparent ambiguities and provide a balanced account of the information I was given. As well as using pseudonyms for the young women, I have used fictional names for two of the three specialist educational alternatives they attended and a generic national name for the programme offered at a third institution. The professionals have also been anonymised.

Terminology

Several points relate to the terminology used in the book. First, in official statistics, teenage conception rates in the UK are based on con-ceptions to women below the age of 20. The term 'pregnant teenager' is applied equally to a thirteen-year old and a nineteen-year old and

regardless of their ethnicity, marital status, family and community sup-port, income and employment status and whether their pregnancy was intentional or accidental. Even within my small research group of similarly-aged teenagers, there was considerable variation across some of these dimensions. Pregnant and mothering teenagers are far from a homogenous group and young women's experiences of pregnancy and motherhood are likely to vary in line with these differences (Macvarish and Billings, 2010; Phoenix, 1991). When considering teenage mother-hood we need to take account of the differences as well as the similari-ties; not just the differences between teenage mothers and other mothers but also the differences between the teenage mothers them-selves.

I use the terms 'pregnant schoolgirl' and 'schoolgirl mother' to highlight the fact that the young women whose accounts inform this book represent the relatively small number of teenage mothers at the young end of the 'teenage mother' continuum: those who were still of statu-tory school age when they became pregnant. They thus represent a small but important minority. Although some were still officially minors and were still completing their secondary education at the beginning of my research, by the end of it, all were the primary caregiver of a child. Throughout the book I have therefore chosen to refer to them as 'young women' or 'young mothers' rather than 'girls', in acknowledgement of the adult responsibilities they had chosen to take on. I use the gender-specific terms teenage mother and motherhood rather than parent or parenthood, not to marginalise young fathers, some of whom are also teenagers, but rather as a way of acknowledging the specific issues and responsibilities that primarily affect women.

Theorising difference

The analytic theme that runs through the book is that of difference. I sought to explore how the differences associated with teenage preg-nancy and motherhood are represented and how these representations influence policy, practice, and ultimately the everyday lives of young women who become pregnant. In my analysis I draw heavily on the social justice work of US political scientist Nancy Fraser. Her ideas about recognition and difference provide a useful lens through which to view the experiences of pupils who become pregnant while still of

statutory school age. I also draw on the work of US legal scholar Martha Minow, particularly in relation to the ways in which schools respond to the difference of teenage pregnancy and motherhood. Two key concepts related to social justice and difference which I develop and use later in the book are Minow's dilemma of difference (Minow, 1990) and Fraser's differentiated recognition of difference (Fraser, 1997).

Martha Minow and the dilemma of difference

In her book *Making All the Difference* (1990), Minow examines the legal and political responses to difference. While her educational interests have focused on bilingual and special education, she makes a number of points that are equally relevant to the discrimination experienced by any pupil who is identified as different. First, in agreement with other scholars (Fraser, 1997; Young, 1990), Minow notes that when individuals or groups are marked out as different, such difference nearly always carries a stigma – a socially constructed stigma based on the perceptions and unquestioned assumptions of the dominant culture. Secondly, she shows that policy responses to discrimination usually take one of two forms: either equal treatment or special treatment. Minow argues that ignoring difference through a 'treat everybody the same' approach and attending to difference through a 'special treatment' approach can both have negative consequences for the individuals concerned, however good the intentions. She explains that an 'equal treatment' approach inevitably requires ignoring the circumstances that have contributed to the inequality in the first place, while the 'special treatment' approach highlights the ways in which an individual or group differs from the norm and thus unnecessarily reinforces notions of difference that may stigmatise them further.

Minow uses pupils in American schools whose first language is not English as an example. She asks whether justice is best served through treating these pupils the same as their peers and teaching in English, so disregarding how this will impede their learning, or should they be taught in their first language, thus placing them at risk of disadvantage in the future? Her point is that special treatment can both address difference or it can accentuate the stigma of difference. She calls this the 'dilemma of difference' which she expresses through the questions:

> When does treating people differently emphasise their differences and stig-
> matise or hinder them on that basis? And when does treating people the
> same become insensitive to their difference and likely to stigmatise or hinder
> them on that basis? (Minow, 1990:20)

Minow's dilemma is something inclusive educators wrestle with on a daily basis. I illustrate using a more recent English study with a group of pupils whose poor attendance, high exclusion rates and low academic achievements mark them out as educationally vulnerable. Kalwant Bhopal's (2011) examination of practices and attitudes towards Gypsy and Traveller pupils identified several examples of inclusive practice that were based on special treatment: flexibility with regard to atten-dance and school arrival time, allowing siblings to stay together or to visit each other's classrooms during their first week at a new school, and lending school resources such as books and laptops to assist with the completion of homework. These practices were aimed at overcoming some of the barriers to inclusion resulting from the different cultural and material realities of Gypsy and Traveller pupils. What Bhopal found, however, was that such special treatment also emphasised the dif-ference and outsider status of these pupils. This contributed to the negative attitudes of some teachers who viewed this as unnecessary favouritism. In this way, such accommodations further stigmatised these pupils and worked against the school's inclusive intent – yet with-out special treatment, some Gypsy and Traveller pupils would have re-mained alienated from these schools. Both equal treatment and special treatment have their drawbacks. There is no simple solution to this dilemma.

Nancy Fraser and a differentiated recognition of difference

Minow's 'dilemma of difference' resonates with the social justice work of Nancy Fraser. Fraser (1997) is critical of approaches to social justice that focus primarily on cultural recognition while marginalising issues of distribution (economic inequality). She argues that achieving social justice requires both redistribution of material resources and cultural recognition of difference. Injustices based on social class, for example, require distributive (economic) solutions while others, such as those related to sexuality, require cultural recognition. However, as socio-economic issues and cultural issues are inevitably intertwined, many

injustices are not that clear cut and require both redistribution and cultural recognition. Fraser draws attention to the division between paid 'productive' labour and unpaid 'reproductive' labour and also labour market pay differentials, as examples of gender-specific forms of social injustice. She argues that these forms of exploitation, marginalisation and devaluation can only be addressed effectively through both redistributive politics and cultural recognition.

According to Fraser, social justice requires both equal treatment and different treatment – both recognition and non-recognition of difference. As these two responses do not sit neatly alongside each other there is a challenge in pursuing both simultaneously. Reflecting Minow's dilemma of difference, Fraser asks: Under what conditions can a politics of recognition support a politics of redistribution, and when does it undermine it? Her answer is that social justice is best served through an approach that is able to combine a politics of redistribution with a politics of recognition; in other words, an approach that is able to address both cultural and economic issues simultaneously. Her proposed solution is a differentiated recognition of difference; that is, recognition of different kinds of differences, some to be eliminated (non-recognition), some to be universalised (recognition), and some simply to be enjoyed. She argues that it is in this way that a politics of redistribution can be reconciled with a politics of recognition.

I suggest that Fraser's view that not all differences should or need to be attended to goes some way towards addressing Minow's dilemma of difference. In this book this argument is illustrated through a focus on pregnant schoolgirls and schoolgirl mothers but the general argument applies equally to other pupils with other differences.

Structure of the book
The book is organised into seven chapters. In this introductory chapter I have set the scene by outlining the specific and broader policy contexts for pregnant schoolgirls and schoolgirl mothers and linked this to the wider educational context whereby schools are now expected to accommodate a much wider range of pupil differences than in the past. I have also introduced the evidence-base for the claims made in the book and the theoretical framework I use to analyse the accounts presented.

Chapters 2 to 5 draw extensively on the accounts of the young women I interviewed over an eighteen-month period. They provide a window, albeit a cloudy one, through which the day-to-day lives of fourteen young women may be seen, heard and felt. They do not make up a unified or complete picture and I cannot claim that the accounts are necessarily representative of the views of pregnant schoolgirls. Nevertheless their words provide valuable insights into issues of identity and agency in relation to the difference created by teenage pregnancy and motherhood and paint a somewhat different picture from that in the wider literature on teenage pregnancy.

Beginning with young women's stories of becoming pregnant, Chapter 2 examines their realisations of being pregnant, the role of contraception and their attitudes towards abortion. Chapter 3 moves to their experiences and reflections on motherhood. Both chapters reveal the contradictions and ambiguities in their accounts, and indeed in their day-to-day lives, as they seek to negotiate multiple positions and meanings within social constructions of teenage pregnancy that largely ignore gender and class-based constraints. A strong theme emerges: young women's day-to-day experiences were made more difficult because of the negative ways in which teenage pregnancy and motherhood were recognised and therefore responded to.

Building on their stories of becoming pregnant and the transition to motherhood, Chapters 4 and 5 look specifically at the interface between their new roles as mothers or mothers to be and the expectation that they remain in education. Chapter 4 focuses on young women's mainstream school experiences while Chapter 5 presents their experiences in specialist educational alternatives and their transition to post-compulsory education. Chapter 4 observes the clear mismatch between policy and practice and in particular the marked reluctance of some schools to support a pregnant pupil to remain in mainstream education while Chapter 5 explores the merits and limitations of educational alternatives and reflects on the young women's educational and employment trajectories. Again, a recurring theme was that young women's experiences of pregnancy, motherhood and education were made more difficult because of the way the difference of teenage pregnancy and motherhood was perceived.

Using the concept of difference as the analytic axis, and returning to the theoretical framework inspired by Fraser (1997), Chapter 6 shows that many of the ways in which young women were recognised as different were inherently stigmatising and made it difficult for them to develop positive and respected identities as pregnant and mothering teenagers. It raises questions about the validity of some of the assumptions that are made about young mothers and highlights some alternative and affirming responses to difference that were evident in their accounts. It also draws attention to how differences relating to gender and social class remained largely unrecognised yet shaped the choices and possibilities in young women's day-to-day lives.

In the final chapter I draw together the arguments presented in the earlier chapters and point to the policy and practice implications that stem from my findings. I call for policy which recognises a greater range of differences between young people and which adopts broader conceptualisations of social inclusion and exclusion. This would require greater recognition of the ways in which class and gender shape young people's choices and possibilities. I argue that Fraser's concept of a differentiated recognition of difference goes some way towards resolving Minow's 'dilemma of difference' and spell out what this means in practical terms for schools to be more supportive of this particular group of marginalised pupils. This concept and the analytic model provided can generate less stigmatising and more affirming attitudes and practices towards all pupils, no matter what their differences.

2
Becoming pregnant

Becoming pregnant: a snapshot

> Everything they told me is true but you have to solve your own problems, innit.

Shae, the youngest of five siblings and the only daughter, lived in a small two-bed apartment with her mother. She was 14 years old and in her second last year of secondary school when she became pregnant. She had been in a steady relationship with her boyfriend, who was three years older, for two years and had been using the contraceptive pill from shortly after they became sexually active. At the time Shae became pregnant, her mother's housing situation had become uncertain and as a consequence Shae had been spending nights at various people's places, including some nights with her boyfriend and his family.

Shae had not wanted or expected to become pregnant so found it easy to ignore the early signs of pregnancy and at first to deny even the possibility that she might be pregnant. It was only because of the persistent persuasion of a friend, after she missed a second menstrual period, that Shae eventually took a pregnancy test and discovered that she was indeed pregnant. Even with the definitive medical result, her new reality took time to sink in. The situation in which she suddenly found herself seemed overwhelming and unreal.

> Well I knew I was pregnant but I just didn't want to think about it. It was hard to think that I was actually going to have a baby.

Her initial feelings of disbelief and shock were accompanied by thoughts of the negative impact pregnancy and motherhood would have on her future plans, and she dreaded the negative reaction she expected from her family.

The first person she told about her pregnancy was her boyfriend and he told his family. Their reactions were mixed. They were happy about it but also worried that Shae was too young to be a good mother.

> They were happy ... but also disappointed, because of my age. They didn't think I was going to be as good of a mum as I am ... because of my age.

Shae was apprehensive about telling her mother and brothers. She was also anxious about her ability to cope as a young mother, about how pregnancy and motherhood would affect her education, and about the deteriorating relationship between her and her boyfriend. She briefly considered abortion and discussed this with her boyfriend.

Shae had not yet told her mother or siblings she was pregnant when her boyfriend's mother intentionally let it slip by making her own anti-abortion stance clear during a brief visit to collect her son. Shae's mother was left to draw the obvious conclusion.

> Dan's mum walked in and said 'oh what do you mean about the termination, we don't believe in termination here', and mum's going, 'what?' And she [Dan's mother] says, 'you don't know?' and mum's looking at me like, 'I'm going to kill you', and that's how it all came out.

As she had anticipated, her mother and brothers were disappointed, worried and angry. Like Shae they thought being pregnant would mark the end of her present life and would stop her pursuing her own interests.

> They just didn't want me to be pregnant. They said, 'you're not going to do anything with your life'. They were like, 'you need to enjoy your life' and 'you're going to get stuck in the house' and 'I've seen it before' and 'the baby's father don't help and you think it's all going to be sweet happy families but it's not'.

Some family members put pressure on Shae to terminate her pregnancy but she received support to make her own decision from others. One brother was particularly influential.

> My youngest one, he was dead upset, crying, and he was like, 'get rid of it, please'. But one of my other brothers, he was saying to me, 'it's what you think, it's not what others say, it's *your* decision, it's *you* that's got to live with it not them'.

Amidst the turmoil of her internal thoughts and feelings, the factors to weigh up and external pressures to contend with, Shae ultimately decided to continue with her pregnancy. Despite being only 14, she thought an abortion was not right for her.

> In the end, I just thought to myself, 'it was my own fault getting pregnant, I'm big enough to get pregnant then I'm big enough to look after him'. Everything they told me is true but you have to solve your own problems, innit.

Six months later, aged 15, Shae gave birth to a healthy baby boy.

Becoming pregnant: a collage

This is one story among fourteen. It provides a brief and fragmentary glimpse through the eyes of one young woman and raises some of the issues that are integral to the experience of becoming pregnant as a teenager. Uncertain living circumstances, changing relationships with significant others, attitudes towards sex, contraception and abortion, power dynamics between and within families, and societal expectations all feature in Shae's story. Like those of other young women, her story reveals both her vulnerability and her resilience, dependence and independence, and the need to make tough, life-altering decisions and take responsibility for them.

This chapter tries to convey something of the lived experience of becoming pregnant for young teenagers in England today. What were the circumstances within which they became pregnant? When and how did they realise they were pregnant and what did they think and feel about it? What sense did they make of their pregnancies and how did they position this alongside the views of their family and wider society? My purpose in presenting these accounts is two-fold. Firstly, they serve to paint a somewhat more complex and nuanced picture of the experience of becoming pregnant while still at school than generally presented in the literature. Secondly they raise important questions about some of the assumptions that underpin current policy. A critical examination of

these assumptions is the first step in promoting more holistic under-standings which will, in turn, contribute to less stigmatising representa-tions and therefore more helpful responses to the difference of teenage pregnancy. The accounts presented in this chapter thus lay the founda-tion for the analysis of difference presented later in the book.

Realising, confirming and accepting pregnancy

Policy on teenage pregnancy stresses the prevention of conception through better access to sexual health services and better sex and relationship education (see Chapter 1). This chapter begins by explor-ing the young women's knowledge and experiences of contraception and their attitudes towards abortion. My findings challenge the policy assumption that ignorance about sex and contraception is a significant factor in the UK's high rate of teenage pregnancy. It also raises concerns about the representation of pregnant and mothering teenagers as foolish, morally deficient or irresponsible.

Despite the considerable variation in young women's 'becoming preg-nant' stories, there were also some commonalities. First, in line with other research (Tabberer *et al*, 2000), most of the young women's preg-nancies were unplanned; an unwanted and unexpected outcome of sexual activity. Secondly, realising and then accepting pregnancy was often a drawn out process that was far from straightforward. All of them noticed missed periods and experienced physical symptoms such as tender breasts, feeling nauseous, feeling tired or simply feeling different but they responded in different ways. Several young women recognised their symptoms and sought confirmation early in their pregnancies. Aimee illustrates. She and her boyfriend had not been sexually active for very long and had been using condoms so she was not expecting to become pregnant. Her knowledge of the indications of pregnancy how-ever, over-rode her surprise at having such symptoms. She sought a pregnancy test which revealed that she was six weeks pregnant.

> When I first found out I couldn't believe it because my periods were often late anyway ... and I've always used protection ... so that didn't enter my mind and then it got to, like, I was getting really sick in the morning and I was getting even more tired and I know that these are the symptoms of pregnancy. (Aimee)

For the small minority whose pregnancies were not accidental, the symptoms had of course been anticipated and pregnancy was recognised and confirmed early. For others, it was a slower process of recognition. When symptoms persisted or when a friend, or mother, or boyfriend's mother suspected or suggested pregnancy then confirmatory actions were taken. In Shae's case, it was the persistent persuasion of a friend that eventually made her take a pregnancy test.

Five of the teenagers initially responded to their growing awareness that something life-producing and life-changing had occurred with firm and on-going denial. As might be expected, this group included the four who were the youngest when they conceived. The implications of finding themselves pregnant at the ages of 14 or 15, with up to two more years of secondary school to complete, felt overwhelming; denial was therefore a rational and understandable initial response. Within this context, being four months (two young women) and three months (the other two) into their pregnancies before undergoing a pregnancy test seems less surprising.

Like some of the others, Libby reported 'knowing deep down' that she was pregnant but avoided facing pregnancy and its multitude of implications, at least temporarily, by denying her pregnancy to herself and others, and by not taking a pregnancy test.

> I started feeling sick but I didn't really want a pregnancy test because I knew I was pregnant. I was scared to go to the doctors but my friend helped me out and offered to come to the youth club with me. She said it's better to find out sooner rather than later so I could tell my mum. (Libby)

Libby did not seek a pregnancy test despite three missed periods because she anticipated negative reactions from others and understood the challenging realities of motherhood. Other young women spoke about the social and educational implications for their adolescent lives when explaining why it took so long to accept their pregnancies.

A positive pregnancy test was inevitably accompanied by a broad array of thoughts and feelings. For some, these were intense and overwhelming. Others focused on the positive as well as negative aspects of this new development in their lives. They understood the practical implications for their everyday lives and were aware that becoming pregnant at their age ran counter to societal and, often, family expectations. They

feared negative reactions from parents and judgment from wider society and some felt uncertain about their ability to cope with the challenges and demands of motherhood.

Aimee provides a useful illustration of the melee of thoughts and feelings that comprised her initial reaction to a positive pregnancy test.

> Well I was thinking a lot about my education. And ... I was happy to know ... you know, I've dreaded, when you're at school with your friends you're like, 'I hope I'm not infertile'. And it was like, 'whew, I'm not'. But then I was gutted that I thought that I couldn't keep the baby. Me and [my boyfriend] were just like, 'we're not going to get the support', 'they're going to be really upset and we're going to have to get rid of the baby' ... and for school as well. I thought I wasn't going to get my GCSEs, I'm not going to go to college and I'm not going to get the job I want to get. (Aimee)

The young women felt disbelief; they were confused, uncertain and anxious. They worried about: 'what are mum and dad going to say'; 'what about my education'; 'how will I cope with a baby'; 'I know I want to keep it'. Some of them referred to physiological responses associated with shock: 'I was shaking'; 'I couldn't even breathe'; 'I was numb'; 'I couldn't speak' – or used metaphors such as 'it was like the world stopped spinning'. Clare was one of these. When I asked her what she thought and felt when her pregnancy was confirmed, she replied:

> I don't know. I was just blank and I kept staring at it [the line indicating a positive result] and thinking: 'Oh my God this isn't true!' I just looked at my friend and I told her. I just sat down and I was shaking because I had to ring my mum and my sister and I couldn't. (Clare)

Unsurprisingly, given the enormity of the transition to motherhood when they were so young and still dependent on their families, the reality of their pregnancies often took a few days, if not longer, to sink in and be fully accepted. As might also be expected, the three young women whose pregnancies were planned spoke about being excited and happy, and their adjustment to the idea of approaching motherhood was easier and faster.

The role of contraception

Given that most teenage pregnancies are unplanned, how might these accidents be explained? Policy assumes lack of knowledge among young

people as a key explanation for high teenage conception rates so I was keen to consider what light the young women could shed on this matter. I found that nine out of fourteen had not been using any form of contraception when they became pregnant yet their accounts suggest that they all had enough knowledge about it to prevent pregnancy. How might this apparent contradiction be explained? And what about the five who had been using contraception? How did they view contraceptive failure?

'It's only one little pill'

Of those who had been using contraception, two had been using condoms and three the contraceptive pill. Aimee, who reported always using a condom with her boyfriend, remained somewhat mystified about her pregnancy. Sarah, on the other hand, said she and her boyfriend had sometimes but not always used condoms and that she knew she might get pregnant. She had not intentionally planned to get pregnant but she and her boyfriend had discussed their desire to start a family at some point.

Three of the young women who had used the pill reported using it inconsistently. Two of them had missed a pill and thought it did not matter, and the other had been ill. Rebecca's misuse of the pill was not simply about ignorance. She appeared well informed about this form of contraception and knew what she was meant to do in the case of forgetting to take one.

> The first time [I got pregnant] I missed a pill. You're supposed to wait seven days and use other contraception ... and I didn't. I thought it's only one little pill, it'll be alright. (Rebecca)

Knowledge was not translated into practice consistently. Inconsistent use of the pill is not confined to adolescents. One US study revealed that across all age-groups, around half of unintended pregnancies result from inconsistent use of this form of contraception (Trussell, 2004).

Shae offered a similar explanation when speculating about how she became pregnant. She thought she had missed a pill or not taken it at around the same time each day. At the time she became pregnant she was highly stressed about her mother's recent eviction from their home and was spending nights at different people's places, so it was hardly

surprising that she forgot to take her pill consistently. Based on her work with young mothers in London, many of whom reported not wanting to become pregnant, Phoenix concluded: 'While it is theoretically possible to separate contraceptive failure from failure to use contraception as recommended, in practice it is difficult to distinguish them' (Phoenix, 1991:81).

'You just don't think it'll happen to you'

The fifth young woman who used contraception but nonetheless became pregnant was Sonia. She was 17 years old and had a 22 month old son when I first met her. Like most of the others, her pregnancy had been unintended. She explained that she had tried several different methods of contraception when she first became sexually active, but that at the time she conceived she had not been using contraception regularly or consistently because 'you just don't think it'll happen to you'.

Our subsequent conversation, however, shed further light on this. She did not like the side effects of the pill or the injection and she had also tried the implant. Weight gain, feeling sick, irritation from an implant or aversion to injections are unwanted side effects, as reported by young women in my work and in other research (Davies *et al*, 2001; Luker, 1996; Phoenix, 1991). Davies *et al* (2001) insightfully argue that choices relating to contraception use can only be understood in relation to the quality of methods available. The teenage mothers in their study were well aware of different birth control methods, and had access to them, but ease of use and side-effects meant that they did not use them consistently. Responsibility and inconvenience for contraception, and any associated side effects, falls almost exclusively on women, but this is not generally recognised in research or policy on teenage pregnancy.

Sonia, and four of the nine others who had not been using contraception, did not think about pregnancy as an outcome of their sexual activities. They understood that unprotected sex meant there was a possibility of becoming pregnant – they just did not think it would happen to them. Megan said, 'I'm not making excuses ... I knew I might get pregnant, but I didn't really think it would happen'. Interestingly, and mirroring other research where pregnancy was unplanned yet

contraception was not being used (Allen and Bourke Dowling, 1998), becoming pregnant still came as a shock to these teenagers.

'If you fall pregnant, you fall pregnant'

When talking either about their own pregnancies or teenage pregnancy in general, half of the young women conveyed a fatalistic view of why and how teenage pregnancies occur. They viewed getting pregnant as something that just happens that is largely beyond the control of the individual. References to 'falling pregnant' were common and carry subtle overtones of 'pregnancy as accident'. Katie's view on why teenage pregnancies occur was:

> I don't know. It's just the normal teenage thing. You go out and you experience your sexuality and if you fall pregnant, you fall pregnant. (Katie)

Other research has found that some young women view life as something that happens to them, over which they have little control (Allen and Bourke Dowling, 1998; MacDonald and Marsh, 2005). As some of this work also points out, however, there are myriad intersecting factors that influence young people's outlook, choices and actions. These remain largely unrecognised within policy and research, thus making it difficult to make sense of apparent contradictions or to develop more holistic understandings about teenage pregnancy. In their qualitative study of young people growing up in Britain's poor neighbourhoods, MacDonald and Marsh (2005), for example, look to both neighbourhood and broader class-related factors to explain the 'complicated, ambiguous accounts' (144) they gathered. In their study, part of this complicated account was the discrepancy between young women's subjective viewpoint (a belief that it would have been better to wait until they were older to have their first child) and their actual lives (that they were all young mothers). MacDonald and Marsh suggest the fatalistic views held by some of their participants were 'induced by lack of choice, poverty and other lived experiences of social exclusion' (p145).

In my study, Lisa's reference to luck provides a second example of a view of pregnancy (and life?) as something that just happens. Her words mirror something of MacDonald and Marsh's complicated, ambiguous accounts. When I met Lisa for the second time she had recently given birth to her second child. Like her first pregnancy, this one had been

unplanned and had come as a shock. She spoke about her strong anti-abortion views and acknowledged that she could have prevented this pregnancy but thought she had simply been unlucky.

> I was shocked for the second time but I knew that I weren't going to get rid of it. That's just something that I don't believe in. I could have prevented it but I weren't lucky enough. (Lisa)

On the surface, both of Lisa's pregnancies could be classified as failed contraception. She was using the contraceptive pill when she became pregnant for the first time, and the patch for her second pregnancy, but she had not been using either consistently. She sometimes forgot to take her pill or apply a fresh patch. She explained, 'I'm just not good at things like that'.

> I'd miss a day and try and take two the next day. I'm just not good at things like that. And the reason why I chose to use a patch the second time was because I didn't want to have the injection or the coil. (Lisa)

This is a somewhat mixed scenario. Lisa thought she had been unlucky to get pregnant – she viewed it as something largely beyond her control. However, she had recognised her inconsistent use of the pill and sought the patch, a longer acting form of contraception, thus demonstrating a degree of personal agency. Her outlook, choices and actions were in-visibly gendered in that responsibility for contraception and manage-ment of side effects were exclusively her responsibility. It is important to see beyond the initial fatalism to also recognise the classed and gendered constraints on young lives.

'I was shy ... to go and get condoms and contraception from the youth club'

Several of the young women spoke about their hesitation about going into what felt like a very public and surveilled space, such as a family planning clinic, in order to access contraception, because they were clearly so young. They were conscious that being sexually active at their age was not socially condoned. Libby did not feel too young, at the age of 14, to become sexually involved with her 16 year old boyfriend but she felt unsure what reaction she would get from the medical profes-sional with whom she would have to consult to be prescribed the pill. Negative public perception of youthful sex was a barrier to her access-

ing certain forms of contraception. This even extended to her local youth club, which distributed free condoms as part of a nationally funded scheme. The young women in my study are not alone in this. Embarrassment or fear of lack of confidentiality when it comes to accessing contraception is an issue that has been raised in other research (Phoenix, 1991; Stone and Ingham, 2003). In a questionnaire-based study with users of youth oriented sexual health services across the UK, researchers noted this was an issue for the 27 per cent of their sample who were under 16 (Stone and Ingham, 2003). Across their wider sample, 61 per cent of young people reported that they did not access a service until after they had become sexually active yet only 11 per cent indicated that this was because they did not know about the service. Lack of knowledge about contraception or sexual health services was not the primary barrier. Interestingly, almost 90 per cent of the users of these services were female, reiterating my earlier point that responsibility for contraception falls primarily on women.

In addition to her embarrassment, and as was also true of some of the other young women, contraception was something Libby had never discussed with her boyfriend. Only one young woman was explicit in airing her dissatisfaction that by unspoken default, contraception is a woman's responsibility.

Given the number of studies that suggest otherwise (see Phoenix, 1991; Stevens-Simon *et al*, 1996), it is curious that lack of accurate knowledge is still seen as an important determinant of teenage pregnancy. The issue of side-effects and responsibility for contraception belonging primarily to women are also absent from policy debates about teenage pregnancy yet have been raised as concerns by young women (Davies *et al*, 2001; Luker, 1996; Phoenix, 1991). Policy also fails to recognise that embarrassment, fear of lack of confidentiality, and awareness of the social unacceptability of adolescent sex create barriers to contraceptive use. These issues are largely absent in the teenage pregnancy literature and in policy but the accounts of young women in this and other research suggest that they warrant further consideration.

Planned versus unplanned pregnancy

My research, as well as other studies, supports the general assertion that most teenage pregnancies are unplanned, however, the distinction

between planned and unplanned may not be as clear-cut as it seems. In my study I was uncomfortable with straightforward categorisation of the young women's pregnancies as either planned or unplanned because this rendered potentially important questions less visible and left little room for considering ambiguities and contradictions. What meaning, for example, can be taken from the fact that nine young women were not using contraception yet indicated that their pregnancies were unplanned? What about the young woman who spoke about her pregnancy as being neither planned nor unplanned, 'if you know what I mean', or the one who gave different indications of the extent of intentionality relating to her pregnancy across different interviews? How might the stigmatised status of teenage pregnancy, or their view of me as interviewer, have influenced their willingness to speak candidly about pregnancies being planned? What about the difference between unplanned and unwanted? I remain unsure about the answers to some of these questions, however, in agreement with other research (Barrett and Wellings, 2002; Cater and Coleman, 2006), my data suggests that the concepts of planned and unplanned are not well defined or clear cut and that intentions and decision-making around pregnancy are more complex than policy responses to teenage pregnancy suggest.

'Well it weren't no accident'

Three of the teenagers indicated that their pregnancies were planned and one further participant placed herself ambiguously somewhere between planned and unplanned. Katie who was 16 years old with a ten month old son when I first met her was the clearest about the intentional nature of her pregnancy. In response to a question about realising she was pregnant, she began her reply by stating 'well it weren't no accident' and that she and her boyfriend were very happy with this development. Possibly of significance, her pregnancy followed an earlier miscarriage. Katie also constructed her narrative as different from that of most teenagers who get pregnant which she considered to be unplanned.

> Well it weren't no accident that Daniel came along because we'd been planning it for months. And I lost a baby in August ... so we were really happy [about the subsequent pregnancy]. And it was different from all the other teenagers I know because most of theirs are accidents but we really sat down and thought about it. (Katie)

Sarina was also clear about intentionally becoming pregnant. Aged fifteen, she accidently became pregnant toward the end of Year 10 but like Katie, subsequently miscarried. She miscarried a second time before conceiving again early in her final year of school, now aged sixteen. She explained that from her first pregnancy, her boyfriend, who was four years older and who she had been in a relationship with for two years, had expressed a desire to father a baby – and with two miscarriages, she had become anxious about not being able to carry a baby to full term. Although it is difficult to judge the extent of her own desire for motherhood at this point in her life, it was clear that pregnancy and motherhood was not as daunting a prospect for her as it was for some of the other young women. So her story, like many of the others, is more complex than it initially seemed. It also illustrates how the specific dynamics of the relationship with male partners may influence not just when and how to start having sex but also the procreative outcomes.

Mia, the other young woman who was definite about the intentional nature of her pregnancy, said it was 'hard to explain'. She recounted a pregnancy scare a few months earlier. After missing a period, she had bought a self-testing kit and was shocked to find she tested positive. Over the subsequent week, she and her boyfriend decided she would continue with the pregnancy. When she later sought formal confirmation from her doctor her test came out as negative. Having become accustomed to the idea of having a baby, this was disappointing news and over the subsequent months she and her boyfriend stopped using contraception with the view that Mia would become pregnant again.

One feature common to these accounts is an earlier pregnancy and miscarriage, or in Mia's case, the belief of pregnancy. A second common feature is a long term relationship with a man who wished to father a child. Stories such as these challenge the policy assumption that all teenage pregnancies are accidents and can therefore be explained largely in terms of ignorance.

Abortion

One of the decision-making crossroads on the path to teenage pregnancy is whether and when to become sexually active. Another is whether and which contraceptive method to use. In the event of conception, a third decision is whether to continue or terminate the preg-

nancy. In the UK, approximately half of the teenagers under 16 and a third of 16 and 17 year olds choose to terminate their pregnancies (ONS/DH, 2008), but like teenage pregnancy rates, there is considerable geographic variation; teenage pregnancy rates are higher, and abortion rates lower, in areas of high social deprivation (Lee *et al*, 2004). Research reveals that young women from socially deprived areas are more likely to hold anti-abortion views (Tabberer *et al*, 2000) and more likely to perceive fewer negative implications of becoming a mother (Turner, 2004).

Social policy in the UK is underpinned by Rational Economic Man assumptions of an independent individual who is detached from any wider sense of family or community and where the right and responsible choice would be to terminate an unplanned pregnancy. Not to do so is viewed as irrational and irresponsible. Clearly, all the teenagers in my study chose to continue with their pregnancies. Their accounts suggest that there may be some merit in recognising alternative constructions of a teenage decision to carry a pregnancy to term.

Parents of the young women in my study influenced pregnancy outcomes through explicitly or implicitly expressing their own anti-abortion views or through offers of support. This was important given the age, state of dependence and educational stage of the young women. The strong anti-abortion views I found were underpinned by ideas about responsibility and the sanctity of life. The internal conflicts and external pressures that the young women had to resolve included how to balance personal needs and desires to lead a normal adolescent life with those of the desires of motherhood and those of an unborn child, and how to take an independent stance within the constraints of dependence. Their responses to these dilemmas appeared to be based on constructions of responsibility and rationality that differ from those embedded in policy.

'*I knew I could never go through with it*'
None of the teenagers agreed with abortion and only one of them (Shae) seriously contemplated it. Many viewed their pregnancy as a baby from the moment it was confirmed, or as one young woman put it, 'right from the blue line'. Abortion was seen as a moral issue inseparable from views about the sanctity of life and they used emotive words

such as 'kill' and 'murder' when speaking about it. Sarah echoed the views of many of the others when she spoke about abortion as 'getting rid of a life' which she was partially responsible for creating and there was some evidence that families explicitly or implicitly sanctioned such views.

Some young women experienced more internal conflict or external pressure than others in relation to this issue. Tracy for example, was aware that she lived in a community where abortion was not considered the 'right' response to an unwanted pregnancy. She did not think she could go through with a pregnancy only to give her child away – yet she felt unsure about how she would cope as a fifteen year old mother.

> I thought I couldn't get rid of a kid cause I would be a child murderer but then I didn't know how I could cope with having the baby. I didn't know what to do. People were saying that you can't kill off a child but if you don't want it you can give birth to it and put it up for adoption. But after giving birth to it I couldn't do that. (Tracy)

Tracy's account confirms other research which suggests that decisions relating to abortion are influenced by a range of factors including community views on the unacceptability of abortion (see Tabberer *et al*, 2000; Turner, 2004). It highlights the emotive language and strength of feeling engendered by this issue. Reflecting the language used by young women in my study, a teenager in another English study recounted: 'I told this woman I worked with and she turned round and called me a murderer' (Tabberer *et al*, 2000:19). This research shows that a decision to terminate a pregnancy may result in open hostility and isolation from peers.

Clare, like Tracy, struggled with resolving the tension between community expectations and personal desires or needs – but from the other end of the 'attitude to abortion' spectrum. Clare was the only participant who lived in a socially affluent area and, although personally non-judgmental about abortion, did not believe it was the right option for her. She said, 'I don't think I could have coped with it mentally. It would have broken me'. She knew that her family and community considered abortion to be the rational and appropriate course of action for a young woman in her position but it was not one she was willing to take no matter what the personal cost or inconvenience.

> I wanted my life ... do you know what I mean ... and people said, 'why didn't you get rid of him then?' but that's the easy way out ... and I don't do easy way out. (Clare)

Despite the pro-abortion attitudes prevalent in her community, she chose to continue with her pregnancy.

Shae was the only teenager in my research who came under pressure from some family members to terminate her pregnancy. She concurrently experienced pressure from her boyfriend's family not to go through with an abortion. Her boyfriend's mother seemed to represent the voice of the community with her forceful and unambiguous statement: 'What do you mean about the termination. We don't believe in termination here.' In the end, influenced partially by her oldest brother, Shae opted to continue with her pregnancy, but like the other young women, her decision was fraught with conflict.

The moral stance taken by these young women conveyed strongly held community and family-influenced constructions about responsibility. They viewed continuing their pregnancies as the responsible and therefore right thing to do, regardless of the inconvenience or difficulties it might cause them. As Rebecca said:

> Basically I looked at it as a mistake that had to be rectified but I didn't want to rectify it with a termination. (Rebecca)

Her statement echoes Clare's reference to 'I don't do easy way out'. Their words provide an alternative view of a group of young women who are often represented as irresponsible, irrational or feckless. Policy assumes that abortion is the right (rational) course of action but for the young women in this study, a different rationality prevailed.

These 'becoming pregnant' stories challenge the view that high teenage pregnancy rates can be explained primarily in terms of ignorance. They also raise questions about the representation of pregnant teenagers as morally deficient or irresponsible. Rather, they suggest a place for more complex understandings about the meaning-makings that influence teenage sexual behaviour, contraceptive use, attitudes towards abortion as well as the place of parenthood in young people's lives. They suggest that alternative constructions of the difference of teenage pregnancy are needed – and as I argue later, constructions that recognise a wider range of differences as well as those that are less stigmatising of young people.

Young people's views and experiences of SRE challenge two additional policy assumptions and it is these to which I now turn. Firstly, while it seems that better SRE would have been welcomed by the young women, I argue that SRE, on its own, is unlikely to be the policy solution that is expected of it. Rather, understanding the relationship between SRE and young people's sexual behaviour generally, and between teenage pregnancy and SRE in particular, requires a more complex analysis than current policy solutions suggest. I also challenge the assumption that delivering SRE is unproblematic for schools. This is not necessarily the case and I look to the wider social and educational context within which SRE takes place to highlight some of the factors that confound an effective SRE experience for young people. I also draw on young people's ideas about how SRE could be improved and highlight some practical implications for schools in relation to content and delivery.

Sex and relationship education: myths and (mis)conceptions

> The key task for schools is, through appropriate information and effective advice on contraception and on delaying sexual activity, to reduce the incidence of unwanted pregnancies. (DfEE, 2000:16)

The above quote from the sex and relationship education guidance that was issued to all schools in support of the teenage pregnancy strategy, highlights the key role to be played by schools in reducing the UK's high teenage pregnancy rate. It is the policy solution to the supposed 'ignorance' cause of high teenage conception rates and is based on the premise that providing knowledge will lead to informed and responsible decision-making and behaviour. Given the considerable focus on better SRE within policy, I was keen to consider teenagers' experiences and views on this important part of the curriculum.

Sexual knowledge and views on the importance of SRE

In keeping with other studies that show that SRE is wanted by the majority of young people and their parents (Alldred and David, 2007; Wiggins *et al*, 2005), the young women in my research all considered SRE to be important. When asked what in particular they thought was important they invariably referred to learning about the risks associated with sexually transmitted infections and also the risk of pregnancy, indicating that they saw promoting sexual health and preventing

pregnancy as two of the main functions of SRE. I asked Louise whether she considered SRE to be important and she replied:

> Yes, I do ... so then teenagers know more about it. They think they know everything but they don't ... so you can teach them more ... so they know the risks and things like that.

Young women's accounts suggested that they had enough sexual and contraceptive knowledge to keep themselves safe and none of them thought that high teenage pregnancy rates are because young people do not know about contraception or the risks of unprotected sex. Clare stated: 'Everyone knows that if you have unprotected sex then you are more likely to get pregnant or catch something'. Five of the young women, however, also thought that some young people do not know enough about sex, and four others said that although they did not personally feel naïve or ignorant, there were some things they would like to have known more about, such as more detailed and in-depth information about different forms of contraception and sexually transmitted infections.

The young women learned about sex through a range of sources: friends, magazines, school, the internet and other media, and their mothers. Who or what they turned to for information varied from person to person with some relying more heavily on certain sources than others, however, peer group discussions were clearly important for many and, with three notable exceptions, parents were the least preferred source of information about sex. These three young women described their close relationships with their mothers and its importance for their sexual knowledge and thought that school SRE was particularly important for those not in their position. Rebecca explained:

> If you can't talk to your mum and dad, cause some people can't ... I was lucky enough to be able to sit with my mum and say, 'listen, you know what I mean ... I think it's going to happen', and she was like, 'get down that doctors then'. But some people ain't got that relationship with their parents so they need to be told in other ways.

For the majority of the young women in my study however, the sexual information they wanted and needed came from sources other than parents, and most viewed school SRE as having an important role to play in this respect.

Some of the young women observed that sex is all around them in television soap operas, films, popular music and advertising. It is the mixed nature of these messages that the SEU (1999) report claims to be one of three main causes of the UK's high teenage pregnancy rate. Constant media messages implying sexual activity as the norm run alongside an embarrassed silence about the reality of adolescent sexuality. As I argue later, the non-recognition of adolescent sex leaves some teenagers engaging in sexual activity without knowing how best to protect their sexual health and demonises those teenagers who do become pregnant through assumptions of moral impropriety.

Views on adolescent sex: rights and rites (of passage)

All the young women in my study began having sex below the age of legal sanction and research shows that they are not alone. The young people in Stone and Ingham's (2003) UK study as well as those in Sieving *et al*'s (2006) US study indicate that sexual activity among those younger than sixteen is not unusual. Three related points about young people's attitudes towards sex and how they positioned them alongside those of friends, parents and wider society are evident in my research. Firstly, although some of the young women attributed their early sexual activity to feeling mature for their age, they held a belief and expectation that adolescents 'go out and experience their sexuality' (Katie). They were aware that young adolescent sexual activity is not socially condoned – but that it is not necessarily condemned by all adults either. Clare thought that adult taboos can make some young people more interested in sex and her comment that 'there's no way to stop young people having sex' implies that some adolescents view sex as a right. Her words also suggest a parental expectation and acceptance of adolescent sexuality, albeit reluctant. Speaking about young people and sex, Clare said:

> It's part of growing up. And when people say, 'don't do it', it's more tempting to do it. And there's no way to stop young people having sex. This is what my mum says, 'you can put your daughter on the pill and you can stop them from staying over but if they are going to have sex then you can't stop them'.

The parental acceptance indicated by Clare was found among other parents, particularly the few who had a close relationship with their daughters. Rebecca and Aimee, for example, both reported having open

conversations with their mothers about sex and contraception prior to becoming pregnant. By encouraging their daughters to start using contraception, these mothers conveyed their acceptance of adolescent sexuality and an expectation that they would not get pregnant. Possibly pertinent to this acceptance is that their daughters, aged 15 when they became pregnant, had been going out with their boyfriends for twelve months or more and the couple regularly spent time in each other's family home.

The young women in my study conveyed a view of adolescent sex as a normal part of adolescent life but not one which is socially condoned, although it is in a way accepted or at least tolerated by some (more liberal) adults. Perhaps the SEU (1999) report has a point with its suggestion that young people are confronted with mixed messages about sex.

Peer pressure was another recurring theme. This was described as not so much a direct pressure to be sexually active but rather as a more subtle, almost self-imposed pressure emanating from a desire to avoid standing out as different – in this case by appearing to be sexually naive. Although stating that such pressures did not play a part in their own early sexual endeavours, many young women acknowledged that peer pressure does play a role in early adolescent sexual activity. They suggested, for example, that young people did not want to feel left out of the crowd by being the only virgin in their peer group.

Thirdly, and tied closely to the idea of peer pressure, some young women emphasised that adolescent sex is also to do with wanting to feel grown up. Again, most young women did not ascribe their own behaviour to this explanation. When commenting on peer pressure Mia, for example, said:

> No one wants to feel that they are not part of the group or are being left out. A lot of girls feel that they are a lot older if they have sex but that's not true ... you don't really know much more about life just because you've had sex at an early age.

Thus sexual activity seemed to be viewed as an important signifier for maturity and movement towards adult status – in other words, a developmental rite of passage. Only a few of the young women drew attention to negative aspects of early sexual involvement. Clare, for

example, saw romantic involvement at a young age as potentially traumatic.

> The whole relationship thing is just such a big part of a teenager's life but it must be the worst thing possible that can happen to teenagers because it just rips them apart. Everybody thinks they're falling in love and having sex for the first time and getting married.

Interestingly, only one young woman made reference to the pleasurable aspects of sex as a potential motivating factor while among all of them, the concepts of lust and desire appeared to be entirely absent.

Experiences of SRE: too little, too late, too biological, too didactic and too embarrassing

Although good sex education is an important part of a well-balanced education and something that is wanted and valued by the majority of young people and their parents, there is some evidence that young people, including pregnant teenagers and young mothers, are often dissatisfied with the sex education they receive (Allen, 2005; Wiggins *et al*, 2005). Without exception the young women in my study did not rate the SRE they received highly.

Despite the policy emphasis on better education about sex, the young women in my research appeared to have received little in the way of meaningful or memorable SRE. Most remembered some of it, a few lessons here and there, but they expressed dissatisfaction with the minimal amount they received. It was not just a matter of quantity; many of the young women found what they received lacked the depth and detail they wanted. Louise's comment that 'I'd looked into it myself' reminds us that school is just one among a number of sources of sexual information for young people, although I was unsure to what extent her seeking information outside school reflected her dissatisfaction with school SRE. When asked what she remembered about SRE, Louise replied:

> I think I had about two or three lessons and it weren't very detailed. They gave us a few information packs and a few activities. I knew all about it any-way because I'd looked into it myself but the lessons weren't very detailed.

Interestingly, Louise had started using the pill when she became sexually active but had stopped using it at the time she conceived because she

did not like the side effects – particularly, weight gain. So although she knew how to prevent pregnancy and took steps to access contraception, she later discontinued because of unwanted side effects – an issue that policy conveniently ignores.

Katie viewed the SRE she had received as inadequate because it focused on condom use rather than other forms of contraception which she would like to have known more about. Her words raise the issue of the impracticalities of, and young people's attitudes toward, using condoms (see also Abel and Fitzgerald, 2006). When asked whether she recalls much SRE, Katie replied:

> Yeah I do but it weren't very good. It were really rubbish ... because you only get told about condoms ... not so much about the pill or other things. And no one uses condoms anyway ... they're too much hassle ... and the lads don't like wearing a condom and they will always make some excuse.

Her statement raises the issue of power differentials between young men and women in early sexual encounters. It also resonates with my earlier observation that young women tend not to discuss contraception with their boyfriends because there is an unspoken assumption that contraception is a women's responsibility.

A recurring theme in relation to delivery of SRE was the embarrassment factor. Some of the young women reported outsiders coming into their school and said they preferred this arrangement rather than having regular staff teaching SRE. This was based on their experiences of teachers being embarrassed or lacking competence in teaching SRE.

In line with other research (Alldred and David, 2007; Holland *et al*, 1992; Measor *et al*, 2000) four of the teenagers acknowledged the potential gender-linked difficulties when SRE takes place in mixed-gender groups. They noted, in particular, how the boys do not take it seriously or use it as an opportunity to ridicule girls/women or to engage in masculinity competitions with each other.

> I did [have SRE] but it was with a bunch of lads so it was just really funny so nobody paid any attention. (Sarina)

Finally, one young woman attributed the lack of SRE in her school not just to teacher discomfort, as alluded to by many of the others, but to the systemic influence of league tables. She insightfully argued that as

long as there are league tables, schools will prioritise the examinable subjects. She posed the question, 'Why would you spend an hour doing SRE when you could be doing something for your league tables like science, maths or English?' She seemed to be tuned in to what teachers in her school may well have been thinking about SRE – and what other research has highlighted as a problematic consequence of the low status of SRE as a non-examinable subject (Alldred and David, 2007; Buston *et al*, 2002).

Sex and young people: controversy and discomfort

Policy assumes that delivering SRE is unproblematic for schools. This is not the case. Sex education, like teenage pregnancy, has long been associated with controversy and discomfort (Buston *et al*, 2001; Hampshire, 2003) and is an arena full of conflicting myths and beliefs. Some people, for example, believe that sexual knowledge and access to contraception encourages promiscuity among young people, while others take the view that young people need knowledge and access so they can make good decisions for themselves. The content and values considered appropriate in sex education is also contentious (Measor *et al*, 2000) and opinions about the role of the state versus the role of parents in providing sex education are deeply divided (Hampshire, 2003). These features create a minefield of uncertainty for schools, and an environment plagued by fear of parental objections or wider public criticism. It is little wonder that research has found that sex education causes anxiety within some schools and among some teachers (Alldred and David, 2007; Wight and Buston, 2003).

Limited teacher experience and expertise add to these tensions and leave some teachers feeling reluctant or unwilling to deliver this vital part of the curriculum (Buston *et al*, 2002). Teachers' heavy workloads mean the demands of SRE may conflict with responsibilities in other curriculum areas and leave little time to plan, develop relationships with outside agencies or to develop relevant specialist SRE knowledge (Baraitser *et al*, 2003). The non-statutory and loose nature of the guidance means that schools and their governors have considerable leeway in deciding exactly what will be delivered while the non-examinable status of SRE within the National Curriculum means that it may be given low priority in some schools. These factors have resulted in a

diverse and variable landscape: variability in teacher commitment to SRE (Buston *et al*, 2002); variability in the time allocated to SRE and in the adequacy of the teaching (Ofsted, 2002); and variability in emphasis and content (Hoggart, 2003).

Advice for improvement

Young people's views offer some useful ideas about how effectiveness might be enhanced. These ideas relate primarily to two areas which I consider in turn; content and delivery.

Content

The SRE guidance for England and Wales (DfEE, 2000) states that the three main elements of sex and relationship education are: attitudes and values; personal and social skills; and knowledge and understandings. In theory then, SRE should comprise a well-rounded programme. Research with young people, however, mine included, indicates that more focus goes on knowledge while values, attitudes and skills remain neglected areas (Abel and Fitzgerald, 2006; Strange *et al*, 2006). Teenage pregnancy research has drawn particular attention to the importance of communication and negotiation skills and how the lack of these skills can result in unplanned pregnancies (Hoggart, 2003; Osler and Vincent, 2003; Wiggins *et al*, 2005). Seven per cent of the teenage mothers in Wiggins *et al*'s (2005) study indicated that pregnancy had resulted from their lack of skill to negotiate contraceptive use with a partner who preferred unprotected sex or wanted a baby. Speaking about her sexual health work with young women, a professional in another study stated:

> What we found was that the young people we were working with had a reasonable knowledge of safe sexual practices ... but where they were falling down was that they were not assertive enough or confident enough. Their communication skills were not at a level where they could keep themselves safe. (Osler and Vincent, 2003:153)

In line with these findings, several of the young women in my research spoke about knowing they could get pregnant through their sexual activities but felt unable to talk to their boyfriends about contraception. Although they did not state it explicitly, they implied that they would have welcomed a greater focus on the relationship rather than the biological aspects of SRE. But the young women also spoke about

38

pupils needing more knowledge, specifically, information about different forms of contraception other than condoms and the pill, information about where they can access contraception, and information about sexually transmitted infections. One young woman emphasised how important it was that young people knew that visits to a GP or sexual health practitioner are confidential. She thought that if young people do not understand this, they are less likely to use those services. This supports my earlier suggestion that young people view SRE as having an important role to play in reducing teenage conceptions.

Only one young woman pointed out that sex education focuses on the dangers of sex while ignoring the pleasures. In line with other research, she suggested that greater emphasis on the emotional dimensions of relationships would be helpful (see Halstead and Waite, 2003; Kehily, 2002). What young people needed to know about sex and relationships, is, as Mia said:

> Contraception ... all areas of sex ... so how it's done ... the dangers to sexual health ... and the good points as well because they always tell you about the bad but they never tell you about the good ... and like you can feel closer to that person if you have sex and things like that. And they need to do more on the emotional side.

As noted by others (Allen, 2004; Ingham, 2005) and as discussed in some depth by Michelle Fine (1992), the themes of pleasure and desire are conspicuously absent from discourses on adolescent sexuality.

Delivery

The young women in my study thought that SRE should incorporate more group activities and discussions and fewer passive activities such as watching a video, or didactic forms of teaching such as listening to the teacher. These are ideas that would improve delivery of many parts of the curriculum. They also suggested more practical activities such as physically handling different forms of contraception, and more invited speakers and visits outside school, such as to the nearest youth-friendly sexual health clinic. In support of other research (Alldred and David, 2007; Baraitser *et al*, 2003), some thought that SRE should be delivered by outside experts or specially trained teachers rather than class teachers. This was based on their perception that some teachers are uncomfortable teaching SRE. They thought that when teachers do deliver

SRE they should be knowledgeable about content and comfortable talking to young people about sex. Rebecca illustrates these views and advises that schools deliver SRE more regularly. Like many of the others, she also raises the issue of teacher embarrassment:

> I think they should have at least one lesson a week, from Year 7 to Year 11. And they should have like specialised teachers ... not just like your tutor doing it. You should have people who are trained to know how to talk to young people in that way, cause if you get a bunch of thirteen year olds and start talking to them about sex and stuff, they're just going to laugh. A lot of teachers are embarrassed cause they think ... I don't know what they think but they must be embarrassed caused we never had any sex education.

The timing of particular content was also raised as an issue – in particular, ensuring that young people have the necessary knowledge before they need it. Aimee suggested that condom use should be introduced earlier than Year 10. Her advice on improving SRE was to bring in outside experts:

> When we were in Year 10 we went into the hall and we put on condoms and all that lot but by that time most of them were already ... like, you know, it was a bit late then ... it should have been happening ages ago. And my tutor, she didn't teach us anything about sex, she just showed us pictures of what diseases can do and that was because she was too embarrassed to talk about it. That's why I think people should come in who are experts and they know more about it.

Aimee also suggested, however, that some teachers can teach SRE well. She thought that the appropriateness or otherwise of an ordinary class teacher teaching SRE was related to the extent to which they were perceived as relaxed, confident and competent with content and delivery. Mia spoke about better and more varied teaching and also the importance of teachers being both comfortable with content and able to relate well to young people. Again, the embarrassment factor featured in Mia's comments:

> The teachers need to be better informed on how to get it across as something that is natural and not something that is dirty because that's what happened at our school. The science teacher was so embarrassed all the way through. The lads in the corner were going: 'Oh, look at her tits' and all this. The lads weren't taking it seriously and the girls were laughing at the teacher because he was going red. So teachers need to explain that sex is a normal thing and nothing to be hidden.

Mia thought that one consequence of teacher embarrassment is that it inhibits a more meaningful pupil engagement with content.

> If you're a kid and you don't quite understand something you're not going to ask that teacher who is dead uncomfortable because he just wants to get it over and done with.

The general picture that emerged was that the young women in my study viewed SRE as important, highlighting in particular its sexual health function. Although they did not view either themselves or other young people as necessarily ignorant about sexual matters they concurred that more information would be welcomed both for themselves and others. Sources of sexual information were widely available but peer groups were clearly key – and for a minority of young women, their mothers. They viewed adolescent sex as a normal part of growing up and upheld a belief and expectation that young people will be sexually active, although they were also aware that such behaviour is not socially sanctioned. They thought that the desire to feel part of the peer group and perceptions of sex as a signifier for maturity contributed to some young people's early sexual behaviour.

In relation to their own SRE experiences, young women had few positive things to say, viewing it as too little, too late, too biological, too didactic and too embarrassing. They advocated more practical activities, more group work and discussions, visits outside school such as to the local sexual health clinic, and more specific and detailed information. Some of them argued for the use of outside specialists to deliver SRE, others for specialist training for those within the school. Either way, what they needed was an adult who was competent with subject knowledge who was also comfortable talking to young people about sex and able to sensitively manage the classroom and gender dynamics that would allow meaningful engagement with content to take place.

3

Being a teenage mother

Your age don't determine whether you're a good mum (Mia)

The previous chapter focused on teenagers' experiences of becoming and being pregnant and their views of SRE. I questioned the validity and usefulness of policy constructions of young people as ignorant about the biology of sex and contraception and of young women as irrational or irresponsible in choosing to continue with their pregnancies, despite their youth and state of dependence. I suggested that, instead, a wider range of factors should be recognised as influencing young people's sexual behaviour and the outcomes. I challenged the assumption that delivering good SRE is unproblematic for schools and presented young women's ideas about how delivery of this important part of the curriculum might be improved.

This chapter explores teenager's experiences of motherhood. The young women reflect on the positive aspects and challenges of motherhood, and on the positions in which they found themselves as a consequence of being a teenage mother. One of the emerging themes is that motherhood may be experienced differently by those who are part of a stigmatised group from how it is for others. Although young women spoke about the pleasures and rewards of motherhood it was clear that their experience was made more difficult by the way their age difference was recognised. As I argue later, this occurs alongside the non-recognition of other differences, including those related to gender and social class. Whether it was professionals they came in contact with, members of the public, or even members of their own families, other people's re-

actions to their youthful motherhood made their lives more stressful and influenced their thoughts, feelings and behaviour, sometimes in detrimental ways. Dominant representations of teenage motherhood thus work against the support intended by policy. These representations need to be challenged to produce more affirming attitudes and practices. Young mothers' accounts also raise important questions about the appropriateness of the policy expectation that they be in education, employment or training (EET).

Becoming a teenage mother: mixed thoughts and feelings

Inquiries about the positive aspects of motherhood frequently drew responses from young mothers about feelings of love, about having someone to look after, and about feeling important because of the special mother-child bond. They talked about simple daily activities such as spending time with their babies, and about memorable occasions such as witnessing important developmental milestones. They often conveyed pride in their motherhood role and the achievements of their child. Libby illustrates this when she talks about her son's first steps. She told me:

> I like spending time with him ... getting to take him for walks and taking him swimming and being proud of him, like when he took his first steps and when his teeth came through. Yeah, like when I said to my mum, I used to shout, 'quick, look, Damian's walking', so I was proud of that.

Some young women spoke about how motherhood gave them a direction in life and how they felt more mature and responsible. Lisa, for example, thought that motherhood had made her grow up. Her words suggest that it gave her a sense of purpose and meaning that she felt she lacked before. Speaking of her transition into motherhood, Lisa said:

> You can still do things with your life. It's just up to young people to decide if they want that responsibility. You have to grow up a little bit. (pause) I'm glad for it. Before I left school and that I was just ... just doing nothing really ... so I'm glad that I settled down and I've got my baby to look after.

These themes recur in other qualitative research with young mothers. Some researchers speculate that some young women view motherhood as a legitimate pathway to adulthood (Dench *et al*, 2007; Hanna, 2001; Rolfe, 2005). Another common theme in my and other research is that

teenage motherhood is seen as an opportunity for positive change in one's life (Duncan *et al*, 2010; Luttrell, 2003) – or in the words of one young women in this study, 'to get my life back on track' (Clare).

Interestingly, three of those in my study, including Libby who spoke so excitedly about her son's first steps, were hesitant at first about saying anything positive about motherhood. I remain unsure if this was because they were unaccustomed to thinking about teenage motherhood in positive terms, were not expecting to be asked about positive aspects, or because they thought it was unacceptable to talk about the positives aspects of their situation. I suggest that the stigmatised status of youthful motherhood may have contributed to this hesitant stance.

It was not all rewards and pleasures, however, and the young women's perceptions and experiences were certainly not all positive. Their thoughts and feelings in relation to motherhood were often mixed or contradictory. Teenage mothers are often asked if they want to have a baby and, as noted by Luttrell (2003), the answer is complex; both yes and no. Clare, in my study, exemplifies this apparent contradiction. She spoke about wanting her son and not wanting to change him or her situation but acknowledged that she had not anticipated or wanted her life to be as it currently was. Clare told me:

> I worry my mum sometimes ... I do. She said, 'do you actually want him'. Yes, I love him to bits ... but I didn't want this ... I didn't want my life like this. I wouldn't change it ... I wouldn't change him ... but people just think it's easy and it's not.

Subsumed within her statement 'I didn't want my life like this', were a range of challenges that were now part of her everyday reality There were the external challenges of managing financially and the physical demands of long days being both a full-time student and a mother. There were also the internal, emotional demands. Being the primary caregiver of a baby inevitably involves at least a degree of sleep deprivation, and for Clare, an on-going struggle with what I refer to as her internalised 'teenage mother-phobia'. This left her with feelings of doubt and inadequacy about very common mothering experiences. She thought that if she had been older she would not have given herself quite such a hard time about choosing to ignore her crying baby occasionally.

I've had bad times with Luke, like three weeks ago we were still up at quarter past three and I just put him in his cot and walked outside. I had to stand outside. It's not all good ... and if my [older] sister did it, it would be all right ... but because it's me, I always think it's the age thing. I need to put those barriers down because I'm very defensive about it.

Along similar lines, most of the young women expressed no regrets about their transition to motherhood but simultaneously wished that they had waited or been older when this happened. This is a recurring theme in the literature on teenage pregnancy (see Luttrell, 2003; Rolfe, 2005; Seamark and Lings, 2004). Many of the teenagers in Seamark and Lings' (2004) English study thought they were too young to have a baby but at the same time did not regret their decision to continue with their pregnancy. Similarly, those in Luttrell's (2003) Canadian study reported regretting having sex so young but not having a baby. She speculated that her young participants viewed expressing regret about having a baby to be unacceptable. Given prevailing expectations that young women delay motherhood until after establishing a career, expressing regret about the timing of the transition to motherhood may be viewed as acceptable or possibly expected.

The challenges of motherhood

The young women's accounts touched on the wide range of challenges they faced. Some were generic and might therefore be experienced by any new mother. Being the primary caregiver of a newborn baby will inevitably impact on daily routines, restrict the freedom to come and go, affect energy levels and family finances. Young mothers spoke about the constant responsibility, the feeding and changing of nappies, the sleep deprivation, the worry and stress when a baby is unwell, the loss of freedom to socialise with friends and the financial stresses. However, these generic challenges are not experienced equally by all. It is easier for mothers with greater financial resources to get out and about to socialise, to pay someone to undertake certain domestic tasks, and the anxieties about the financial implications of childrearing are likely to be less. Their living environment is likely to be more secure, less crowded and generally less stressful. Living arrangements among my sample were often far from ideal and certainly far from secure. Over the eighteen month period I saw them, eight chose or had to move home at least once, for a variety of reasons including strained relations with

family members, changing relationships with the father of their child, financial difficulties, a parent with whom they lived being evicted, and a tenanted property being sold. A secure roof over their heads was not something they took for granted.

Other challenges that young mothers spoke about were specific to teenage motherhood and linked to age-related assumptions that others made about them. Subtle yet constant questioning of their adequacy as mothers, pressure to prove themselves, and managing the tension between their role as mother and student were recurring themes. Considering each in turn, I show how the way in which their youthfulness was recognised was unhelpful because it was based on stigmatising assumptions which undermined young women's confidence as mothers. As I discuss more fully in Chapter six, it also limited the recognition of other differences.

Too young to mother?

Tracy was 15 with a 4 month old daughter when I first met her and was being educated at a pupil referral unit that catered exclusively for pregnant and mothering schoolgirls. She had many positive things to say about her time there but disliked being told how to be a mother, whether by staff through their specially adapted curriculum or by the health professionals who visited the centre on a regular basis. However, as the excerpt below shows, Tracey explained that it was not just staff at the pupil referral unit who did so but also family members and 'everybody' who felt the need to offer unsolicited advice.

> Like when the nurse ... she tries to tell you not to wean your baby till six months. Being told how to be a parent, it does annoy me, and my family does it as well. It's not just this school, it's everybody.

She disliked this because

> ... It seems like they're trying to say that we don't know what we're doing because we're young. I know they're not saying that, it just sounds like they are. I *do* know when she wants something ... she's got all different cries for different things. She's got the playful one, the tired one, the poorly one, the 'I want food' one ... loads of different ones.

This situation may be a common experience for many new mothers, but perhaps one that is accentuated with these young women whose

transition to motherhood occurs earlier than what is currently considered normal. Given prevailing discourses about children having children, the implications of receiving such advice might be more keenly felt. As alluded to by the other young mothers, such treatment did little to instill confidence in their own mothering abilities.

Pressure to prove oneself

A second recurring theme in young women's accounts was a strong desire and motivation to prove something: 'to prove that I can do it' (Megan); to prove that 'I can be a good mum and that I can get my life back on track' (Clare); and 'to prove everybody wrong' (Rebecca). It was not something they explicitly identified as negative but rather, it appeared to be a pervasive presence in their lives. Some researchers speculate that this is one way that young mothers attempt to manage being stigmatised and gain respectability (Hanna, 2001; Jewell *et al*, 2000). The young mothers in Hanna's (2001) Australian study, for example, went to considerable lengths to prove they were worthy citizens and competent loving parents. It seemed that the young women in my study felt that they had a number of things to prove: that they were good mothers, by taking considerable care over how their babies were presented; that they were responsible citizens, by being in education, employment or training; and that their lives were not a disaster, by developing socially acceptable career aspirations. For some of the teenagers, this meant taking on gruelling schedules of study and mothering.

Megan illustrates this well. When I first met her she was 17 years old with a one-year old child. The following excerpt, where she talks about the stereotype about teenage mothers not being good mothers, highlights the pressure to 'prove everyone wrong' by being a good mother and continuing with her education at the same time. The theme of teenage pregnancy as the end of one's life keeps recurring.

> At first it used to upset me [other people's negative attitudes] but not any more cause I think I've been a great mum and I've coped really well, so I think a 17 year old can do just as good as a twenty-seven or a thirty-seven year old. The best thing about it is proving everyone wrong ... proving to everyone that you can do it and just because you're young, it don't mean your life's ending.

When I asked what she was looking forward to about motherhood, Clare replied along similar lines: 'proving that I can be a good mum and I can get my life back on track'. As she subsequently explained, this meant, 'getting myself a career ... and getting myself into a routine'. She appeared to be motivated by a desire to regain the public approval and acceptance that she felt was lost when she became pregnant at sixteen. Like Megan, and some of the others, she was determined not to be a recipient of welfare benefits. Although not expressed directly, being on benefit appeared to be associated with being a failure and therefore a less worthy citizen.

Clare returned to this theme in our second interview, explaining that when she discovered she was pregnant, she felt a pressure that she had not felt before to succeed at college and 'be a good mum'. On reflection she thought 'it was all too much'.

> Before I first found out I was pregnant I was happy. I was on a work place-
> ment ... and nothing really bothered me then, but as soon as I had Luke,
> that was it ... I knew I had to do something, cause I didn't want people to
> look down on me. But then ... later, I just felt like it was all too much.

She continued with her part-time job during her pregnancy and after her baby was born, and then six weeks after giving birth, she began a college course as well. She could only work and study because her mother looked after her son during the day while she was at college and again in the evenings while she went to work. Clare explained:

> So I was getting up before seven, getting him dressed and fed, getting to
> college for nine, coming home at about half three, seeing him for like two
> hours, starting work at 6.00 till midnight and then waking up with him at
> five, and then back at college for 9.00. I lasted doing that for about a month
> and then I was just absolutely shattered.

Clare's drive to go to college was not simply about proving that she 'is OK' by doing what is expected of someone her age. She later ceased her paid employment but continued her college course as she wanted to do something other than being a full-time mother.

> I thought about taking some time out ... like when he's two, but I just can't
> stay at home the whole time. It would drive me mad. And that's not be-
> cause I don't enjoy him ... it's just I need to be out some of the time.

Clare's mixed bag of thoughts and feelings about her experiences of motherhood exemplify a 'complex fluid messiness' (Reay, 2006) that recurred throughout other young women's accounts. I use it here to illustrate that one of the more challenging aspects of their experiences of motherhood was that they felt pressure to prove themselves in ways that are unlikely to be felt by older mothers.

Tensions in managing the dual role of mother and student

Even for those with considerable family support, juggling the dual roles of mother and student presented additional challenges. The description above of Clare's initial post-birth daily schedule gives a flavour of this. Although she later ceased work, she continued with her college course. At our third interview Clare was living independently and was part-way through her full-time college course. She described her routine:

> I have Monday all day with him [her baby], and then Tuesday his grandma has him ... I drop him off at nine and pick him up at four and then take him home, bath him and get him into bed for about half seven. Wednesday he's at nursery. I'm only at college till half past twelve but I leave him at nursery till five just so I can go to ASDA and do my shopping or go home and clean up ... or stay at college and do my assignments. Thursday I'm at college in the afternoon ... one till eight ... he's in nursery one till six and then his dad has him on a Thursday night.

Like some of the other teenage mothers and professionals alike, Clare expressed mixed thoughts and feelings about education – but this was not because she had low aspirations or was educationally unmotivated. Although she viewed continuing her education as important, she was concerned about the impact her busy schedule had on her relationship with her son and later, on reflection thought that she should have waited until he was older before returning to full-time education. In contrast, Lisa decided to stay at home with her children until they were one year old but was happy putting her children in nursery or daycare after that. This was not because she was uninterested in college. She told me, 'I can't wait to start college'. When I asked her why, she explained, 'because it's 'me' time'. Lisa spoke about the social aspects of college and valued the fact that she would be meeting new people. She also saw college as helping her progress with her life. She wanted to get

50

her hair-dressing qualifications and start work and hoped to have her own salon one day. On the other hand, she valued her motherhood role and felt it was important for her to have this time now with her children.

Other young mothers revealed similar tensions and conflicting desires with regard to motherhood, education and employment. The decision each took was the result of a complex interaction of factors including the age of her child relative to the start date of a given course, desires for social contact and 'me time', the acceptability of available childcare options, the degree of family support, local community norms about caring for your own child, and wider societal expectations to be in education or employment. These tensions are not experienced by their non-mothering classmates or by older mothers who can expect a period of maternity leave. These differences remain unrecognised, yet they strongly affect the teenage mothers' daily lives.

Attitudes towards and experiences of childcare

Being a teenage mother and staying in education inevitably means having to leave a child in the care of someone else for part of the day. Two themes emerged for the young women in my study in relation to this. First, in line with other research (Dench *et al*, 2007; Harris *et al*, 2005) most were initially reluctant to use childcare. Secondly, over the course of the study, all who had used childcare perceived benefits to their children. I illustrate each in turn.

Whether it was at a nursery or with a private child-minder or in one case, even with her own mother, most of the young women expressed mixed feelings about using childcare and they all spoke about initial difficulties leaving their child with someone else. Some retrospectively regretted having returned to education as soon as they did. Several related factors appeared to explain these trends; separation anxiety, uncertainties about how well her child is being looked after, and guilt about leaving her child in the hands of someone else.

Separation anxiety is of course common and is felt by each individual mother to different degrees (Hock *et al*, 1989). Uncertainty about how well her child is going to be looked after and feelings of guilt when her child cries when left behind are common mothering experiences no matter what age the mother (*ibid*). Leaving a very young baby, in the

case of two young women when their babies were just six weeks old, appeared to be particularly difficult. Sonia was one of the two and she spoke about leaving her baby at home with her mother so that she could return to school. But she found that she missed her baby and worried about him and before long stopped attending school so she could look after him. Eight months later when her son was ten months old, she began attending Stepping Stones, an e2e (Entry to Employment) programme that catered specifically for pregnant teenagers and teenage mothers. Although she still found leaving her child difficult, this time in a nursery near to her course, it was not as difficult as when he had been just six weeks old. She thought that this was because he was older and she could see that he was happy at nursery and being well cared for. She had also reached a stage where she wanted to be out doing something other than full-time mothering.

Sonia's description of what made it difficult to leave her child with someone else repeats the explanation offered by others in my study and in other research; they worry about whether their children are being well looked after (Durant *et al*, 2005). Because of this anxiety, Sonia used to turn up at the nursery unexpectedly to check on the care of her son. She explained that she gradually became more trusting of his temporary carers and thus more comfortable leaving him in daycare. When asked what made it hard leaving her son at nursery, Sonia replied:

> I just hated it, leaving him there. I didn't know what they were doing to him. [pause] I used to go like at all different times of the day to make sure they weren't doing anything to him. Like in my lunchtime, or if I finished early I didn't tell them, I just used to turn up and check in on him. And they were always doing everything right. And now I'm fine ... I can leave him and I'm not worried about him.

There were several exceptions to this general pattern, however. When I first met Lisa, she was pregnant with her second child and had recently begun attending Young Mums To Be (YMTB) while her eleven month old attended a nearby nursery. She seemed quite comfortable leaving her daughter in nursery while she attended YMTB and gave two reasons for this. First, she thought it was important that she had some time to herself. Secondly, because of this, her baby had regularly spent a few hours with different family members from an early age and was there-

fore used to being separated from her mother for short periods. She also thought that her child benefited from attending nursery.

Shae was also comfortable leaving her son at nursery while she attended college. This was partly because her son seemed relaxed and happy at the nursery but also because she had a good relationship with nursery staff. Like Lisa's baby, Shae's baby was used to being separated from his mother and looked after by other adults, as he had attended the on-site nursery at the pupil referral unit where Shae had completed Year 11. Shae told me:

> When I seen him enjoy it I thought, 'he's all right', and there's all the toys and other babies and he'd like crawl off and just be playing, innit. He was like a bit wary and all that at first but he was fine. And when I seen him smiling I thought, he's enjoying it.

She went on at once, however, to point out that she did not completely escape parental guilt about abandoning her child.

> But the other day he was crying and I felt dead bad. He was crawling to the gate, [imitating unhappy baby sound], and I was like standing there sad like, and the nursery nurse was looking at me like, 'go away, just go'. And I had to go. The longer I stood there, the more he'd cry.

Other teenagers also spoke about feeling guilty when they left their baby in nursery, although this theme is seldom mentioned in the literature on teenage pregnancy. Perhaps such experiences are so common for all mothers who leave their children in day-care that they are not considered noteworthy.

Three additional factors that may contribute to reluctance to use childcare were evident in my work and also recur in the literature. The first is that the young women in my study were highly critical of other teenagers who had a baby but did not take care of it themselves. These 'other' teenage mothers were considered to be neglectful parents, a theme to which I return.

Secondly, some teenage mothers clearly prioritised their mothering role over society's expectation that they should be in education. Other research on teenage motherhood notes a strong cultural pressure against using formal childcare in communities where local norms construct a good mother as someone who looks after her baby herself

(Dench *et al*, 2007; Harris *et al*, 2005). This is likely to exacerbate the tension felt by being expected to simultaneously adopt two conflicting social roles; that of mother and student/worker. Many women may feel this tension but perhaps particularly those who have a baby at a time in their lives that current (middle class) norms suggest is too early.

A third factor that the young women identified as contributing to their reluctance to use childcare was anxiety about being judged to be lacking parenting skills. In accordance with other research (Daycare Trust, 2002; Phoenix, 1991), some of the young women in my study thought they were presumed 'guilty' (inadequate) until they had proved themselves 'innocent' (capable) as parents. As Mia said:

> I think some people, especially if they're single parents, get that attached to it being them and their baby, and they don't want to leave their baby [with others] because in the back of their mind, they don't want any judgement passed or anything like that.

Despite these difficulties and reservations, all who used childcare thought it provided both social and developmental benefits. The young women spoke about the learning opportunities provided by exposure to a range of different activities as well as to other children. Childcare also gave mothers time out from being a mother. Interestingly, most of the teenagers in my study did not talk specifically about the pressure to be in education and therefore the need to leave their babies with someone else. The education part of their lives was an accepted and unquestioned norm. Part of 'proving themselves' was to fulfill social expectations of a young person their age by being in education, employment or training. Only one young woman, Lisa, explicitly questioned these assumptions but this was not because she did not see value in education. She had some clear educational plans but she wanted to be a full-time mother for the first year of her children's lives.

The young women's reflections on their experiences as teenage mothers reveal some positive aspects as well as challenges. Although some of the challenges were generic, others were specific to teenage motherhood. Compared to older mothers, their lived realities were influenced by their desire to disprove stigmatising stereotypes and this made their lives more stressful. They were determined to prove that they could still do something worthwhile with their lives by continuing their education

as well as be capable, good mothers. Some of the young mothers feared being judged by others and this made them reluctant to use childcare. I develop some of these points further by looking more closely at the young women's experiences of stigma. I highlight the ways in which their lives are made more difficult because of the stigma of teenage motherhood and I argue that this works against the supportive intent of policy.

Stigma, stereotype and shame

> I'm not proud of it. Right from when I first knew I was pregnant ... and I'm still the same now ... sort of like ashamed. (Clare)

Pregnant and mothering teenagers are highly visible to the public gaze. In the UK, this occurs at three different levels: firstly through the decade long national Teenage Pregnancy Strategy and its local implementation; secondly through sensationalised media coverage of exceptional cases; and thirdly, at an individual level, through the embodied experience of pregnancy or having a young child in tow – being heavily pregnant or with a baby is not something that is easily hidden when out in public.

This disapproving public gaze considers pregnant and mothering teen-agers fair game for disrespectful treatment. Qualitative research with pregnant and mothering teenagers reveals prejudiced treatment to be common and awareness of negative depictions widespread (Coleman and Dennison, 1998; Formby et al, 2010; Wilson and Huntingdon, 2005). The young women in my research, although not usually the direct recipients of abuse, were acutely aware of being stigmatised. Public places such as the high street, the supermarket, the doctor's surgery and public transport became sites where their youthful looks and swollen bellies or pushchairs gave them away as irresponsible citizens. They were conscious of sideways glances, subtle and not so subtle comments whispered behind backs and their experiences of pregnancy and motherhood were peppered with intrusive questions, disapproval and, occasionally, blatant prejudice.

This section examines young women's experiences of stigma, how it affected them and how they chose to respond to it. It explores their understandings of the basis of stigma as well as their own views on teenage pregnancy. As Clare's remark implies, one of the pervasive

themes in their accounts was that of shame. They spoke about feeling accused, tried and found guilty: guilty of being too young to be capable mothers; guilty of getting pregnant on purpose so as to access social housing and live off welfare; and guilty of not fulfilling their citizen responsibilities of completing their education, getting a job and earning their own keep. These are enduring discourses through which pregnant and mothering teenagers are constructed as second-class citizens and therefore deserving of disrespectful treatment. The young women's accounts, however, reveal both a resistance to and an acceptance of such discourses. Finally, although they recognised that their own lived realities challenged popular stereotypes, they also perceived these as being true of 'other' teenage mothers. Their views about teenage pregnancy and why it is seen as a problem largely matched policy rhetoric, with only a few young women questioning the problematisation of teenage pregnancy.

Differential treatment

One way that stigma is experienced is through differential treatment. The professionals with whom the young people in my research had the most contact during pregnancy and early motherhood were doctors, midwives and health visitors. Their experiences with these health professionals were, on the whole, positive; most found they were treated no differently from how they expected any pregnant or new mother to be treated. There were a surprising number of unpleasant exceptions to this rule, however, such as being treated with indifference, not being given information that they should have been given, and being asked intrusive questions that almost certainly would not have been asked of an older woman. Clare illustrates by contrasting her experience with hospital doctors to that of her midwife; the former was negative and the latter positive. She thought that an older woman would have been treated more respectfully by the doctors but she said that the midwife 'didn't even question me about my pregnancy'.

> I had to go to the hospital about something and the doctors there were questioning me about everything ... none of it was their business. Like if I'd been older they wouldn't have done that. I got a nice welcome from my midwife though. She explained everything ... and she didn't even question me about my pregnancy.

Another young woman recounted a bus journey where she was asked to vacate one of the seats at the front of the bus that was reserved for the elderly and those unable to stand. Heavily pregnant and at the end of an already tiring day at her educational institution, she found herself standing for the rest of her journey home. She thought that if she had been an older pregnant woman, she would not have been asked to vacate the seat or that another passenger would possibly have offered her theirs.

Staff members at Stepping Stones, one of the educational alternatives for pregnant and mothering teenagers, confirmed the young women's accounts of differential treatment. They felt defensive about their students when members of the public made derogatory assumptions about them and they saw the disapproving stares they received when they ventured into public spaces. One of the teachers expressed her frustration with the comment: 'If I have one more person say to me Vicki Pollard', I'm liable to resort to violence' and her colleague observed, 'When we go out as a group, we see the looks people give them'.

Standing out for its exceptional nature and feel-good result, Mia reported a contrasting experience from a member of the public – a friendly inquiry about how long until her baby was due and whether her pregnancy had been going well. I include it not just in the interests of presenting a balanced account but as a way of highlighting the pervasive theme of shame in teenage mothers' lives and that respect can be regained by conforming to unquestioned age-related social expectations. As they continued chatting, Mia learned that this woman's own 16 year old daughter was pregnant. Mia recalled the woman's parting comment; 'I'm proud of you'. This was noteworthy because it was unexpected and contrasted with the more frequent yet subtle messages that instilled shame. Mia's interpretation, based on their conversation, was that she was proud of Mia for continuing with her education. The less obvious discourse in operation here, and one that appeared to be accepted by both young women and the adults in their lives, is that in line with public policy, partial salvation from the folly of teenage pregnancy and motherhood can be achieved through staying in education. As we saw in the previous section however, juggling the dual roles of mother and student is no easy task.

* An exaggerated fictional character featuring in the comedy series Little Britain who epitomises the feckless, welfare dependent teenage mother.

The effects of differential treatment

Being young is the linchpin of unhelpful stereotypes and stigmatising discourses and the young women were conscious that teenage mothers are viewed as too young and therefore too inexperienced and immature to be good mothers. There was some evidence that being viewed and treated in demeaning ways resulted in the internalisation of shame, an undermining of their confidence to be good and capable mothers, feelings of guilt, and an acceptance of disrespectful treatment as normal. Similar themes have been found in other work on teenage motherhood (see Formby *et al*, 2010; Hanna, 2001). Writing about the intrusive questions and negative attitudes experienced by the young mothers in her study, Hanna (2001) observed, 'Sometimes they were able to resist these condescending attitudes, but more often than not they internalised the negative stereotypes which portrayed them as a deviant group' (p460). Parallels can be drawn to the experiences of other socially stigmatised groups. Some of those who identify as LGBT (lesbian, gay, bisexual, transgender), for example, internalise society's homophobia, experience shame and come to view themselves and other LGBT people in negative ways (Kitzinger, 1987).

Stigma can be internalised and undermine personal confidence and capability. On a positive note, and helped in no small measure by her attendance at Stepping Stones, Megan spoke about how over time her initial lack of belief in her ability to be a good mother was gradually replaced by growing confidence:

> I did feel like that at first [judged by others] but as I got further along I just thought a young mum can do just as good a job as what an older mum can do.

Similarly, Tracy spoke about how the teenage pregnancy midwives conveyed an expectation that of course she would be a good and capable mother. She found this memorable because it contrasted with her experience with other professionals and members of the public where the implicit message was 'you're going to be a disaster as a mum and not going to cope'. Tracy is not alone in this. Among the 33 young mothers interviewed by Rolfe (2005), many thought that the professionals they had contact with had low expectations of their being able 'to cope with parenting and to achieve anything with their lives' (p241). Tracy found otherwise:

> They were just looking at it [my pregnancy] as, like, another life that is being brought into this world. It's not like I was not knowing what I'm doing and leave it when it's poorly or something like that. And [other] people were looking at you like you're going to be a disaster as a mum and not going to cope.

It may be noteworthy that the two midwives she referred to were employed by the health authority as teenage pregnancy specialists and were unlikely to have accepted these posts if they did not have a special interest in and positive attitudes towards the young women with whom they would be working.

Clare illustrates how stereotypes and shame can be internalised; that is, 'it still don't come out of your head' – despite the affirming messages from those close to her that she was a good mother. She also spoke about feeling guilty. Her comments below were made in reference to the view that teenage mothers are irresponsible if they go out and leave their children to be looked after by someone else. She felt self-conscious when she was seen out on her own in her local community without her baby.

> And do you remember in my first interview I said how my sister had called me Vicki Pollard? Well it still don't come out of your head. And people always say to me, 'why do you give yourself such a hard time, you're doing a good job, you've got a happy little boy'. I never seem to praise myself. When I go out I always feel guilty that people are saying, 'oh, she's out', do you know what I mean? I never give myself the OK.

Clare also spoke about feeling self-conscious as a teenage mother when out in public with her son. The one situation in which she felt less visible was when her boyfriend was with them. She attributed this to feeling like a proper family. That is, there is something more respectable about adhering to a socially expected family form.

Some of the young women appeared to barely notice reactions that would normally be considered disrespectful because such treatment had become so expected. Sonia, for example, initially suggested that no one had treated her any differently because of getting pregnant so young. Later in the same interview, however, she incidentally commented 'sometimes I get dirty looks but I'm just not that bothered' and in her next interview she spoke about teachers 'looking at me sideways'.

Responses to differential treatment

The young women's responses to these experiences were characterised by passive acceptance. They took it in their stride by ignoring comments and looks, and adopting an 'I'm not bothered' attitude. Megan gives a flavour of how they accepted negativity from members of the public as just one of those things young women in their position learn to cope with.

> The looks you get down town and the comments that you hear off older people, in the end you just get cool about it ... stuff like, 'they're too young' and 'they won't cope'.

Some of the young women were more relaxed about this than others. Lisa took the view that:

> You do get people staring at you and stuff but it don't bother me. People can say what they want.

They frequently minimised and ignored such treatment. Libby, for example, was acutely aware of public disapproval although nothing had been said directly to her. The indirect nature of public expressions of disapproval meant that her easiest response was simply to ignore it.

> Yeah ... well I've heard them but they haven't said anything to my face ... it's like behind your back, sort of thing. Like, 'she's got a baby and she's so young' ... so I just ignore it.

Libby attributed these negative reactions to ideas about teenagers being unfit mothers and getting pregnant so they will not have to undertake paid work – a stereotype she was quick to challenge.

Some of the young women appeared to receive more negative public reaction than others. Sarina attributed her lack of negative experiences to the way she presented herself – a manner that conveyed she was respectable and knew what she was doing. Modifying behaviour so as to distance themselves from negative stereotypes was a common response to differential treatment. Sarina said:

> If you were to push a pram in a track suit going like with an attitude, that's when they're going to say something. I don't really carry myself like that. I'm a young mum but I don't think I'm seen as a young mum that don't know what she's doing.

In the interview she went on to suggest that respect is gained not just through being well dressed and presented, but by ensuring the same is true of her baby. Having their babies immaculately presented was a recurring theme among the other young mothers. This often entailed buying designer gear – not for themselves but for their babies. As Sarina implies, being able to provide for your child in this way is equated with good parenting.

> And you see some young mums with maybe the worst pram, like budget prams and then they [the general public] think why would you do it [have a baby], cause they ain't got a lot of money.

These views and interpretations were repeated by professionals. The two teachers at Stepping Stones said their students were acutely aware of negative public attitudes towards them, in particular, the popular belief that they were too young to be good mothers. They noted how important it was to their students to dress their babies well and what lengths they went to to disprove stigmatising stereotypes. Sometimes this meant refusing to ask for, or accept help.

> J: They over-compensate. They won't allow anybody to help them with anything because they have to be seen as coping with it all and not needing any help.

> A: You know, they have to have the babies in the best designer gear and the best pushchair.

> J: And it's just because when they walk out on that street they don't want anybody saying that ...

> A: They can't look after them.

> J: They might not have food for themselves but they will make sure their baby's got the best gear they can afford. (Stepping Stones staff)

The importance of appearances arises widely in research with teenage mothers. US researchers Jewell *et al*, (2000) reported that many of the teenage mothers in their study bought expensive clothes and pushchairs for their babies in an effort to prove that they were good mothers. In the UK, Phoenix (1991) found the teenage mothers in her study reluctant to accept second hand clothing, even when money was short. She noted that, 'many women felt (probably correctly) that the adequacy of the care they provided for their children would be assessed on

the basis of children's appearance' (Phoenix, 1991:195). In his analysis of representation, Hall (1997) throws some light on this with his observation that clothes fill more than a simple protective physical function; it carries meaning through what they signify. One example he gives is that a suit signifies a professional. In the eyes of the young women in my study, the best pushchair or a well-dressed baby similarly signified a good mother. So for these young women who are already socially stigmatised, public assumptions based on how their babies are presented may be even more keenly felt than is the case for other mothers.

The two professionals quoted above highlighted another way in which young mothers respond to differential treatment – or, in their example, anticipated differential treatment. They suggested that stigmatised public representations meant that their students were often reluctant to use public spaces, even those designed to support families, such as Sure Start Children's Centres. They saw some merit, therefore, in providing specific services for pregnant and mothering teenagers where they would feel less likely to be publicly scrutinised. Their words also allude to a class-related issue; services such as mother and toddler groups may be perceived by some teenage mothers as a middle class thing and not a public space within which they would feel comfortable. They explained:

> A: If you go into Sure Start ... that is not really accessible to teenage mums because of the stigma ... because of what other people might say.

> J: Most of the ones here wouldn't consider going to mothers and toddlers. If it was a specific teenage mothers and toddlers, then possibly ... but it's seen as a middle class thing.

> A: Something that posh people do ... 'they're all stuck up'. And that's how they feel going to a family centre ... 'oh god, it'll be full of social workers and all the other mums are going to look at me'. (Stepping Stones staff)

In this way, access to potentially valuable sources of support is restricted. This illustrates Wilkinson's (2007) view that more unequal societies are characterised by less trust and less community involvement. In his analysis of health and social inequalities he argues that all people need to feel valued and respected and that social status differentials, such as those indicated by large income disparities, have a considerable impact on whether people feel valued, looked down on, or disrespected. It seems that little has changed in the 20 years since Phoenix (1991)

observed that awareness of being socially devalued makes teenage motherhood a more stressful experience than that of older mothers.

Challenging stereotypes

Although the young women in my study appeared to accept prejudiced treatment with dignity, this did not mean that they also accepted stereotypes as true or such treatment as justified. They expressed anger and frustration at being treated or portrayed in disrespectful ways. Similar findings have also been noted in other research (Rolfe, 2005; Schultz, 2001). In longitudinal, ethnographic work with ten young mothers, Schultz's participants objected to the negative stereotypes they perceived. Along similar lines, Aimee in my study expressed anger at the negative, and in her view, false portrayal of pregnant teenagers as intentionally getting pregnant to go on welfare. Her annoyance was targeted at phone texts that had been sent to a popular local radio station. Aimee was quick to challenge this stereotype and point out that all her classmates at the pupil referral unit were taking their education seriously and planning for future employment:

> Well it's just that they [people] are always saying that you just want to have a baby to have the money and never work ... and it's not all like that. Everyone I know here [at Phoenix] is determined to get a job.

Young women also expressed frustration and anger at the unbalanced and sensationalised portrayals of pregnant and mothering teenagers in the media – in particular the highlighting of cases which maintain certain stereotypes while ignoring others which challenge stereotypes. Albeit somewhat more blunt than most, Clare's statement below is illustrative of other young women's comments. It reinforces a theme that was evident in their earlier accounts of becoming pregnant; that of pregnancy as the end of life. In Clare's example, the end of life refers to the end of one's useful contribution to society through paid employment, in which case, 'you might as well just go shoot yourself', thereby preventing yourself from being a drain on society. I asked Clare how she thought she and other pregnant teenagers were perceived by the public and she replied:

> They've got a view of people living off the social and not doing anything. They think that if you're pregnant as a teenager then your life is ended and you might as well just go shoot yourself.

Clare continued in the interview to highlight the silence about pregnant teenagers and teenage mothers who do not conform to the aforementioned stereotype. Her indignation and sense of injustice was apparent among other young women in my research.

> I get really fiery about it because people don't see us doing this [Young Mums To Be]. And they don't see people going to college. There is a woman who came in to speak to us about alcohol and she's at uni and she's got a five year old son and he's already talking about going to uni and being like mum and she was seventeen when she was pregnant ... but you don't hear about that. You must have heard about this girl called (inaudible) in the papers ... she was thirteen when she became pregnant. She was in all the papers but no one knows about that woman who came in last week.

Shae drew attention to the other side of the same coin. She spoke indignantly of a non-mothering friend who had stopped attending her college course. She perceived it as a double standard that neither this common occurrence (young people dropping out of college) nor the fact that as a young mother she was managing to juggle the dual responsibilities of a full-time college course with being the primary caregiver of a sixteen month old child were newsworthy; and she was critical of her friend for showing no determination.

> It's like I get really angry cause my friend, she's just been doing an ICT course, yeah, and it's like she can't be bothered. She ain't going no more. I phoned her today and I said, 'how come you've not been at college?' And she's like, 'well I'm waiting for the course next year'. And I'm thinking to myself, 'now wait a minute, that should have been me'. And I'm saying [to her], 'I've got a baby. You ain't got no responsibilities, no nothing and you just want to lie in bed?' And it's like, I don't get to lie in bed. [laughter]

These stories support a frequently argued point about silence as a repressive tool that maintains certain discourses (Foucault, 1976). Dominant representations of teenage mothers as educationally unmotivated and lacking aspiration are maintained partially through the lack of public recognition of stories such as those reported here. They also highlight the importance of ensuring that accounts such as these are made more public and they remind us that once established, a stereotype or reputation is difficult to change. As Phoenix noted on the first page of her book about young mothers, 'The notion that teenage motherhood is a social problem is so deeply ingrained in public consciousness that evidence to the contrary is hard for people to believe' (Phoenix, 1991).

Us and them

The young women were aware that teenage pregnancy is stigmatised and seen as a national problem. Their understanding of this matched the rhetoric of previous governments; teenage pregnancy is a problem because of the cost to the taxpayer through benefit payments, social housing and through loss of tax revenue. This discourse was much less dominant in the subsequent New Labour government publication used to launch the Teenage Pregnancy Strategy where the 'problem' shifted to focus more sharply on the negative life outcomes correlated with teenage motherhood. Nevertheless, it seems that that association with welfare dependency remains strong. When asked what her thoughts were on why teenage pregnancy is seen as a problem, Louise replied:

> Because, obviously, it's people claiming money, isn't it? Some teenagers will do it just to get money so they don't have to get a job or whatever. I think that's wrong ... that teenagers can get pregnant so they can claim benefits and not have to work.

Interestingly, despite their own experiences of stigma and although their own lives and those of the other young mothers they knew did not conform to dominant stereotypes, they still thought these were true of other young mothers. They were judgmental and disapproving about these 'other' teenage mothers and distanced themselves from them. They had a view of other young mothers as having babies for 'a fashion trend' (Shae) or 'as an accessory' (Aimee), to 'get their own place' (Megan) or because 'they don't know what else to do' (Clare). Another common stereotype they accepted as being untrue of themselves yet true of other young mothers was that of being an immature, selfish or neglectful parent. Rebecca, for example, expressed disapproval of young women going out and leaving their mothers looking after the baby. She thought they were therefore not responsible mothers.

These findings mirror the 'othering' found in other work with teenage mothers (see Allen and Bourke Dowling, 1998; Jewell *et al*, 2000; MacDonald and Marsh, 2005; Mitchell and Green, 2002). Allen and Bourke Downling's (1998) observed that although the young mothers in their study had not become pregnant to access council housing, they believed this was true of other young mothers. Studies such as these reinforce earlier work by Pheonix (1990), who found that young mothers

used particular discourses to stigmatise other young mothers as a way of distancing themselves from negative associations. Mitchell and Green (2002) liken this to a form of Foucauldian self-surveillance in which critical 'othering' maintains an environment of social censure.

Not all the young women I met had bought quite so readily or whole-heartedly into popular stigmatising discourses and some questioned the taken-for-granted rationalities upon which policy is based. Lisa, for example, was puzzled about public concern about teenage pregnancy. She questioned the idea that the time for motherhood should be after gaining educational credentials and establishing a career. Lisa thought contemplating motherhood once you are in a good job could be even more inconvenient than when you are younger:

> I don't know why the government are worried. To me it don't make a dif-
> ference whether you're old or young. You are going to go through it anyway
> because it is just something that happens in life so why not do it early and
> get on with your life. I think it is ok to have it when you are young because
> if you are older and you've got a really good job and if you do find out that
> you are pregnant you might not want to leave that job.

Two other young women also questioned why having a baby at a young age should be seen as problematic. As Tracy said, 'it's their choice'. How-ever, repeating a familiar theme, she thought teenage pregnancy was seen as a problem because teenagers are viewed as too immature to be good parents and because it is viewed as costly to the tax-payer. What remains unrecognised is the gendered dilemma resulting from the competing social roles of childbearer and employee.

This chapter shows how the lived experience of teenage motherhood was made more difficult because of the ways in which the difference of age was recognised. Particularly for young teenage mothers, their youth-fulness is recognised in ways that construct them as irresponsible or ignorant for becoming pregnant in the first place, irrational for not choosing to terminate their pregnancy, too young to be a good mother, and either a bad citizen for not being in education, employment or training or a bad mother for not being there for their children. We see how unhelpful these age-related assumptions were. There was some evidence that being viewed and treated in such ways caused some of the young women to internalise shame. Their confidence in their ability

to be a good and capable mother was undermined, they felt guilty, and they accepted it as normal to be treated with disrespect.

Restricted access to public services, including childcare made it difficult for young women to seek advice and help. The tensions resulting from taking on two opposing roles, that of mother and student, remained largely unrecognised. Representations and responses to teenage motherhood that focus on age thus undermine the support aspect of the teenage pregnancy strategy. These wider contextual issues, and how they play out in the lives of teenage mothers, need to be understood so that meaningful connections can be made with their educational experiences. It is these connections to which I now turn.

4

Pregnant and mothering schoolgirls: the same but different

The previous chapters have identified a mixture of thoughts, feelings and perceptions related to teenage pregnancy and motherhood and explored how the young women in my study responded to challenges they faced. Pervasive throughout their experiences was the impact of negative public representations of teenage motherhood and the associated stigma. Knowing about these broader aspects of their everyday lives assists our understanding of the negative attitudes and actions that pervaded these students' schooling experiences.

This chapter describes the young women's educational experiences before they became pregnant and then the daily reality at school once their pregnancy was known. Disaffection from school even before getting pregnant has been noted in other teenage pregnancy research. The wide range of generic and specific contributing factors reveal similarities between these young women and other students who become disaffected with education. There is a marked mismatch between policy and practice in how schools support pregnant or mothering schoolgirls. Despite inclusive policy, an inclusive experience was the exception rather than the norm. I note that even in inclusive schools, the dilemma of difference resulting from a pupil pregnancy was not easily resolved. My study shows that the more supportive schools achieved good outcomes, such as educational continuity, by responding flexibly to difference and by ensuring that young women themselves were listened to and encouraged to take more responsibility and control over their own lives.

Disruptive and disrupted school histories
The importance of academic credentials: 'I wanted to get my GCSEs'

One recurring theme in research on teenage pregnancy is the strong association between early motherhood and school disaffection (Bonell *et al*, 2005; Dawson and Hosie, 2005). In Dawson and Hosie's research in ten local authorities in England, only 21 out of their sample of 93 reported enjoying their overall secondary school experiences. My work confirms this trend. Almost all the young women in my research described periods of disliking school. Their dislike ranged from several months to several years and quite often became more pronounced as they progressed through their secondary schooling, so that disaffection and poor attendance was most prevalent in Years 10 and 11. These final years of school are crucial; there are demands of coursework and preparation for GCSE examinations. As we will see, these pressures are often a problem.

Whatever the pattern of disaffection and non-attendance, every student recognised the value of educational qualifications. Whatever difficulties they experienced at school, they all wanted to do well in their GCSE coursework and examinations, and all bought into the official government line, that educational success is the way to better employment prospects.

Mia is an example. Her enjoyment of secondary school steadily diminished. She began truanting early in Year 10 but started taking school more seriously again as GCSE examinations approached. Mia's words typify the views of other students and imply that she understands the main purpose of school to be 'doing GCSEs'.

> I was good for Year 7, 8, 9, some of Year 10, and then I drifted into a crowd and was skiving off ... and a bit of drugs and drinking in the week-ends. I did that for a while and then I started wanting, sort of, doing GCSEs. I could see myself not getting nothing out of school.

This pattern was widespread across my sample. Shae, for example, reported not enjoying school and being 'bad' in previous years. Sometimes she skipped class or was disruptive or did not comply with teacher instructions. But she also emphasised that her attitude towards her education had changed even before she became pregnant. She knew that

'school was for education and not to come and mess about' and said that getting an education in the form of achieving good GCSE grades had become important to her. When I observed that she had now modified her rebellious behaviour, she replied: 'Course I did. I wanted to get my GCSEs. It's only a few years of not thinking, innit'.

Most of the young women I met were already disaffected from school before they became pregnant. But despite the difficulties many of them had at school, they all thought education was important and all, without exception, wanted to do well at school. Neither of these findings is new. The importance girls attribute to education has been highlighted in research with teenage mothers (Dench *et al*, 2007; Zachry, 2005) and also in research with girls more generally (Lloyd and O'Regan, 1999; Osler and Vincent, 2003). In these studies, and in my own, students saw a link between educational qualifications, post-school training opportunities and future employment prospects. Even those who had difficulties wanted 'an education'. This created tensions for those students who were not enjoying school. They truanted as a way of dealing with their difficulties and were acutely aware that they were not meeting the expected academic standards that would be rewarded with the desired high GCSE grades. This resonates with Hey's (1997) ethnographic work which found that many working class girls had given up on school success even though they recognised that without it they would not get good jobs.

A range of factors combined to produce disaffection

The young women attributed negative attitudes towards school to a wide range of factors. School-based issues such as difficulties accessing the curriculum and difficult relationships with teachers or peers were common, as were feeling unfairly treated or not being listened to. Issues outside of school, such as family or housing difficulties, contributed to school-based difficulties for some, while for others the unfortunate timing and poor management of major school re-organisation exacerbated already existing difficulties. The young women's accounts also highlight the sense of failure and alienation that resulted from larger systemic issues such as a narrowly focused academic curriculum. Truanting as a way of dealing with these difficulties became a vicious circle and often contributed to a bad situation becoming worse.

Shae spoke about the more satisfying relationships she had with staff at the specialist pupil referral unit compared to her mainstream school, and attributed this to differences in how students are treated. She thought that students in schools are often not treated fairly or with respect. Shae had felt she was not listened to, understood or cared about at school and this made her less willing to attend:

> Like you talk to them [teachers] with respect but you don't get respect back. That's why kids in school now, they don't give teachers respect cause the teachers talk down to them. At [the PRU] you get spoken to properly. That's why it's so settled there. But the teachers at [old school] are like looking down on you, 'go to your lesson', 'why have you got that on'. They don't ask you why [it is happening]. I told them about my situation and I was told, 'well you need to do better' but I couldn't. They didn't know I was pregnant then ... but it was my living situation [that was the problem]. So in the end I just stayed off school.

Shae thought she had sometimes been treated unfairly by teachers at her school because of her earlier reputation for being rebellious. She re-counted feeling angry about being taken out of a mock examination in Year 10 because she did not have the right uniform even though there were other students in the same examination who also did not have the precisely correct uniform. This was the final straw for a pupil whose precarious housing situation meant that she did not always have access to all her belongings, who had recently realised she was pregnant, and who had studied for the examination because she was determined to do well in her GCSEs. Shae's response was simply to give up and stop attending school:

> After that I didn't go back to school for a good two months cause I thought, 'I've tried and I've tried, I'm pregnant now anyway, so what's the point?'

Interestingly, Shae's situation appeared to improve dramatically after teachers at school found out she was pregnant. Her own attitude towards school became more positive, as did her relationships with certain staff members. She attributed this to realising that at least some staff members cared about her and were willing to encourage and support her in her educational endeavours.

Bullying from peers was another recurring theme and often led to self-exclusion. Clare attributed her early departure from formal education

at 15 primarily to the unsettling effects of another school closing and her school getting a throng of new pupils. She began to be bullied and no longer felt safe at school. She became depressed and developed an eating disorder after someone in the playground called her fat. The school responded to her non-attendance by arranging a part-time programme for the remainder of Year 9 and then in Years 10 and 11 she attended college part time, instead of school. Although these arrangements had some merit, the underlying issue of school bullying was not addressed.

Katie's school attendance was adversely affected by bullying too. Her story highlights that each student's experience is particular and that some students have to manage challenging situations outside school, as well as those within school. Like Clare, Katie stopped attending at the end of Year 9 and attributed this primarily to bullying. Although she reported the bullying to teachers, she found the school's response of talking to the perpetrators ineffective. Interestingly, apart from being bullied, her schooling experiences were largely positive. She described some of her teachers as 'decent' and 'fun' and drew attention to the understanding and support of one particular teacher about her difficult out-of-school situation. Hers is just one example among many where a key person, often a teacher, made an invaluable positive difference for a pupil. Katie explained that:

> This teacher understood my life because even then I weren't at home and I was stopping with my auntie and that ... and he understood why.

Being listened to and understood was a tangible demonstration that she was valued and worthy of respect.

Despite this teacher's support, Katie stopped attending school altogether for several months. There appeared to be no follow-up from school or the education welfare service and she spent a lot of time on the street doing nothing. She explained: 'I weren't living at home. I was just walking round everywhere ... around the streets'. It sounded like a lonely existence but clearly better than being at school. Later that year Katie met her boyfriend and started missing even more school to spend time with him. By part-way through Year 10, Katie was pregnant.

Tracy provides a third example that is both similar to and different from those of Clare and Katie. It re-emphasises that most young people value

education and that non-attendance is often a strategy for managing negative schooling experiences rather than because they do not want to be at school. Tracy skipped a lot of school because of bullying, but she always attended her French class even though the pupils who bullied her in other classes also attended French. The teacher's good management of class dynamics made it possible for Tracy to attend. She felt safe because 'the teacher was really strict'.

> The way I was skiving ... say I had six lessons a day, I would go to one. That was my French, cause I liked that ... even though there was those people in class who used to do my head in. The teacher was really strict so it was easy for me to go to French.

Tracy found other aspects of school problematic. She had difficulties with the work and with the way teachers taught. Interestingly, she pointed the finger not so much at individual teachers, or even teaching approaches, but rather at large class size which meant that some pupils, including herself, could not get the help – or the sort of help they needed – to understand tasks and complete work.

The challenges faced by pupils at school often overlap and combine and make the connections between different factors difficult to see. Sarina initially said school was 'boring' and explained how disliking a particular teacher, or his or her teaching style, sometimes meant she had been unwilling to engage with the lesson. In our second interview, however, it became clear that the pressure to perform academically in particular ways as she moved up the school explained her growing disaffection. These were ways that did not come easily to Sarina and she disliked the change from practical lessons towards teaching-to-the-test. Physical education was a subject Sarina had enjoyed until it became more theoretical and students were regularly tested on the names of skeletal, musculature and other bodily systems and she began falling behind on coursework. She observed:

> The first few years of school aren't like the last few years ... cause when you hit Year 10 and 11 it's all just coursework and it's all about your GCSEs ... and like with the coursework it all piles up on top. [pause] I got so behind.

So it was the organisational structure of the education system and the considerable emphasis on GCSEs that contributed to Sarina's disaffection from school. She began to feel like an academic failure and less

valued because she was not an academic high achiever. The negative impact of wider systemic structures such as this remain largely un-recognised, at least at official level.

Another commonly repeated theme was the adverse effect social diffi-culties had on the students' enjoyment of school and their ability to concentrate on lessons – in particular, their relationships with girl-friends. Students spoke about the changing loyalties that operate within girls' friendship circles and the power these exercise over girls' enjoy-ment of school. Lisa found it difficult when her school closed down and she was temporarily accommodated at another school while a new academy was built. The new social networks, the frequent arguments between girls, and uncertainties about how she would be treated from one day to the next, caused her considerable anxiety. This made her un-willing to go to school some days. Other research also highlights this and suggests that the gender-specific and less visible nature of these antagonistic relationships means that the negative impact on girls is often overlooked (Hey, 1997; Osler and Vincent, 2003).

My work supports the strong association between teenage pregnancy and disaffection from school that has been found in other research, but there are two additional points to make. Firstly, there was a wide range of factors that contributed to pupil disaffection, but in many ways the experiences of the young women in my research were no different from those of any other disaffected student, boy or girl. Issues of curriculum, teaching style, interpersonal relationships and educational systems are generic rather than specific to pregnant or mothering schoolgirls and paying attention to these would benefit many pupils. Other differences are group and individual-specific. In my research, the extent and im-pact of bullying, as well as self-exclusion as a common coping strategy, highlight some gender-specific patterns that need wider recognition in order to better meet the needs of girls. One might well ask whether out-comes would have been different if Katie or Sarina's non-attendance, or Tracy and Clare's bullying, had been addressed in more consistent and effective ways.

School responses to pupil pregnancy

Chapter 1 showed that teenage pregnancy policy aims to prevent teen-age conceptions occurring in the first place and to help teenagers to

stay in education should they become pregnant. The underlying rationale is that staying in education will result in gaining worthwhile qualifications which will then translate into well-paying jobs. This rationale applies to all pupils who are perceived as vulnerable, not just those who become pregnant. Current political discourse explains social exclusion in terms of young people being out of work because of their low aspirations and low levels of educational qualifications. Staying in education and gaining qualifications is therefore seen as the logical solution to the problem of social exclusion – a view that has rightly come under some criticism for being overly simplistic (Francis and Hey, 2009; St Clair and Benjamin, 2011).

I drew attention to the school guidance and the expectation that schools support a pregnant pupil to stay in education, and that pregnancy is neither a reason to exclude a pupil from school nor for ignoring non-attendance. Although alternative arrangements may be made, as long as they meet the undefined criteria of 'suitable', the guidance is clear that the initial school response to a pupil pregnancy should be to support the pupil to remain in school. This guidance aligns with broader national and international movements towards more inclusive education.

This section examines how schools reacted when a pupil became pregnant, what processes and outcomes resulted, and how this was perceived by the students concerned. It provides useful insights into how current policy is enacted and experienced. Four key themes emerged. Firstly, there was much variation from school to school, and even within school, as to how a pregnant pupil was responded to. School responses ranged from unofficial exclusion, to simply ignoring a pupil and her circumstances, to reluctant acceptance and support, to immediate acceptance and support. Some of the pupils experienced blatant prejudice, discrimination and public humiliation while others were met with non-judgmental attitudes coupled with simple practical accommodations which exemplify the inclusive ethos intended by policy.

Secondly, despite national policy, many schools were reluctant support a pregnant pupil and staying in mainstream was the exception rather than the norm. Of the twelve students who were still of statutory school age when they became pregnant, four were directed immediately to the

pupil referral unit, even those who were early in their pregnancy. Two had already ceased attending school prior to becoming pregnant and alternative educational arrangements, albeit limited, were eventually made. Three pupils were effectively excluded from their schools with no satisfactory alternative arrangements being made, and the remaining three continued in their mainstream schools, at least for a period of time.

Thirdly, the young women's accounts showed how little input, if any, they had in the decisions made about them, and how this disempowered them. Finally, for those few who remained in school, the difference of pupil pregnancy was clearly a challenging one. Some staff made incorrect assumptions about how important education is to a pregnant pupil, and even in the supportive schools, the process of inclusion was neither smooth nor straightforward.

Four different stories

I illustrate these themes and how they played out in the lives of certain individuals by presenting four contrasting case-studies. Three of these pupils became pregnant during Year 11 and one during Year 10. Aimee was expediently dispatched to the pupil referral unit on revelation of her pregnancy. Shae, in contrast, was supported to stay in her school until late in her pregnancy, and then continued her education at the pupil referral unit. The third pupil, Sarina, was summarily rejected by her school because of her pregnancy. Eventually some home tuition was arranged but this was largely unsatisfactory. Rebecca, the fourth pupil, remained in her school, sitting her GCSEs alongside her non-pregnant peers.

Aimee

Aimee was attending school regularly and aiming for good GCSE results when she became pregnant. An early confirmation of her pregnancy at six weeks came as a huge shock and caused her great anxiety. She worried about negative reactions from other people and the effect that being pregnant might have on her education and future employment prospects. Her mixed bag of thoughts and feelings included: 'I'm not going to get my GCSEs, I'm not going to go to college, and I'm not going to get the job that I want'. It was clear that both Aimee and her mother

77

had particular concerns about whether, and how, she might continue her education.

Aimee's mother phoned the school to tell them her daughter was pregnant and was promptly told about the pupil referral unit for pregnant and mothering teenagers. The school assumed, and implied, that Aimee's education would continue there. Over the next week a meeting with the head-of-year and local authority officer was organised to discuss arrangements for her. Aimee was surprised to find that this was to be her last day at school and neither her teachers nor her classmates knew why she visited all her teachers that day collecting coursework. Although she knew that being pregnant was likely to be a point of gossip around the school, she was not expecting to have to leave quite so soon. In principle, remaining in school might have been an option but in practice, this was not one that the school was keen to support. Health and safety concerns were put forward to justify this stance. Aimee got the clear impression, however, that it was not necessarily her needs that lay behind the school's reluctance for her to continue with them but rather the potential inconvenience to the school.

> We did talk briefly about it [me staying], but they preferred me to go somewhere else. [pause] Cause she [head-of-year] was saying like they'd have to put more effort into me if I was staying there ... because of health and safety reasons. [pause] They didn't seem keen on it.

Aimee understood the health and safety concerns of the school but thought that a few simple measures such as leaving class a few minutes early to avoid being pushed in crowded corridors would go some way towards minimising these. Lunchtimes were not a concern as she lived nearby and left the premises each day to have her lunch at home.

The following week, still early in her pregnancy, Aimee duly started at the pupil referral unit. In line with government guidance, she stayed on the roll of her mainstream school while attending the PRU. However, once there, her old school made little effort to keep in touch, to provide coursework or to communicate important information about her forthcoming examinations. The poor communication meant she missed out on some essential coursework which resulted in her failing one of the GCSE subjects she had expected to pass.

So attendance at the PRU early in her pregnancy was something that Aimee went along with rather than was actively part of. Although she perceived benefits to being there, such as the lower teacher-pupil ratio and less formal structure of that environment, the process of getting there was disempowering. She was shocked at the end of the meeting at school to find that she would not be returning. She had no opportunity to say goodbye to friends and found the school unwilling to even consider how her education might be supported at school. She attributed this partly to the additional effort that maintaining her in school might require. Although she thought that health and safety issues were important, she also thought that they could easily be managed in school, at least for a time. The lack of contact with her school, which was still funded to educate her, impaired her educational outcomes and left her feeling rejected and unconvinced that staff were genuinely concerned about her education. In Aimee's case, the difference of her pregnancy was not one that the school seemed willing to accommodate.

Shae

Shae, who was in Year 10 when she became pregnant, had experienced a somewhat more tumultuous journey through secondary school than Aimee had. Issues outside school had caused periods of sporadic attendance but, like Aimee, she appeared motivated to achieve some GCSEs. At the time she became pregnant, her mother's precarious housing situation meant she was spending 'a few nights here and a few nights there'. She sometimes skipped school and when she did attend, seldom had the correct uniform. The school's lack of understanding or support for her out-of-school circumstances contributed to conflict-ridden relationships with some of the teachers.

Shae had been pregnant for eight weeks when it was confirmed, but with the exception of her boyfriend, she kept it to herself for several months. Her family, school and peers only found out much later through third parties. At school, a classmate eventually stated what was becoming increasingly obvious. As illustrated below, Shae was reluctant to say anything because she was embarrassed to be pregnant at her age. She explains how her school found out:

> I started showing. And one of my friends just shouted out to another girl across the room, 'oh Shae's having a baby', and the teacher of course could

hear. I tried to deny it but she said, 'I can tell by your face'. [pause] I was embarrassed ... because of my age.

News travelled quickly. Most of Shae's peers took a non-judgmental view of her pregnancy but among staff there was a mix of acceptance and disapproval. She recounted that although nothing was said directly: 'You could see it on some of their faces ... like, 'you're nothing".

The school's initial response was to direct Shae to the pupil referral unit. After some discussions with Shae however, her head-of-year was instrumental in persuading the headteacher to support her to stay at school until she had finished most of her GCSE coursework. Small but important accommodations were made, such as allowing her to leave class a few minutes early to avoid the crush in the corridor to minimise health and safety concerns and, as her pregnancy progressed, a reduced timetable allowed her to concentrate on her core subjects. The head-of-year also assumed responsibility for delivering work to the pupil referral unit that Shae subsequently attended and for ensuring that she was kept informed of all examination arrangements. Shae explained:

> She was the one that was like asking the headteacher if I could stay there for a bit longer to do my coursework and pushing him into ... like, if I was to stay a bit longer, then when the kids go out for break then make it so that I could go out earlier. And she was the one who got me into [the PRU] ... and she's the one that comes in now and brings my work.

It was clear that the attitudes and actions of this one teacher were successful in influencing how other staff members viewed Shae and her situation and ultimately led to more inclusive practices. As a result, Shae continued to feel part of her school and felt encouraged to take her education seriously. Interestingly, and as Shae was quick to point out, her attitude towards her education improved markedly after she realised she was pregnant. It seemed that the anticipated responsibilities of motherhood increased her determination and motivation to gain educational qualifications. This theme was repeated by many of the others in my study and confirms earlier research with pregnant schoolgirls (Hosie, 2007; Pillow, 2004). As Shae stated:

> I don't think I would have done my GCSEs if I hadn't had Max, cause I was skiving, going off with my friends. And now I think, it's not just my future, I've got a baby now, I have to care for him. It's not all about friends any more.

Shae felt that most staff and pupils supported her decision to continue her education in school despite being pregnant. Among peers, the difference of pupil pregnancy was more a point of interest than taunting. She could have gone to the PRU immediately, but she found the prospect of continuing her education in a new setting where she did not know anyone daunting. Her desire to stay in mainstream education appeared to be motivated by her wish to complete coursework and to maintain her friendships.

By the time Shae was seven months pregnant, negotiating the stairs had become difficult and staff suggested that it was time she thought about going to the pupil referral unit. The final decision about when she finished at school and started at the PRU, however, was Shae's.

> They could see me struggling, cause at [school] it's like flight after flight [of stairs]. I had to go to a lesson on C floor, and that's like two flights to get up there each time. And Miss Lawrence ... she'd see me waddling up the stairs and getting out of breath and she'd be laughing at [with] me saying, 'you've really got to go Shae, you can't stay with your friends'.

Shae remained in her mainstream school until she was more than seven months pregnant, returning to school to sit most of her examinations. In contrast to Aimee, she stayed in contact with friends and teachers and attended her end-of-year prom which had clearly been a highlight for her and an ultimate sign of belonging.

> Yeah and I went to the prom as well. I'd had Max [my son] by then. I had the teacher dancing. I pulled her onto the dance floor, and she was like, 'no I can't dance' and the next minute she was dancing and I was laughing. It was a good night.

Shae had moved from being an angry, rebellious pupil to one her school had become proud of and happy to support. She contrasted the response of some teachers' to her pregnancy at first – 'You could see it on some of their faces, like, 'you're nothing" – to subsequent responses – 'You've done it'. She exemplifies that some pregnant teenagers become determinated to disprove the dominant stereotypes about them. It seemed important to Shae to show that becoming pregnant was neither a disaster nor the end of her formal education.

> But now, like when I go back to school for my exams, they're looking at me like, 'wow, you have done it' and 'you're not looking down' and 'you're all right'. I've shown them that I can do it.

81

Shae felt like she had a genuine choice about her educational placement and the timing of her departure from school and the school made adjustments to address health and safety concerns while she was with them. When she finally left to continue her education at the pupil referral unit, effective communication between the two contributed to good educational outcomes. The actions of her school meant that Shae continued to feel part of it and made her feel she was valued and cared for.

The difference in the two schools' responses to Aimee and to Shae could have been influenced by factors to do with the pupils. Research shows that a pupil's behavioural and academic history in a school influences the willingness of staff to invest time and energy in supporting a pupil (Wedell, 2005). In the case of these two pupils however, it was Shae who had the more chequered history within her school yet it was her school that was more accepting and supportive. Even when she was not physically present in her school, she still felt as though she belonged. To a large degree, and as intended by policy, her school had dealt successfully with the difference of pupil pregnancy.

Sarina

Sarina's school reacted with disapproval and rejection when she became pregnant in Y11. Lack of support and follow-up appeared to be a determining factor in her total disengagement from education. She reported enjoying Years 7 and 8 and had attended regularly but during Year 9, the pressure of SATs (Standardised Achievement Tests) and her friendships with older adolescents outside school meant she lost interest in school. A pregnancy and subsequent miscarriage in Year 10 coincided with further deterioration in her attendance and relationships with staff. During Year 11 she became pregnant again and was told by the school not to return. According to her school, and in contrast to policy, remaining in mainstream education was not an option.

> They said, 'we can't have you in school whilst you are pregnant. It just causes too much attention and we don't allow it anyway'.

Sarina perceived the health and safety and school insurance reasons her school put forward to justify her exclusion as an excuse. She acknowledged the risk associated with crowded, bustling corridors but

pointed out, as did other young women and professionals, that a staff member who is pregnant can continue working until late into her pregnancy. She also highlighted a further inconsistency. Her school's response to the difference of pupil pregnancy suggested unacknowledged and unspoken views about the deserving and undeserving, and about moral contamination. She thought that a pregnant pupil was no more different from other pupils than those with other conditions or special educational needs, many of whom are now unquestioningly included in mainstream education. And she pointed out with exasperation that pregnancy is not contagious.

> One lad said, 'why do you have to leave?' [And I said], 'Well they say it's because of health and safety'. [pause] But I think that it's just an excuse. If they say that, then why should a kid that's got Down's Syndrome or something like that be allowed in a mainstream school when there's kids who are running past and fighting ... or someone who's broke their leg and are on crutches. They're still allowed at school. They make exceptions for being like that but not if you're pregnant. [pause] It's not an illness. It's not like chicken pox that everyone can catch.

Interestingly, her reference to being viewed as contagious points to the possibility that it is not the difference of pregnancy *per se*, but rather what it represents that is being silently recognised; an uncontrolled adolescent sexuality makes her morally contagious. Sarina thought the school's response to her pregnancy was more to do with maintaining a particular reputation – one that did not include acknowledging adolescent sexual activity. She thought her school was unsupportive because of

> ... reputation. Word gets round. Like they go to these teacher conferences and some people think it's disgusting [to have a pregnant pupil in school]. Also, it probably looks bad for the school because it's like they're allowing underage sex.

Other young women and professionals took the same view. One teacher speculated that schools are reluctant to include a pregnant pupil because doing so conveys an acceptance of adolescent sex, the sight of a pregnant pupil in a school uniform is bad for the school's reputation, and schools are anxious about health and safety implications. She also noted the same double standard highlighted by several of the teenagers – that a pregnant teacher often continues teaching late into her pregnancy.

> I think there's a fear that if one person is seen to be accepted that 'oh it's all right then to be pregnant in school' ... and I suppose the young person is seen to be pregnant wearing your school's uniform. And I think some schools are very fearful on health and safety grounds as to whether they can genuinely accommodate somebody, but teachers who are pregnant often stay almost full-term. (Mainstream teacher)

A teacher from a different school was critical of other schools in her area that were explicit about using health and safety reasons to exclude a pregnant pupil. In line with official policy, she viewed this as unacceptable and thought that some schools were afraid to include a pregnant pupil because it would damage its reputation.

> I know of schools where, you know, 'we' re not having a teenage mum in school. We'll say the reason is health and safety but actually we don't want her seen around here because it might look bad on the school'. You can dress it up in health and safety, but at the end of the day, there isn't really a health and safety issue. (Mainstream teacher)

Sarina was not alone in her view that her exclusion from school was not purely about health and safety concerns.

After revealing her pregnancy Sarina was told about the pupil referral unit, but unlike Aimee and Shae, there was no liaison with the local authority officer and no process to ensure an effective transition to this alternative provision. When asked what she would like the school to have done differently, she replied: 'Meet with me! They never even sat down and had a meeting with me.'

When Sarina stopped attending school altogether, there was eventually some follow-up from an education welfare officer but this was not consistent or on-going and did not resolve her situation. Although she remained on her school roll and was sent her examination timetable, incomplete coursework meant she had to drop most of her subjects. Sarina's already diminished sense of being valued as a member of her school was exacerbated by her school's uncompromising reaction to her pregnancy. Her difference was clearly not one her school was willing to deal with.

Rebecca

Rebecca, like Aimee and Sarina, was in her final year of compulsory schooling when she became pregnant. Like many other Year 11 pupils, GCSE coursework and preparations for end-of-year examinations loomed large in her life. She was a high achieving pupil who had a history of good school attendance and aimed to achieve passes in all 14 of her GCSE subjects. This is an accomplishment that any Year 11 pupil would rightly feel proud of.

Becoming pregnant left Rebecca feeling distraught and worried about how this would affect her plans to go to university. She was one of only two in my sample of fourteen who had considered higher education – an issue I return to later. Rebecca's mother phoned the school to inform them of her daughter's pregnancy and a meeting was quickly convened. The outcome was that Rebecca was directed to the pupil referral unit. She was given a clear impression that 'pregnant pupil' and 'mainstream school' were mutually exclusive categories. According to school staff, her needs would be better met at the pupil referral unit.

> The impression I got was that they didn't want someone pregnant in their school. They wanted me to go and have a look around Phoenix [the PRU]. Basically they thought that I would be better off there.

Rebecca's uncertainty about this proposal was confirmed when she and her mother visited the unit and realised that she would be unable to continue with all her GCSE subjects. Home tuition had been raised as another alternative but this would only have been a few hours a week and again meant she would be unable to continue with all her GCSEs. Rebecca wanted to continue working towards her 14 GCSEs with her friends at her mainstream school. In her view, this was the most 'suitable' way of supporting her education – yet despite national guidance, this seemed not to have occurred to those responsible for her education.

Rebecca's school was initially reluctant for her to continue but she thought being pregnant was irrelevant to her ability to continue studying and certainly not a reason for being 'sectioned' (excluded). She made her case at another meeting. Like Sarina, she rejected the 'pregnancy as disease' discourse she perceived. Her words echo another familiar theme. Becoming pregnant appeared to provide Rebecca with an addi-

tional incentive to do well in her examinations and thus to 'prove everybody wrong'.

> I said to my teachers, everyone that was there [at the meeting], why should I go and do my studying at home just because I'm pregnant. I've not got some disease, I'm just carrying a baby. There's no point in me being sectioned like that. I'm still as capable of doing my GCSEs ... as I [subsequently] proved. And that's maybe why I did so well, because I wanted to prove everybody wrong. And it took a lot of persuading, cause they weren't happy about it at first, but I did it.

Her choice of the word 'sectioned' is interesting. It may convey something about how she was feeling at the time. Normally applied to the mentally ill or those with severe intellectual impairments when they are unwilling to accept care or treatment, it involves non-consensual admission to a medical or psychiatric facility – or in Rebecca's case, the pupil referral unit.

With the clear support of her head-of-year and headteacher, the school agreed that Rebecca would continue her education with them. Interestingly, Rebecca thought the fact that she was a high achieving student and would therefore contribute positively to her school's league table results influenced the school's willingness to accommodate her desire to stay in mainstream schooling. This supports a frequently made suggestion in the inclusion literature that inclusive expectations and policies do not sit easily within a system where school performance is measured according to GCSE results (Ainscow *et al*, 2011; Wedell, 2005).

Staff reactions to Rebecca's determination to continue her education at school were mixed. She reported that her head-of-year and headteacher were very supportive, as were most of her subject teachers, 'once they got used to the idea'. Not all staff were equally supportive however, and she was the recipient of judgmental comments or looks from some staff members and peers. She described an incident with a teacher who was not one of her subject teachers but who was called upon to cover for her usual teacher one day.

> He was teaching our lesson and I was just chatting with my partner [classmate] ... asking him what he was on about cause I didn't quite understand it. That teacher then turned around and said to me, 'slappers like you don't belong in this school'.

Rebecca was understandably shocked and upset to receive such a blatantly prejudiced and publically made comment. She said she did not know what to do and felt she could not stay in class after that. Although she suggested that such an inappropriate comment was the exception rather than the norm, her experience is an important reminder that dealing with stigma and prejudice is an everyday reality for those who become pregnant when they are young.

Rebecca was the first pregnant pupil at her school who was enabled to remain. The school consequently found itself on a steep learning curve about how best to accommodate her difference. Despite senior management support, lack of a clear and agreed process meant that Rebecca was left to tell her teachers about her pregnancy and request accommodation as and when a need arose. She consequently found herself in some awkward situations: being unsure whether working with certain chemicals in science was safe for her unborn child; growing out of her school uniform; having to justify going to the toilet during a lesson. This created much unnecessary stress for a pupil who was already dealing with the additional physical and emotional demands of being pregnant while studying for 14 GCSEs alongside her non-pregnant classmates. She described an incident that happened before she was issued with a toilet pass.

> One thing they did do that was quite decent is they gave me a toilet pass. But it was only because I brought the issue up, because I needed the loo, and I said to my English teacher, 'I really need the loo, do you mind if I just nip off for two minutes?' And we ended up having this massive argument. I really needed the toilet and she was like, 'why do you need to go to the toilet so badly?'

Rebecca explained that only a few classmates and a few teachers knew she was pregnant at that stage, and she did not feel ready to announce her pregnancy publicly to all and sundry. She felt embarrassed and frustrated.

> I was in the middle of a lesson and I didn't want to say to her in front of all the people in my class ... I didn't feel ready to tell them all, 'I'm pregnant, I need to go to the toilet'. You know what I mean? So I just walked out, got my bag and went home.

To avoid situations like this Rebecca advised that all staff be informed about a pregnant pupil by senior management but that the pregnant pupil herself should decide when to tell her friends and classmates. She thought every school should have a school policy that specifies how a pregnant pupil will be accommodated, including when and how staff will be informed, what health and safety implications there might be, how these will be addressed, and how uniform and attendance issues will be dealt with. Sensible guidance like this is offered to schools by many local authorities – the local authority where my research took place included. Sadly, it was clear from the professionals and the young people in my research that the gap between guidance and day-to-day practice is considerable.

Rebecca continued in her school and was in her last six weeks of pregnancy when she sat her examinations. She succeeded in achieving A-C grades for all 14 of her GCSE subjects. A less assertive and educationally motivated pupil in the same school, however, had a very different experience. When Rebecca's friend Emma became pregnant shortly after Rebecca did, she simply stopped attending. There was no follow up, no meeting was convened, and no support for this student's continued education was offered. But Rebecca was clear that she wanted to complete her education with her friends in the school she had been attending for the last four and a half years. She also believed she had a right to do so. The poor implementation of policy, however, meant that her difference as a pregnant pupil created unnecessary challenges, including that of convincing others that mainstream education was indeed the most 'suitable' place for her.

Pregnant schoolgirls and school-aged mothers: the same but different

We have seen the considerable variation in how school's responded to the difference of teenage pregnancy and that an inclusive experience was the exception rather than the norm, despite inclusive policy. This confirms the experiences of rejection found in other research with teenage mothers, both in the UK and overseas (see Dawson and Hosie, 2005; Luttrell, 2003; Pillow, 2004; Shacklock *et al*, 2005). It seems little has changed since Harris *et al* (2005) wrote of the young mothers in their study: 'Once they were pregnant, they were often actively rejected and

stigmatised, reinforcing messages to them that they were nc
in the education system' (Harris *et al*, 2005:25). But we have
how some schools provided more affirming experiences and su
a pregnant pupil to stay in education – thus meeting the inclusi
of policy.

A closer look at how schools managed the difference of pregnancy or
motherhood provides further insights into policy in practice. The stu-
dent's accounts highlight the daily dilemmas that may be encountered
as well as the school responses that are helpful. I focus on the ex-
periences of Shae, Rebecca and Mia, the three pupils who continued in
their schools after becoming pregnant. I also present the experiences of
Libby, a pupil who returned to her school as a young mother. Their
accounts are particularly useful for illustrating Minow's dilemma of dif-
ference and show how even with the best of intentions, dealing with
difference is neither straightforward nor easy, but that certain school
responses are more likely to be helpful.

Mia, like Shae, remained at school until she was over seven months
pregnant. Her story reveals a desire to be treated both differently and no
differently from her non-pregnant classmates – an issue that was also
raised by Shae and Rebecca. This desire appears to be contradictory
but, as discussed more fully later, school responses that involve both
equal treatment and different treatment go some way towards resolving
Minow's dilemma of difference.

When the school was informed that Mia was pregnant, some staff mem-
bers were encouraging and supportive but others were judgmental and
unsupportive. As her baby's birth got nearer, Mia sometimes found it
difficult to finish all her schoolwork because she was tired and uncom-
fortable and she found that some teachers were more lenient with her
than they were with other pupils. Although she thought this differential
treatment might have been motivated by good intentions, she would
have liked more encouragement to complete work rather than being
able to get away with things. In this respect she wanted to be recognised
as no different from her non-pregnant classmates. Her words portray
some of the 'complex, fluid, messiness' (Reay, 2006) that typified much
of what the young women recounted. Her concluding phrase encap-
sulates a point forcefully made by both Shae and Rebecca: 'Just because

I'm pregnant doesn't mean treat me different'. Mia said being treated the same as her classmates would have been helpful.

> It upset me really, cause even though I know it was a bit my own fault getting pregnant [pause] and I'd stop doing the work sometimes [pause] but they could have pushed me a bit, like talked to me the way they talked to anyone else. Just because I'm pregnant doesn't mean treat me different.

There were other situations where Mia thought it important to acknowledge her differences. She found the school chairs and desks uncomfortable in the latter stages of her pregnancy and would have liked a more accommodating chair. And she would have appreciated an occasional simple inquiry about how she was doing:

> I think sometimes, something like having a comfy chair is good, but you don't need that until you're say seven months ... but it's just things like asking how you are. Like obviously you don't ask everybody that, but if you're coming in heavily pregnant, it would have been nice sometimes to have been asked.

This desire to be treated both differently and no differently was a recurring theme. Shae and Rebecca spoke about feeling emotionally volatile throughout their pregnancies and attributed this to fluctuating hormone levels. They said that some days they found themselves upset about things they would normally have brushed aside. So as not to be perceived as different, Shae kept her sensitivities to herself. This meant absenting herself to the toilet on several occasions so that no one would see her cry.

> When you're pregnant it's your hormones [laughing]. Yeah, you take things to heart, and the teachers, they just see it like you shouldn't be pregnant anyway and any problems and it's like, 'well you shouldn't have got pregnant'. [pause] But I was a hard nut. I wouldn't let anyone know ... like if I'd cried, I'd go off to the toilets.

Fluctuating hormone levels, tiredness and discomfort are everyday realities for any pregnant woman but within a school setting these may be perceived by those in authority as more problematic. Alldred and David (2007) suggest that school fear of bulging bodies and tearful outbursts 'highlight the naturalised absence of emotion and the body from the dominant pupil discourse' (p179). The pupils in my study wanted to be treated the same as their classmates despite these differences. Shae

encapsulates some of these apparent contradictions. She explained that the stairs were tiring, the chairs and desks were uncomfortable, and that some afternoons she would have liked a short rest after lunch; but she also liked not being singled out as different from her peers even though it was sometimes hard.

> It was the stairs that did me in ... cause my belly was sticking out so far. And I'd have to push my chair back, otherwise I wouldn't fit [at my desk] ... but they didn't really treat me any different. That's what I liked. But it was hard some days.

So despite these difficulties, being treated the same was appreciated because it helped convey a sense of belonging. Shae was clear about what schools could do to make it easier for pregnant pupils:

> Well, just treating them all the same really, innit. Making them feel like they're [pause] wanted [at school] ... else you're not gonna want to get up and go.

Her words emphasise the importance generally of making all pupils feel welcome at school and that this can partially be achieved through equal treatment.

Rebecca, too, emphasised that she did not want to be singled out as different. Rather than leave class five minutes early like pregnant pupils do in some schools, she wanted to move from class to class with her friends. The same applied to her examinations. She did not want to sit in a room on her own; she wanted to be 'normal'.

> When it came to my GCSE's I was really close to my due date so they said I could go into a separate classroom on my own and do them but I said no. (pause) I wanted to be normal so I was in the middle of the hall at my little desk.

Rebecca rejected the health and safety excuses that some schools use to dispatch pregnant girls on the same grounds.

> I did the steps every day. It's not like, 'you're pregnant, you [therefore] can't walk up and down these stairs'. If the fire alarm went now, we'd have to use the stairs to get out of here, you know what I mean?

Being treated differently was particularly unwelcome when it was perceived to be based on incorrect teacher assumptions about a pregnant pupil. Mia told me how one of her teachers effectively ignored her after

finding out she was pregnant. She thought the teacher assumed that Mia's formal education was over and she resented not being able to get help with her schoolwork from her.

> I can remember one teacher who wouldn't take any notice [of me], like I'd have to ask her for my work and things like that ... as if I wasn't going to be bothered doing it. I just felt like I was all on my own.

Whatever her teacher's underlying motivations and beliefs, Mia would have found it more helpful to be treated the same as other pupils – and specifically, to be encouraged and supported to progress educationally. The effect of teacher expectation is a widespread issue that applies to many pupils. Research shows that pupil characteristics such as race, ethnicity, social class and special educational needs all influence teacher expectations (see Dunne and Gazeley, 2008; Rhamie, 2007; Rubie-Davies *et al*, 2006). The young women in my study found that differential treatment based on low teacher expectations further reinforced messages about being educational misfits who would achieve little in their lives.

A school-aged mother

Libby was a teenage mother in the process of returning to her school when I first met her. Her circumstances were different from those of the pregnant pupils but her desire to be treated both the same and differently from her classmates, and the dilemma this posed about what is best and what is just, were the same.

Libby had been directed to the pupil referral unit when she became pregnant in Year 10, but she returned to her mainstream school the following year when the nursery at the pupil referral unit could no longer cater for her eight month old son. Libby therefore faced the prospect of completing her final year of schooling in a mainstream school she had not attended for over a year, having had limited access to the National Curriculum during her absence, and as the mother of an eight month old child. How were these differences to be recognised?

Libby explained that she had initially been reluctant to return to her old school because she was unsure how staff and peers would treat her. As was also true of the other young women in my study, and as seen in other research with young mothers (Coleman and Dennison, 1998; Duncan *et al*, 2010), she seemed acutely aware that the difference of

teenage pregnancy is stigmatised. She explained feeling particularly nervous on her first day because: 'I thought they might think differently about me with having a baby and that'.

During our second interview, Libby reported that she had made new friends and was enjoying school, although she found some aspects hard. She attributed her successful reintegration to school primarily to non-stigmatising attitudes from staff and classmates, and to the school's pragmatic and flexible responses to her circumstances. As part of her reintegration plan it was agreed that Libby would undertake a part-time programme working towards three National Vocational Qualifications (NVQs). She thought that this was appropriate for her needs and was one way of enabling her to juggle school alongside motherhood. She came to school just for those subjects while a childminder looked after her son. Even on this part-time arrangement, however, she found the dual demands of parenting and school very tiring. This was particularly the case when her son was teething and she was up with him during the night. She got very tired and occasionally missed days of school, thus putting her behind in her school work. She appreciated what she perceived as considerable commitment from one teacher who took the time to go over work she had missed.

Some days Libby still found juggling motherhood and school a challenge. She appreciated that the school treated her just like any other pupil by phoning her if she missed more than one consecutive day, but at the same time she felt somewhat pressured. As she explained:

> When I was really tired it was hard for me to do all my work and I would be falling asleep in class. They were just always on to me and that was making me worse, and sometimes I used to get depressed from school cause I was so tired ... cause when I started back at school I was up during the night with him [her son] because he was teething.

Libby's reintegration to school was supported through a combination of equal treatment and different treatment. Being offered a part-time timetable was one way of recognising that although she was legally required to be in education she was also the primary caregiver of a teething child. The message implicit in this arrangement was 'your education is important but we recognise that you also have other responsibilities'. The demands of motherhood were also recognised by one of her teachers giving her extra help after an absence.

In other respects, Libby was treated the same as any other student and the fact that she was also a mother was treated as irrelevant. A phone-call home after more than one day of unexplained absence conveyed the message that 'we expect all our students to attend regularly even if you are a mother as well as a student'. As we saw, this created some tensions for Libby.

A mainstream teacher at a different school described their response if a pupil became pregnant – they aimed to convey an expectation of on-going attendance that would be supported through a flexible approach to timetabling and attendance. She reported that:

> If anybody discloses that they are expecting, we tell them that we can manage that in school ... that you'll be expected to come to school up until your maternity leave starts, then we'll support you with work at home. And then when you come back to school you'll be phased back in ... and obviously we'll make sure that if you need to come in a little later because you've got to get baby ready in the morning or you need to leave earlier or you can't manage a full day then we will look at your timetable and cut it down to something that's realistic ... realistic when you're caring for your child as well. (Mainstream teacher)

This teacher was clearly aware of the dilemma of difference posed by being a school pupil and a mother. Her school aimed to be as flexible as possible about part-time attendance while ensuring that the student's future opportunities were not unduly affected. The school encouraged students to strive for five A-C grade GCSEs, including the core subjects of English, maths and science, which would allow them access to a wide range of educational opportunities after 16.

Two teachers at another school said they viewed a flexible approach as an essential aspect of their inclusive philosophy and practice. They suggested that for a pregnant pupil this could often be achieved through relatively minor modifications such as a less demanding timetable and leaving class a little early to avoid crowded corridors. They emphasised that talking to the young woman and her family was key in supporting educational continuity and that students should have some control over, and responsibility for, what happens and how. But most of the young women in my study described a complete absence of consultation. These teachers' words also reveal a non-recognition of the dif-

ference of teenage pregnancy. The school's inclusive ethos was interpreted to mean that pregnancy itself was seen as irrelevant. No matter what the pupil difference, the school's aim was curriculum access and the achievement of qualifications.

> S: It's just little things. like saying, 'You may leave the lesson five minutes before the bell so you're off the corridors before the crush happens'.
>
> R: Or, 'You can come in at 9.00 after everybody is in class' – or 'you can leave at 2.30'. You know ...
>
> S: It's about talking to the young woman and her family and saying, 'What do you want?' If they want to come back but cut down the number of subjects they are doing then that's not a big issue for us if it means that they have some access. And these are the sorts of things that we do whether it's a broken leg, a teenage pregnancy, someone who is on medication that makes them tired or someone who is autistic. It doesn't matter what their issue is, if it's a barrier, you try and make it so it's easier. (Mainstream teachers)

Minow's dilemma of difference may be impossible to resolve. Libby might be disadvantaged in the future because she could only study part-time and pursued NVQs rather than GCSEs. However, juggling just three subjects along with motherhood seemed to be as much as could reasonably be asked of her. These examples show that it was the combination of equal treatment *and* different treatment that was helpful for the young women in my study. The implicit messages conveyed to students when schools adopted a differentiated recognition of difference – recognising some differences while intentionally not recognising others – successfully supported the policy aims of educational continuity.

This chapter has focused on students' educational experiences before they became pregnant and after their pregnancy was revealed. I hope to have conveyed something about the 'complex, fluid messiness' (Reay, 2006) of individual experiences and drawn out some overarching themes. Certain themes recurred: the extent of students' school disaffection before they became pregnant; some schools responded unhelpfully to the difference of pupil pregnancy but other schools were supportive and flexible. Despite their good intentions and despite adhering to policy, schools did not find it easy to resolve the dilemma of difference resulting from a pupil pregnancy but some did manage to tackle it in

ways that provided valued support. This was achieved primarily through adopting a differentiated recognition of difference, as discussed in Chapter 6. First, however, I turn to the students' experiences of educational alternatives to school.

5
Educational alternatives:
benefits and limitations

Supporting educational continuity through arrangements other than mainstream education is a strategy applied to a wide range of pupils who are labelled as vulnerable, at-risk, or risky. These are the pupils whose differences make them, for one reason or another, difficult for schools to accept or accommodate. Most of the young women in my study spent some time in a centre or programme that catered specifically for pregnant and mothering teenagers. A specialist pupil referral unit catered for a number of students while they were still of statutory school age. Two specialist e2e programmes enabled success-ful transition to post-compulsory education.

This chapter recounts the students' experiences in these educational alternatives and considers their merits and limitations. The safe and welcoming environments these educational alternatives provided con-trasted strongly with the students' alienating educational experiences in the past and were clearly key to their continuing or re-engaging in education. Their accounts offer important information about what schools might do to create more affirming environments for all pupils. This centres on issues of relationships, classroom organisation, teach-ing and learning strategies, and learning support. The chapter ends with a discussion about educational achievements and future plans. We see that the young women feel constrained in their choices and find themselves challenged by taking on dual roles – of mother and student – that do not sit easily together.

Phoenix: the pupil referral unit

The local authority provided a pupil referral unit for pregnant school-girls and school-aged mothers. The PRU catered for around eighteen pupils at a time. It was well staffed and incorporated an on-site nursery and two nursery staff. Six of the young women I worked with continued their education at Phoenix when they left their mainstream schools. One began attending Phoenix late in her pregnancy, after first being supported by her school to stay in mainstream as long as she could. The remaining five started at Phoenix early in their pregnancies, some because they chose it and others because they were led to believe it was their only option.

Every one of the students spoke highly of Phoenix and they all appreciated and benefited from their time there. Much of what they valued echoes research undertaken in other pupil referral units and educational alternatives, both those specifically for pregnant schoolgirls (Dawson and Hosie, 2005) and those that cater for other differences (Crozier and Tracey, 2002; Pomeroy, 2000). Their experiences in the PRU contrast almost point for point with the very secondary school experiences they had found most difficult and which contributed to their disaffection with school. We look first at the generic features which characterise educational alternatives and then at those that are specific to being pregnant or a young mother.

Perceived benefits: generic

The young women identified numerous benefits, both educational and pastoral, of studying at Phoenix. They enjoyed the smaller classes, being able to get more help with work, access to a tailored programme, and the wider range of teaching and learning strategies. They welcomed the less formal and more respectful relationships between staff and pupils, and the absence of bullying. One student, Sarah, particularly appreciated feeling cared about, being listened to and being able to get help with her schoolwork, again echoing other research (Finlay *et al*, 2010; Pomeroy 2000). Her words point to a qualitatively different relationship between staff and pupils from that in her mainstream school. Sarah said that staff at Phoenix were 'not the same as a normal teacher' and that:

> The teachers were better ... they was more caring. Like they check that you're all right and things like that. If you need help with something, you just go to them. And if you've got a problem, you can go to them as well. They'll listen to you. [pause] They are not the same as a normal teacher.

Clearly, part of being listened to involved being able to talk to staff about issues outside school as well as about education. Integral to such relationships was trust; trust that staff would be non-judgmental and trust that whatever was said would stay between the two of them. It was about staff showing genuine interest in them, taking and having the time to listen, acknowledging the importance of all aspects of the students' lives. But it was also about respecting confidentiality and responding in non-judgmental ways to whatever the students tell them. For those who already feel publically judged and whose out-of-school lives are often demanding, the pastoral aspect of the relationship may be particularly valuable.

Being able to get help with academic work was also important. Tracy, who attended Phoenix from early in her pregnancy spoke for all six of those who were there when she enthused about the benefits of smaller classes and a greater variety of teaching and learning strategies than teachers employed in her mainstream school. Smaller classes meant students were given attention when they needed it, as Tracey observed:

> Well it [Phoenix] was so small. There's only a few people there so we got a lot more attention. You didn't have to sit there in a class and listen to the teacher all the time. You did some [listening] and then you got on with your work. And you did quite a lot on the computer ... and you did stuff in a way that helped you remember ... and that made it easier.

In light of the disaffection many of them had experienced in mainstream school, some of which was attributable to difficulties accessing the curriculum, it is unsurprising that the student appreciated a learner friendly environment. And predictably, given the importance they placed on GCSEs, they valued being able to continue working towards them at Phoenix. Aimee, for example, stressed the importance of being able to continue with her GCSEs but was glad that there was no bullying and she could focus on her learning:

> When I came here it was great. I really enjoy it here better than school and I think it's because everybody is so nice to each other. And I was just really

> pleased that I could carry on with my GCSEs ... get the same education as I would at school.

The students said they did better academically at Phoenix than they would have at school. Research shows that an alternative setting, with smaller class sizes and different relationship dynamics, can create a much needed and valued second chance at education (Crozier and Tracey, 2002; Pomeroy, 2000). Some of the young women said explicitly that being pregnant gave them added incentives to take their school-work seriously and do well. Other studies too have found that in contrast to the commonsense notion that pregnant and mothering teenagers lack the motivation to complete their education, they greatly valued education (Durant *et al*, 2005). Moreover, pregnancy can be a turning point, motivating them to take their education seriously (Dawson and Hosie, 2005; Duncan *et al*, 2010).

As well as benefits, the young women identified some limitations of Phoenix. Shae explained that she could not continue with all her school subjects when she moved to Phoenix, and the extra-curricular activities she had enjoyed were unavailable. She did not frame this aspect of her new educational setting as a disadvantage but spoke about it in a matter of fact way, and appeared to be grateful to continue her education there, even if the curriculum was limited.

Interestingly, Phoenix was promoted within the local authority as a centre that offered individually tailored programmes and encouraged the completion of nationally recognised qualifications. In reality, the small staff numbers and therefore limited expertise understandably placed considerable restriction on the breadth of the curriculum to which pupils had access. Although not explicit, one reading of Shae's words is that the pupil is made to fit the system rather than the other way round. Speaking about the educational options that were available to her at Phoenix, she said:

> I didn't have many because [at school] I was doing loads of things ... maths and history and science. [At Phoenix] They had to fit me a timetable that was more up to them. So I had to finish expressive arts. I couldn't do that anymore because they don't have that. I was doing PE ... and I couldn't do that anymore [laughter]. And I was doing the choir at school and they don't have that sort of thing ... so just little things like that.

So Shae's educational experiences became restricted once she began attending Phoenix.

Rebecca, who chose not to go to Phoenix, was the only one who perceived the limited curriculum would be a major disadvantage to her. For the others, the collective advantages of Phoenix seemed to outweigh the disadvantages of limited GCSE subject choice and few extra-curricular opportunities. Shae speculated that she did better at Phoenix than she would have at school because she was given more help with her work and was away from the distracting influence of peers. She was clear why she was pleased to be at Phoenix:

> ... cause I've learned more than what I would have learned at [old school]. And we have more chance to like speak to the teachers, like when you don't understand, but at school they've got lots more pupils in one lesson and you don't get much time with the teacher, so you learn a lot more [at Phoenix]. I don't think I would have done my GCSEs if I hadn't had Max cause I was skiving, going off with my friends.

Perceived benefits: catering for pregnant and mothering teenagers

Some of the advantages of Phoenix were specific to being pregnant or a young mother. All six pupils who went there liked being educated with other young women in the same position, and this was often the first point raised when I asked them about the advantages. They attributed this partly to the fact that Phoenix provided an emotionally safe place where their youthful pregnancies were accepted rather than condemned. Tracy put it like this:

> There's people here in the same situation as you, whereas at the other schools, if you go there and you're pregnant you'll get called a slag and everything and they'll all be looking at you and stuff.

Schools are not necessarily emotionally or physically safe places for pregnant pupils. Research shows that basic needs such as ready access to a toilet are sometimes denied (Alldred and David, 2007), and as demonstrated in my research, other forms of fair and respectful treatment cannot be assumed. The less rigid structures of centres such as Phoenix make accessing toilets, food and water easier than when they are in school, but students also particularly valued their shared ex-

perience of pregnancy and knowing they would not be judged negatively by classmates or staff.

Not all pupils, however, viewed this aspect of Phoenix in the same light. Mia, who chose to stay in her mainstream school and then had home tuition, said she choose not to attend Phoenix as she did not want to be 'stereotyped as a young mum' or 'put in a category of like all the young mums together'. Instead, she wanted to be seen as a 'normal' school pupil who happened to also be pregnant. Interestingly, my first contact with Mia was at Stepping Stones, a post-compulsory educational alternative. Stepping Stones is similar to Phoenix in that the student group is comprised only of pregnant and mothering teenagers, yet she was happy to attend this programme. She explained how she had changed her thinking on 'all the young mums together' and instead came to value this aspect of her educational setting. Mia spoke about the possibility of attending Phoenix, and her reservations about doing so:

> I felt like I would be stereotyped as a young mum and I didn't want to be put in a category of like all the young mums together. I know it's like that here but I've just got over it ... cause I am a young mum ... and it is better all being together. You can share your experiences.

Mia's change in stance over time reflects something of Minow's dilemma of difference. Non-recognition of her pregnant status at school was helpful to Mia but she also valued the sense of belonging and shared identity she later experienced at Stepping Stones, a facility based on the explicit recognition of the difference of teenage pregnancy or motherhood. This illustrates the fluidity of student experience and that perceptions and needs may, and often do, change over time. What was most helpful for this student in relation to her educational placement was being consulted and given information and options and then taking responsibility for her decisions.

Another advantage the young women identified at Phoenix was the ready access to a range of other professionals. Visits from a Connexions personal adviser, a health visitor and a staff member from the sexual health clinic were valued because they occurred on a regular basis, thus allowing the development of authentic and trusting relationships. Having the professionals come to Phoenix also meant the young women

did not have the cost or inconvenience of negotiating public transport with their bulging bodies or prams.

They identified the on-site nursery as another important advantage. They valued it because it allowed young mothers a break from their caring responsibilities and they could continue their education – but their babies were also close to hand so they could feed and change them during the day. Having the nursery on-site made it easy for students to get to know the nursery staff so they had few worries about being judged as inadequate parents by these professionals. We saw earlier how two potential barriers to using childcare facilities were the young mothers' anxieties about leaving their baby with someone they did not know and could trust, and about being negatively judged as a mother. The on-site nursery at Phoenix appeared to be a good way of addressing these barriers. Although some students anticipated that they might find it difficult when they started college because they would not be able to see their babies during the day, their subsequent accounts suggest that these early nursery experiences made them more willing to use other childcare facilities after they left Phoenix. Speaking about positive aspects of Phoenix, Shae said:

> The nursery, that's a big thing. I don't think a school would be able to have a nursery. Like here we can see them at dinner time, give them dinner cause it's in the same building, and we know the nursery nurses quite well. But when I go to college, I'm not going to be able to see him like that so that's going to be hard.

One of the disadvantages of Phoenix noted above was the restricted academic curriculum it could offer. Conversely, one advantage was the additional curricula, which were not provided at their schools or, in the case of SRE, should have been but were not. Time spent learning about human development, sexual health, pregnancy and birth were valued and appeared to help the young women feel more confident about what, for some, were the daunting prospects of pregnancy, childbirth and motherhood.

Surprisingly, pupil referral units for pregnant and mothering pupils were sparse in the wider region. Among the eight neighbouring local authorities, Phoenix was one of just two such facilities. One reintegration officer thought that maintaining alternatives such as Phoenix im-

portant because 'one size does not fit all'. She explained that the current push for mainstream provision for pregnant pupils meant that her local authority no longer provided any alternatives. She thought this worked against educational continuity because in her experience, there was still a considerable gap between policy and practice when it came to supporting pregnant or mothering pupils.

> Here it's all mainstream. That's the only provision. We don't even provide the home tuition or anything else. I think that's the downfall [of local policy] ... because there's those girls who want to stay in school ... they want to be with their friends but then there's the girls that want the opportunity to be in like a unit where they can have a crèche on-site. And, you know, why not? We need more alternatives. (Reintegration officer)

The argument for more alternatives is an important point but it brings its own dilemmas. The previous chapter showed that one consequence of a local authority having such an alternative was that some schools viewed it as the default option and therefore gave little consideration as to whether, how and for how long mainstream education could be continued. Yet the reintegration officer above found that without such an alternative, some girls simply missed out. My research found commendable examples of inclusive practice in mainstream schools, but also found shocking examples of rejection and belittling in both local authorities, despite their differing positions on pupil referral units. So dealing with difference in affirming and respectful ways is not simply about policy or whether or not an educational alternative exists. It is a more elusive process which requires commitment, compassion, willingness to examine taken-for-granted values and assumptions, and an ability to provide genuine options and choices for young people.

It was clear that the young women valued their time at Phoenix because of its generic features as well as those specific to their circumstances. The smaller, less formal environment, and the opportunities this provided for different sorts of teaching and learning and closer, more trusting relationships with staff than those in their mainstream schools, were all identified as positive features. These would benefit many students. Accommodating students' specific differences as pregnant or mothering schoolgirls, and having this aspect of their lives non-judgmentally accepted by other pupils and staff, was also key to supporting good educational outcomes.

Specialist post-compulsory options: Young Mums To Be and Stepping Stones

The two centres

Young Mums To Be (YMTB), a nationally recognised e2e programme designed specifically for pregnant teenagers, has been available across England since 2000. It provides an accredited NVQ (National Vocational Qualification) Level 1 award which aims to overcome barriers to learning and provide skills and knowledge relating to managing pregnancy, childbirth and motherhood. It is comprised of twelve different units. Two of these focus on antenatal issues; two on neo-natal issues; four on personal health; three on information technology, literacy and numeracy skills with the final unit focusing on accessing further education, training or employment.

Stepping Stones is also an e2e course but is locally driven and the exact programme offered is determined primarily by the two staff who run it and by the needs and interests of the students. Within the broad framework of e2e, precise courses of study are individually tailored and, like YMTB, most young women work towards nationally recognised qualifications such as OCN (Open College Network) or ALAN (Adult Literacy and Numeracy) awards. In contrast to YMTB, the curriculum they offer focuses less on pregnancy, birth and motherhood and more on improving basic literacy, numeracy and IT skills, various aspects of PSED (personal, social and emotional development) and citizenship as well as more vocationally oriented skills and experiences.

Both programmes were located in the city centre and students thus relied on public transport to get to their chosen nursery and then their educational centre.

Perceived benefits: generic

Over the course of my research, nine students continued their education at one of these two programmes, and one young woman spent time at both. Students rated these institutions highly for the same reasons as the students at Phoenix did. They identified the more relaxed and intimate setting than is typical of school or college, the trusting and respectful relationships with staff that this fostered, and smaller group size as positive features of both programmes.

As was the case at Phoenix, students valued the greater range of teaching and learning strategies that were used and enjoyed the combination of small-group and individual work, practical-based activities and computer-based activities. Invited speakers and out-of-class excursions such as going to the local swimming pool added further variety. Having individualised programmes, being able to work at their own pace, and better academic support compared to their school experiences were also noted as positive features – all features which are commonly identified as approaches which work with disaffected young people (Finlay *et al*, 2010; Pomeroy, 2000; Thomson *et al*, 2005).

Louise enjoyed YMTB far more than she had ever enjoyed school. She echoed the views of others when she explained this as partially because she disliked the formality and the rules of school, but also because she found academic side of things easier when she is part of a smaller group, able to work at her own pace and to get help with work when needed.

> It's just having all the rules and things like that which I didn't like [at school]. That's why I like it here because it's not as strict. You can sit and eat in here and have a drink, and you can go to the toilet when you want whereas at school you are not allowed to. [pause] You're in a small group as well. You can work at your own pace here. That's what I like about it. You're not in a rush and you get more individual help as well.

Lisa, who also attended YMTB, added that she liked the practical activities and the fact that it was not all reading and writing. A programme that includes a greater range of activities is more likely to acknowledge a wider range of skills and thus provide additional opportunities for students to experience success. The nursery box Lisa designed and built showed real talent in design, technology and art which had not been fully recognised at school.

Being able to continue in education despite being pregnant or a young mother was highly valued, particularly by students who lacked the credentials necessary to embark on their preferred college programme. Staff at Stepping Stones noted:

> The majority have no qualification, no GCSEs. They've been excluded. Some have been formally excluded and others just haven't been engaged ... low attendance or didn't take their GCSEs for various reasons.

For some of the young women, it was not so much a case of continuing one's education, but rather of re-engaging in education after being lost from formal systems, sometimes for months at a time. The skills and accreditations gained at these two alternatives were important for access to further education, particularly for those who had few or no GCSEs. These programmes were an important stepping stone from NEET to EET. It was not just the tangible outcomes such as accreditations that promoted educational continuity but also less tangible factors such as the development of personal confidence, whether to succeed academically or to manage other aspects of their lives in assertive and constructive ways. Several students spoke about trying but failing college courses before attending Stepping Stones or YMTB but successfully managed college courses afterwards.

Sonia's experience illustrates this. She described how Stepping Stones helped her prepare for college and thought she would not have succeeded without it. This appeared to be due to the OCN accreditations she achieved while at Stepping Stones, plus her improved literacy and numeracy skills. These allowed her to start a Level 2 college course that she could not otherwise have accessed without GCSEs. It subsequently became clear, however, that it was not just the formal creditations but also other aspects of Stepping Stones that had enabled her successful transition to college. As we browsed through the folder which documented her achievements, she told me she had tried to go to college the previous year but had soon discontinued her course. She pointed to a large gap between dates and explained, 'I think I jumped into it [college] too soon cause I hadn't been in school for about two years. I came back [to Stepping Stones] cause I weren't ready for college'.

Sonia attributed the change between her first unsuccessful attempt at college and her later successful transition to her increased confidence. She spoke about some of the less formal aspects of Stepping Stones and how these had boosted her confidence and developed her self-belief. Her negative school experiences during her pregnancy and after the birth of her child meant that she left school with no formal qualifications and feeling she was an academic and personal failure. Sonia is not alone in this. Other research documents the alienation and sense of failure experienced by significant numbers of students, not just those

who become pregnant (Booth and Ainscow, 1998; Finlay *et al*, 2010; Thomson, 2002).

Thomson's (2002) argument that 'the selective academic curriculum is by its very nature one that produces success, average achievement and failure' (p68) resonates with the accounts of the young women in my research and was noted by staff at Stepping Stones. Staff highlighted the sense of academic failure formerly experienced by many of their students and the impact this has on their students' personal confidence. But they also spoke about a more elusive yet essential ingredient of inclusion – the importance of validating the whole student and her different identities. Staff at Stepping Stones positively embraced all aspects of a student, including her different choices and circumstances, and in doing so affirmed their identities as both capable learners and mothers:

> A: I don't mean to sound big headed, but maybe we are the first adult in their lives that's told them that they can achieve, and that we think they are bright and that they are good mothers.

> J: The conclusion that we come to is it's about confidence. They don't get that positive input during their education that actually validates who they are ... and that it's OK to have different choices. (Stepping Stones staff)

In effect, staff supported educational continuity by recognising the many differences the students bring with them into schools in non-stigmatising ways – a point developed further in my next chapter. Stepping Stones counteracted the sense of failure and educational alienation students had experienced at their secondary schools and helped them feel academically and socially more confident and ready to re-engage in formal education. This fits well with the policy aim of supporting young women into education.

Sonia's story illustrates another important point. Re-engagement in education and successful transition to more formal education may take time, particularly when combined with mothering responsibilities. It took Sonia over a year at Stepping Stones to make that successful transition to college and it was both the academic and pastoral aspects of the programme that were crucial in supporting her.

The students also identified staff commitment and support as integral to their success. Sarina, for example, appreciated the fact that the two course leaders at Stepping Stones were always available and always

willing to offer support, no matter what the issue. And we saw that pupils at Phoenix hugely valued having a trusted adult they could talk to about absolutely anything. This confirms the value of pastoral as well as learning support.

Another important feature identified as supportive was the staffs' knowledge about local college courses, application procedures, different childcare options and when and how to apply for Care To Learn* funding. But it was the caring and respectful relationships between staff and students, and the processes they encouraged that appeared to be key to the renewal of their personal confidence, that students at Stepping Stones described. Instead of giving advice, the staff encouraged students to take responsibility and control in their own lives. For example, they did not provide forms or help them complete childcare funding or college applications but instead told students where they could get the forms and agreed to review them once they were completed. They encouraged students to go and look at several nurseries before deciding on the one they thought best suited them and their child.

Relatively small actions like these created frequent opportunities for students to experience success, assume greater control of their lives, and develop feelings of competence and confidence. Practical supports, such as encouraging students to use the centre facilities when making arrangements were more tangible points the students identified as helpful. Being able to use the phone, fax, internet, photocopier and printer ensured that they could complete applications and make arrangements efficiently without incurring personal cost. For those on tiny budgets, this was an important form of support.

Perceived benefits: catering for pregnant and mothering learners

Some of the positive features the students spoke about were specific to being pregnant or a teenage mother. As was the case at Phoenix, spending time with other people of a similar age and in the same situation as themselves was one such feature. Sonia spoke for others too when she said: 'There's people my own age and in the same situation, so I can talk

* This national initiative, supported by the teenage pregnancy strategy, provides up to £5125 per year to cover the cost of childcare and associated transport for a young person in EET.

to them about stuff'. It seems likely that time with others in the same position is valued because of their shared experiences of not only pregnancy and motherhood but also of stigma. Belonging to a group where their circumstances and choices are not met with condemnation or disapproval but rather with understanding and acceptance was a refreshing change. And as staff made clear, students in settings like YMTB and Stepping Stones can give one another more affirming views of their choices, motivations and capabilities than those typically portrayed in the media or in their daily interactions with professionals and members of the public.

A second but related benefit that featured prominently in student accounts is the importance of social contact. Other research with young mothers has attributed motivation to pursue educational outlets to their being bored at home and needing social contact (Harris *et al*, 2005; MacDonald and Marsh, 2005). My work supports this. Enquiries about their reasons for attending these programmes elicited statements such as: 'I was on my own a lot of the time' (Sonia); 'I wanted to do something. I didn't want to just be at home' (Lisa), or 'You get depressed when you're sitting at home on your own' (Sarina). Sarina spoke first about the importance of gaining skills through such programmes but it seemed that she was also motivated by her desire for social contact:

> If I can get some skills while I am pregnant then that's better than sitting at home doing nothing ... sitting there thinking that the world is crashing down. You get depressed when you're sitting at home on your own.

Clare spoke about boredom when she explained why she extended her time at YMTB beyond the usual three months. Her story of not finishing YMTB until three days before she gave birth and starting back at her part-time work and beginning a college course six weeks later, contrasts with the popular media stereotype of the lazy or unmotivated pregnant teen.

> Well I went through till May. I extended it for a few weeks cause I was bored. I had absolutely nothing to do, I was just waiting for him to come. I finished on the Thursday and I had him on the Sunday.

The students' accounts on these matters were supported by the course leaders. The two staff at Stepping Stones thought the need for social contact was the main reason why some of their students came and they

emphasised the importance of access to an emotionally safe space where students did not feel judged for being pregnant or a mother at their age.

> A: To be honest, a lot of them join us because they want something to do.
>
> J: Yeah, they come because they want to be out of the house and they want to meet some other mothers. And they want to be in a group where they feel they are not judged for being a mother or pregnant.

Clare appreciated what she learned about pregnancy, birth and motherhood at YMTB. She said she had attended her local post-natal classes but not the antenatal classes, so the specific knowledge gained at YMTB was important to her. The medical literature on teenage pregnancy attributes the poor birth and neo-natal experiences associated with teenage motherhood to poor attendance at antenatal classes. Although some research identifies the age factor and the teenagers' discomfort in a group of older women (Cronin, 2003; Meade and Ickovics, 2005), rarely is the stigmatised status of teenage pregnancy put forward as a possible explanation. Clare described feeling more positive about herself as a pregnant teenager after attending YMTB. Accordingly, she was later willing to attend post-natal classes. Feeling 'so embarrassed' highlights the internalised shame that recurred in the young women's accounts.

> I came out [of YMTB] with a different attitude … [before] I was so embarrassed … I just completely degraded myself when I found out I was pregnant. It made me feel a lot better being there [at YMTB]. (Clare)

That their pregnancy and motherhood is recognised without stigmatising the young women is important for their self-esteem and confidence and enables them to take more responsibility and control over their own lives. And this in turn leads to better outcomes.

Mia, who had chosen not to attend Phoenix because she did not want to be 'put in a category of like all the young mums together', subsequently attended both YMTB and Stepping Stones – the former during her pregnancy and the latter after she had her baby. Although she spoke positively about both programmes, she placed particular value on the fact that Stepping Stones did not focus exclusively on pregnancy and motherhood. She wanted her focus and identity to include other things. As other students made clear, Stepping Stones succeeded in broadening horizons and challenging stereotypes. It also helped re-shape identi-

ties. This is particularly important in the case of stigmatised identities. Some students said that seeing themselves as competent and capable parents was a valued change. Students also spoke about how Stepping Stones helped them develop a mother identity which did not exclude other and additional possibilities. This contrasts with the pervasive view of teenage pregnancy as the end of one's life or, at the very least, the end of one's formal education. Megan captured one of the benefits of Stepping Stones:

> It's given us all faith in ourselves that we can do both [motherhood and education] and that just because you're young doesn't mean your life has to be based on being a mum all the time. Here [at Stepping Stones] they are telling you that you can also do other things for yourself.

She suggested that an additional advantage of this form of specialist provision was that staff have an understanding of their students' broader lives and the ways in which the responsibilities of motherhood may complicate a smooth educational passage.

> They're understanding here. You're all here because you're either pregnant or a young mum and you're all going through the same experiences where-as a normal college, the fact that people don't understand that you've got a baby at home, so if she's teething and you've had a really rough night of it or she's got chicken pox and she can't go to nursery, they're not going to be ... well they might be understanding but I think that it's a lot easier at a place like this.

The experience of Rebecca, who did not attend Stepping Stones but started an A Level college course, shows us that such understanding or special accommodation cannot be assumed. Rebecca's college objected to her taking an unexpected mobile phone call from her son's nursery during class one day. She was compelled to choose between her course and being contactable by the nursery. As the latter was clearly important to her, she chose to discontinue her course. Rebecca told me:

> One time it rang and it showed [name of nursery] so I just answered it in the classroom, 'is everything all right?' I couldn't just leave it. And they said you either leave your phone at home or you leave yourself at home. I explained to my tutor what happened and she said, 'those are the rules'.

Rebecca subsequently enrolled in a teaching assistant course at a different college where she was allowed to take her phone into class with

her. It is a sad irony that among the 14 young women in my study, Rebecca was the only one who gained enough A-C GCSE grades to enroll in an A Level course, but the inflexible stance of that particular college over her need to be contactable by her child's nursery meant that continuing was simply not an option. The often rigid stance towards pregnant and mothering students has been highlighted in other research (Alldred and David, 2007). In my study, a teacher at Stepping Stones spoke with frustration about this lack of flexibility. She observed that schools often do not recognise that being a mother has obvious implications for what can reasonably be expected, but she and her colleague pointed out that this was equally true of some colleges.

> It seems to be very inflexible ... just from what the girls have said when they've come to us. If they did have their baby when they were 14 or 15, there just doesn't seem to be that much flexibility within the school system. They seem to have a five day or no day approach rather than saying let's do three days with you where you do this, this and this and see how it goes. (Teacher at Stepping Stones)

Several of the mainstream teachers spoke about the need for a flexible, commonsense approach and this was reflected in their school practice, as illustrated by the part-time arrangements made for Libby. Unfortunately such flexibility does not seem to be widespread.

An additional positive outcome noted by several students at Stepping Stones related to changes in thinking. Megan spoke about one of these – the idea that they could be mothers *and* do other things too. This was because the staff gently but persistently conveyed the expectation that gaining additional educational qualifications at Stepping Stones, and then later at college, was both desirable and possible. Indeed, future funding of the programme depended on staff being able to provide evidence that students continued in education, employment or training. Additional outcomes were also noted, however, and some of these were student led, albeit made possible by staff creating the trusting and supportive atmosphere that allowed the students to challenge each other.

Mia remarked on how peers influenced one another in a way that adults might not have succeeded in doing. Her initial unwillingness to extract herself from a violent relationship with the father of her child caused social services to become involved. It seemed that it was not so much

the two broken ribs she sustained, or even the realisation that she was physically unable to protect her child from the father, but the subsequent processing with classmates that led her to end the relationship. She explained that it was helpful hearing the views of people her own age rather than adults. Speaking of Stepping Stones, Mia said:

> It's the best thing I've done in a long while. We get to talk about all sorts of things. Like with the domestic violence stuff, most of the girls, they would give me advice, and although they feel like they're telling me off, I don't mind. And adults are constantly telling me things and that makes me sort of rebel against them but when I hear it coming from my friends, like what it's doing to my child ... [it is different].

Mia went on to explain in our interview that it was being challenged by her classmates to consider the negative emotional impact on her child of witnessing this abusive relationship that was particularly influential in changing her thinking. Staff comments verified Mia's account and highlighted their intentional 'no direct advice' stance. This stance was one marked difference between Phoenix and Stepping Stones. Commenting on their aim to increase students' confidence so that they can assume more control in their lives, one of the Stepping Stones staff said:

> No matter how we may feel about it, we don't say 'you've got to finish with him' or anything like that but we'll give clues or suggestions, 'oh, have you tried it this way' or 'have you thought about this or that?' Our focus is giving them the ability to think for themselves and decide for themselves what they want. And if at the end of that, they get rid of that bloke who's been kicking shit out of them then it's their choice.

Both the staff clearly viewed these other, less tangible outcomes as important in their own right even though they did not contribute directly to the success criteria against which the programme was measured. They spoke with some frustration about an inflexible system that made it hard to meet funding criteria. Funding was dependent on their ability to demonstrate educational progression, but as the pregnant students inevitably drop out of the programme to have their babies, this counts as a discontinuation according to auditing criteria. Staff noted that many of their students return later and eventually progress to college – just not within the time frames that were used to rate an e2e programme successful.

Stepping Stones staff also perceived a contradiction between national policy and its local implementation. They thought funding a limited number of spaces in just two specialist programmes for pregnant and mothering teenagers in a city of several hundred thousand was a poor reflection of a national initiative that aimed to support young mothers with their education. It seemed ironic that over the course of my research, the role of teenage pregnancy reintegration officer was cut from a full-time to a half-time post. This affected her availability to schools, many of which were on a steep learning curve when it came to including pregnant and mothering pupils, as my research shows.

Educational outcomes and trajectories
Achievements and qualifications

Chapter one highlighted the strong correlation between teenage pregnancy and poor educational outcomes as the basis for views about educational vulnerability. In line with this, the educational achievements of the young women in my research were modest. Seven of the fourteen students finished Year 11 with no A-C GCSE grades and a further four achieved either two or three A-C grades. One student achieved four A-C grades although these did not include mathematics, English or science, the three core subjects required to access a range of post-sixteen courses. Another student had just started Year 11 at the time of our final meeting and was in an educational alternative that did not offer GCSEs. The remaining young woman stood out as exceptional for her 14 A-C grades.

Table 1: Number of GCSEs at grades A-C gained by young women

Number of GCSEs	Number or students who gained A-C grades
0	8
2	3
3	1
4	1
14	1
Total	14

The 14-19 curriculum, however, now makes it easier for schools to offer pupils a broader range of options. Three students also completed NVQs as part of their school Year 10 or Year 11 programmes and all students who attended Phoenix also completed OCN and ALAN awards. In some respects, these are positive outcomes. NVQs, OCNs and ALANs are nationally recognised accreditations and thus constitute a constructive way of dealing with difference. They enable students who have difficulty with mainstream school, or whose strengths are not academic, to demonstrate skills in other areas and to gain a sense of achievement as well as formal qualifications. They also provide an alternative route to further education (FE) colleges for those without GCSEs. But dealing with difference inevitably creates dilemmas: in this case, that of the relative value of alternative qualifications. Although not explicit about this, the young women's words suggest a qualifications hierarchy, with GCSEs and A levels clearly at the top.

Sarina was sceptical about the value of alternative credentials, particularly with regard to how future employers might view them. She also thought that students who were still of statutory school age, admittedly a small minority at Stepping Stones, should be able to study for GCSEs. As a student with only two A-C GCSEs, she would like to have had an opportunity to retake her GCSEs while at Stepping Stones. In Sarina's opinion:

> You can do an English OCN. It's not a GCSE but it's equivalent ... but I don't think an OCN stands for very much. When people ask you how many GCSEs you've got, you can't say 'well I've got one in English because I've got an OCN' because it's not the full course. And here, like, they do OCNs on yoga. You couldn't go like to a yoga place and say I've got my level one OCN, I'd like a job.

Confusion among young people as well as potential employers about the relative merits and equivalency of the different qualifications now available is an important issue. It will require more attention in the future.

Choices and constraints

Over the course of my research, ten young women were completing, had been completing, or were about to start college courses. Confirming other research with young mothers (Harris *et al*, 2005; Kelly, 2000;

Rolfe, 2005), their course 'choices' were gendered. Six were doing hairdressing or beauty therapy, two were doing health and social care and the remaining two business studies.

I use the word 'choices' with quotation marks to acknowledge some of the constraints on their choices: low educational achievement; the timing of their births; desire to spend time with their babies; and their own and other people's expectations about what is appropriate or possible for them all influenced their decision-making. College systems, such as having to begin a course at the beginning of the college year rather than after the first semester or having to undertake most courses on a full-time rather than part-time basis, also constrained choices.

Aimee was thinking about becoming a primary school teacher when I first met her. She was aiming for enough GCSEs to undertake an A level programme. Her baby was due in September and she contacted her local college to explore the possibility of starting in the New Year rather than September but was disappointed to find that this was not an option; she would therefore have to wait until the following September. She could also only do the course on a full time basis and as the baby's birth approached she realised that she did not want to study full time while her baby was so young. Like many women, she wanted time with her new baby. In the event, she did not get enough GCSEs to do an A-level programme and at my last contact she was planning to start a health and beauty course on a part-time basis the following September.

Mia had started a full-time business studies course at college. She appeared happy with this outcome but explained that it was her second choice. With no GCSEs she could not pursue her desire to become a legal secretary. Similarly, Shae had been aiming for at least four A-C GCSEs and wanted to pursue an A-level course in law. Like Mia, she was interested in working as a legal secretary or possibly going on to university to study law. She was one of just two participants who spoke about wanting to go to university in the future. She explained that although she achieved four A-C GCSEs, these did not include English, maths or science so her college options were limited. She was directed to a different college where staff helped her consider some alternative, albeit more limited options. As was the case when she moved from her mainstream school to Phoenix, it seemed that she had to fit the system rather

than the other way round. Her 'choice' of business studies appeared to be something she went along with because she was highly motivated to be in education, rather than something she had considered before-hand:

> Cause of my four GCSEs, there weren't many courses going this year that I could do ... and when he said business, I thought I'm fine with that.

Several of the young women were influenced by other people's views of what is appropriate for them. Although I do not know the exact process or what other options had been presented, Clare and Lisa were both directed into hairdressing NVQs as part of their Year 11 programmes. This influenced their subsequent choice to continue with hairdressing at college. Lisa explained that although she did have other ideas and interests, hairdressing was what she knew so what she was planning to return to once her second baby was one year old.

> I would like to do other stuff, but like that's all I know really ... hairdressing. I was gonna try and do midwifery but that's a long course. And I've always liked like interior design and that sort of stuff. And I enjoy cooking as well. I can see myself going more down the hairdressing line though.

Some of the professionals expressed frustration about the students' gendered college courses choices. Staff at Stepping Stones said, 'They all want to be nursery nurses, hairdressers and beauticians'. This is a longstanding issue that has been highlighted in numerous feminist studies (David *et al*, 2000; Leathwood, 2006; Macrae and Maguire, 2000; Paechter, 1998) but seems resistant to change.

EET, NEET and motherhood
The young women's educational trajectories showed that the line be-tween EET and NEET had been crossed several times before and during the course of my research. This zig-zag trajectory was because many of them wanted to spend time with their babies, particularly in the first year of their babies' lives. They knew that pregnancy and motherhood was disrupting their educational plans, but time with their babies, particularly very young babies, was seen as more important (see also Dench *et al*, 2007; Harris *et al*, 2005). Rebecca might have been different from the others in that she wanted a university degree, but she was similar in that she did not want to start her degree until her second child was one.

Mia explained her postponement of entering post-compulsory education in terms of wanting time to bond with her baby but she was affected by other life circumstances too. Her housing situation was uncertain and she was being closely surveilled by social services as she eventually extracted herself from a violent relationship. In these circumstances, the thought of taking on the additional challenge of starting a new course at a new institution where she would be meeting new people and possibly risking further educational failure, was understandably something she chose to put off.

Similarly, Sonia thought that young women should not feel pressured to rush straight back into education after having a baby and that time to settle into the changes and demands of motherhood was important. When I asked about her views on teenage motherhood and education she replied: 'I think you should be able to leave it ... a couple of months at least, just to settle in'.

Sonia's sentiments were repeated by staff at Stepping Stones who thought all women should be able to stay at home and look after their child if that is what they want to do. Several of the other professionals interviewed questioned the expectation that schoolgirl mothers return to education immediately after the six-week post-natal check-up. As the excerpt below illustrates, one reintegration officer's concern was that the choice to mother one's child was being restricted.

> I feel that the maternity leave [rule] is stupid. We try and enforce this kind of six-week return after the baby is born, and really, who are we to say, you know, you should be returning once your baby is six weeks old. (Reintegration officer)

Interestingly, two of the young women who attended Phoenix thought otherwise. They would like to have returned to Phoenix after their babies' births sooner than permitted by the adopted protocol of at least six weeks. The on-site nursery and access to their babies during the day may have made the return to education easier for them. Importantly, neither had any choice in the matter.

Clare, who started her college course six weeks after the birth of her child later said she had mixed feelings about doing so. She thought that although continuing education was a good thing and the funding of childcare through the Care To Learn initiative was helpful, it might have

been better to wait awhile before rushing back to study so soon. She had been too keen to challenge stereotypes about teenage motherhood and prove that she could 'get my life back on track'. Clare said this about the dual roles of motherhood and student.

> It is hard ... but I think with schemes such as Care To Learn, I think that's good. But how I feel at the minute, with everything ... coming to the end of the course, Luke [her son] being all over the place, I just wish I had not gone back so early. I think I needed more time. I mean just as soon as I had him, after six weeks, I was at college. I just rushed. I had no time off at all.

As other research confirms, the dual role of mother and student can be difficult (David, 2003; Kidger, 2004; Phoenix, 1991). Kidger described the young mothers in her study as excluded from the possibility of being full-time mothers because they were expected to be in education, training or employment. But this subjected them to judgment as either a 'bad' mother who is not there for her child, or a 'bad' citizen who had not earned inclusion by being in education. The mothers in Phoenix's study spoke about wanting and needing to be in work but not wanting to leave their child with someone else because they believed a good mother looked after her children herself. These tensions are not easily resolved. Most of the young women in my research wanted time with their babies and also to continue their education. They wanted to be good mothers by being there for their children and by improving their future employment prospects through education. Precisely how they thought they would manage this varied from young mother to young mother. Common to their experiences however were the contradictory pressures of the two important and demanding roles.

6

Reframing difference

The last four chapters have painted a partial picture of what it was like for the young women in this study to become mothers when societal expectations dictate that they dedicate themselves to education and future careers. Each story is different but some disturbing similarities are evident, not least because of the stigmatised way in which teenage pregnancy and motherhood was recognised. This chapter moves beyond the narratives to consider what might be learned from them. I present an analytic model which troubles some of the taken-for-granted assumptions often made about pregnant and mothering teenagers, and suggest some alternative understandings. It is only when certain factors that are often overlooked are foregrounded that less stigmatising and more constructive discourses about teenage mothers will emerge. Only then will the desirable outcomes intended by policy have a chance of achieving reality.

I begin with the theme of 'difference' and my starting assumption that difference is generally identified through comparison with an accepted norm – a socially constructed norm that is based on the perceptions and unquestioned assumptions of the dominant culture. This creates an identified 'other' who is invariably recognised in ways which devalue, marginalise or stigmatise. The chapter shows how this 'othering' affects how pregnant and mothering teenagers experience, interpret and respond to the world in which they find themselves.

Fraser's (1997) emphasis on the links between economic and cultural injustice and her argument that social justice requires both economic

and cultural responses to difference were discussed in Chapter 1. Although Fraser's work focuses on broad aspects of social justice, such as those related to gender, class, ethnicity and religion, her ideas provide a useful framework within which to analyse the experiences of any individual or group who is viewed as different or 'other'. I can apply it to pregnant and mothering teenagers.

Fraser's concept of a differentiated recognition of difference is of particular relevance to my analysis. She calls for recognition of different kinds of differences: some to be eliminated (non-recognition); some to be universalised (recognition); and some simply to be enjoyed. Her critical theory of difference therefore requires judgments to be made about which differences fall into which categories. One interpretation of her views is that recognition of particular differences can be helpful or unhelpful for promoting social justice – or in the case of pregnant and mothering schoolgirls, for promoting their learning and well-being. Non-recognition of difference, too, can be helpful or unhelpful. I considered which differences were recognised in the lives of the young women in my research, in what ways, and with what effect. I show that many of the ways in which the young women were identified as different were inherently stigmatising and made it difficult for pregnant and mothering teenagers to develop positive and respected identities. These were unhelpful recognitions of difference. However, their accounts revealed examples of differences associated with pregnancy and motherhood being responded to in positive ways, affirming their experiences of pregnancy, motherhood and education and promoting their well-being and positive outcomes – that is, helpful recognitions of difference.

While some differences were recognised, others were not. The recognised and unrecognised both had an impact on the young women's thoughts, feelings and behaviour. Sometimes non-recognition promoted their learning and well-being and at other times it worked against it. I refer to these as helpful non-recognition of difference and unhelpful

	Helpful	Unhelpful
Recognition of difference		
Non-recognition of difference		

non-recognition of difference and base my analysis on a quadripartite model of the recognition of difference.

While my main interest is in how educational institutions deal with the difference of teenage pregnancy, and in particular how inclusive practices might be promoted, a consideration of young women's general experiences of pregnancy and motherhood highlights important features of the wider social contexts within which educational institutions operate. Some of the negative responses from schools simply reflect the stigmatised construction of teenage pregnancy and motherhood in wider society. Understanding how these come about helps us develop more holistic understandings and affirming practices.

The first part of this chapter explores social and political representations of teenage pregnancy and motherhood to show which differences are recognised, how, and with what effect. I position these alongside the differences that are not recognised, to highlight the ways in which these various recognitions and non-recognitions promote or work against the young women's well-being. I then focus specifically on how these recognitions link to the young women's educational experiences.

The recognition and non-recognition of difference: dominant representations of teenage pregnancy and motherhood

We have seen how stigma is a pervasive and continuous theme in the lives of pregnant schoolgirls and schoolgirl mothers. How does this come about and what effect does it have on the young women concerned? I suggest that stigmatised representations of teenage pregnancy and motherhood are maintained primarily through a focus on youthfulness. This constitutes an unhelpful recognition of the difference of age. Looking at youthful sex, youthful pregnancy and youthful motherhood, we see the age-related assumptions that underpin stigmatised representations of teenage pregnancy and motherhood and how they affect the thoughts, feelings and behaviour of the young women themselves. Issues are thrown into shadow by the focus on age and some of the differences that remain unrecognised in dominant representations of teenage pregnancy and motherhood relate to gender and social class. The non-recognition of these differences means that the pathologising, individualised discourses based primarily on youthfulness go unchal-

lenged. The combination of recognising youthfulness in stigmatising ways while *not* recognising the influences of gender and social class in their lives has a detrimental effect on the young women concerned and further reinforces stigmatised representations.

Unhelpful recognition of difference
Youthful sex
Adolescent sexuality is a contentious and controversial issue. It touches on hidden sensitivities and engenders strong feelings (Hampshire, 2003). Former British Prime Minister Tony Blair reflected public sentiment in his Foreword to the Social Exclusion Unit report on teenage pregnancy, saying: 'Let me make one point perfectly clear. I don't believe young people should have sex before they are sixteen. I have strong views on this' (SEU, 1999:4). Girls who become pregnant in their early teens are thus marked out as different from their peers by their early sexual activity. They embody a sexuality that is not socially sanctioned; adolescents are viewed as too young to be having sex, and derogatory assumptions are made about those who do. Much of the research on adolescent sex carries implicit assumptions about developmental deviance and moral deficiency. The 'slappers' comment directed at my research participant Rebecca exemplifies such attitudes. It conveys a view of moral contagion from which other students need protection.

Because of such popular representations and the associated negative public attitudes, adolescent sex becomes associated with shame so remains a hidden and silenced part of their lives (Allen, 2007). This occurs within a wider social context of 'mixed messages about sex' (SEU, 1999) and, as Sonia in my study observed, a context where 'sex is everywhere'. The negative attitudes and associated shame affect young people's thoughts, feelings and behaviour, sometimes in ways that are detrimental and reinforce negative stereotypes. There is evidence, for example, that the current demonised recognition of adolescent sex can make it harder for young people to practice safe sex (Brindis *et al,* 2003; Corcoran *et al,* 1997). Libby told me she felt too embarrassed to access contraception because of her age – yet she did not feel too young to be having sex with her boyfriend. This barrier to accessing contraception is not generally recognised and instead, non-use of contraception is seen as further evidence that young people are too young to manage sexual relationships in a mature and responsible manner.

Youthful pregnancy

It is not just their obvious sexual activity that marks out pregnant teenagers as different and morally deficient but also that their sexual activity made them pregnant, and then they decided to continue the pregnancy when they are single, dependent and expected to be completing their education. Pregnant teenagers are assumed to have become pregnant because of their ignorance or their irresponsible or irrational choices and are stigmatised accordingly. Policy is based on an assumption that educational qualifications assure good employment prospects and are the key to combating social exclusion. Pregnant teenagers are represented as irresponsible citizens for failing to conform to expected family forms or life trajectories. Thus they are stigmatised for jeopardising their educational outcomes and future status as respectable and responsible tax-paying citizens.

Such stigmatised representations can cause some teenagers to internalise shame and this can cause them to deny that they are pregnant. Chapter 2 showed that not all the young women in my research realised they were pregnant in a straightforward way. For some it was a protracted, drawn out process which took a surprisingly long time. They confirmed and accepted their pregnancy only after denying it for a while, despite obvious signs that they were pregnant. This delay then reduced their access to potentially beneficial health services. There is evidence that fewer teenagers than older women access antenatal services (Corcoran *et al*, 1997; Meade and Ickovics, 2005) and this has raised concerns. Corcoran and her US colleagues note the 'tendency of younger adolescents to hide their pregnant condition, thus optimal prenatal care may be delayed' (p366). Meade and Ickovics (2005) attribute the lower birth weights of babies and the higher rates of anaemia found among pregnant teenagers to concealment of their pregnancy. Late confirmation of pregnancy and poor attendance at antenatal classes are identified as a problem and are then used as evidence that teenagers are too immature and irresponsible to handle the responsibilities of motherhood, thus perpetuating negative representations. The stigmatising representations that contribute to the noted behaviours of concern are not recognised but are instead individualised and pathologised.

Youthful motherhood

Should youthful sex result in youthful pregnancy and youthful mother-hood, young women are marked out as different in other stigmatising ways too. Phoenix (1991) observes that 'young mother' and 'good mother' exist in public consciousness as mutually exclusive categories. The experiences of the young women in my study suggest that the assumption that teenagers are too young to be good or capable mothers still prevails. This view was conveyed by professionals as well as family members. Similar evidence can be found in other qualitative research with teenage mothers. One study found that 'Some thought that society looked down on them and questioned their ability to be good mothers, just because they were young' (Daycare Trust, 2002:17). The young women in my research seemed painfully aware of representations of teenagers being neglectful, inadequate mothers and having babies for the wrong reasons.

For some of the teenagers in my research, these representations re-sulted in the internalisation of negative messages about teenagers be-ing inadequate parents. As Clare said: 'it just don't come out of your head'. It was as though these popular negative constructions of teenage mothers became part of her identity – as she put it, 'I never give myself the OK'. This can undermine young women's confidence and belief in their own parenting abilities which may then become a self-fulfilling prophesy.

Other consequences may then arise which work against educational continuity. For example, research has found that uptake of childcare services by young mothers is small, but are unclear about why, although some point to public scrutiny as a factor (see Cronin, 2003; Dench *et al*, 2007). Some of the young women in my research explained that their unwillingness to leave a child in the care of others was because they were afraid their mothering abilities would be found lacking. This echoes sentiments expressed by those in Dench *et al*'s (2007) study. Thus, just as public disapproval of adolescent sexuality might block access to contraception, so might fear of public disapproval inhibit access to daycare services. Furthermore, the reluctance to use formal childcare facilities can create a barrier to employment, education or training (EET) thus potentially affecting their future employability. Go-ing against social and governmental expectations to be in EET is then

interpreted as further evidence that they are irresponsible citizens. That pejorative stereotypes inhibit taking up daycare or other public services such as baby and toddler groups is not recognised.

Finally, a further result of negative representations of teenage motherhood was the amount of effort and cost many in my research group expended in trying to disprove stigmatising stereotypes. Their accounts suggest that they wished to regain some of the public approval they felt they had lost by becoming teenage mothers. This meant presenting themselves and their babies in ways they thought signified they were worthy of respect: clean, immaculately dressed and with good quality prams. As Sarina noted, she felt she had to adopt an attitude that conveyed she knew what she was doing as a mother. Several of the professionals I interviewed reported that asking for help with anything to do with parenting was simply not an option for some young mothers. This potentially reduces access to support in a way that older mothers do not experience.

Unhelpful non-recognition of difference

As well as the unhelpful recognition of youthfulness in relation to sex, pregnancy and motherhood, other differences remain unrecognised in dominant representations of teenage pregnancy and motherhood. These too are underpinned by questionable assumptions and negative views of the young women concerned.

Youthful sex

Research suggests that general social attitudes towards adolescent sex do not necessarily match the views, attitudes and experiences of adolescents. A good many young people are sexually active. The latest available data from the National Survey of Sexual Attitudes and Lifestyles indicates that 30 per cent of boys and 26 per cent of girls are sexually active before the age of 16, the age of legal sanction in England (Wellings *et al*, 2001). Many of those in my study, all of whom did so before they turned 16, clearly viewed adolescent sexuality as an inevitable rite of passage. They appeared to regard it as a normal part of growing up. Adolescent sexuality could be recognised as more than just sexual behaviour. Luttrell, in her work with young mothers, suggests that it is about 'what young people know and believe about sex, what they think

is natural, proper, or desirable, and in what ways they think they are not measuring up to sexual norms' (Luttrell, 2003:140). Adolescent sexuality can be understood in the light of development rather than deviance.

Secondly, not all adolescents who are sexually active are demonised as those who become pregnant are. Representations of developmental deviance and moral deficiency are selectively applied. The sexual activity of male adolescents, as well as that of females who prevent pregnancy by using contraception or seek abortions, is invisible and quietly ignored. In contrast, the swollen bellies of the 'others' attracts disapproval and contempt. Society's discomfort with adolescent sex seems to be concentrated on pregnant teenagers. It was only Rebecca who was called a 'slapper', not her classmates, some of whom were probably sexually active.

Thirdly, simplistic assumptions about ignorance, promiscuity or foolishness fail to recognise the complex and multifarious range of factors that influence adolescent sexual behaviour. Although lack of knowledge does appear to account for some teenage pregnancies (Snow, 2006), there is little evidence from my study, or others, that such ignorance is widespread. For example, Wiggins *et al* (2005) found that only 15 per cent of the young mothers in their large sample said they had unprotected sex because they did not know enough about contraception. Similarly, in a study in the US by Stevens-Simon *et al* (1996), only a minority of the young mothers interviewed attributed their pregnancies to lack of knowledge. All those in my research appeared to know enough about the 'plumbing and prevention' required to keep themselves safe, most did not intend to become pregnant, yet nine of the fourteen were not using contraception at the time they conceived.

Rather, sexual behaviour needs to be understood within the broader context of young people's everyday lives (Abel and Fitzgerald, 2006; Stenner *et al*, 2006). What do adolescents make of their sexual experiences and how might this influence their decision-making? There are countless factors that determine how any sexual encounter might play out. Gilbert's (2007) work on competing risks, for example, suggests that for some young women, the perceived psychological risk of being abandoned by a boyfriend outweighs the perceived physical risk of conceiving or contracting a sexually transmitted infection through unprotected sex. There could be other risks, such as the risk to one's

reputation of becoming or not becoming sexually active – or in practising safe sex (Abel and Fitzgerald, 2006; Measor, 2006). Both male and female adolescents in Abel and Fitzgerald's research in New Zealand schools spoke about their dread of embarrassment over using a condom confidently. Some of them thought that the risk of damaging their reputation through using a condom incompetently overrode the risk of unprotected sex. So it is vital that we recognise the wide range of factors that influence adolescent sexual behaviour and not base our understandings on unfounded assumptions about ignorance, promiscuity and foolishness.

Youthful pregnancy

Also largely unrecognised in stigmatised representations of adolescent sexuality and teenage pregnancy is the expectation that it is women who assume responsibility for contraception and who deal with the inconvenience and possible side effects. There is some evidence that side effects contribute to contraception being used inconsistently (Davies *et al*, 2001; Luker, 1996). Davies *et al* (2001) point out that contraception use needs to be understood in relation to the quality of the methods available. Like the young women in my study, their cohort were not ignorant but 'experienced difficulty in finding methods that felt safe, were easy to use, did not diminish sexual pleasure, and did not generate uncomfortable side effects' (p89). Interestingly, while four of the five young women in my study who had been using contraception expressed dissatisfaction about aspects of the method they had used, none of them objected to the fact that it was left up to them.

There are other gender-based issues which remain largely unrecognised in stigmatised representations of adolescent sex and teenage pregnancy. Feminist research has highlighted a number of dilemmas and double-binds for young people, but particularly for girls, in relation to sexuality such as: different meanings attached to early sexual encounters by young women and young men (Holland *et al*, 2000); different socially prescribed ways of performing masculinity and femininity (Kehily, 2005); and gender-based power inequalities within relationships (Holland and Ramazanoglu, 2002).

These differences produce competing pressures and constraints on sexual encounters, and these affect the use of contraception. If a young

woman is prepared, she is viewed as unfeminine because she is not a passive recipient of sexual advances. If she does not prepare herself with contraception, and consequently conceives, she is viewed as stupid for not taking precautions. If she becomes pregnant and chooses not to terminate her pregnancy she is considered irresponsible or scheming. And across all scenarios, she is considered promiscuous. Luker (1996) captures these dilemmas nicely:

> ... the skills a young woman needs in order to use contraception effectively are precisely the skills that society discourages in "nice girls", who are expected to be passive, modest, shy, sexually inexperienced, and dedicated to the comfort of others (p148).

Kehily (2005) uses the metaphor of girls having to walk the tightrope of 'slags or drags' and emphasises that they are commonly seen and defined in terms of their sexuality. It is the lack of recognition of differences such as these that reinforce demeaning representations of female sexuality, particularly of the young.

Finally, denial, which is looked upon as a pathological response to pregnancy, could be recognised as a normal response. Indeed, denial is a common psychological defence mechanism. Models of the grieving process, for example, present denial as the first stage (Kubler-Ross, 1973). Within psychological literature this is understood as a normal way of rationalising an otherwise overwhelming situation and providing a temporary emotional buffer from the initial shock (Worden, 1995). Some LGBT people report experiencing denial in the initial stages of coming out (Vincent and Ballard, 1997). Both the teenagers who do not identify as heterosexual and the teenagers who become pregnant have to come to terms with being part of a socially stigmatised group and since parental support cannot be assumed, initial denial makes sense.

Youthful motherhood

Also unrecognised is that public scrutiny of teenage mothers creates a source of stress that is not experienced by older mothers, who are assumed to be naturally more skilled and capable parents. Age-related assumptions about neglectful and inadequate mothering impact on the thoughts, feelings and behaviour of young mothers, sometimes in ways that are detrimental or which further contribute to unhelpful assumptions. Neither the impact of stigmatising representations nor the weak

evidence on which they are based is recognised. Kelly (2000) challenges the association between teenage motherhood and a higher incidence of child abuse and neglect. She cites research which shows that the discrimination faced by teenage mothers causes stress and isolation and it is this rather than age that explains the correlations that have been found between teenage motherhood and child abuse and neglect.

Secondly, sometimes the actions taken by teenage mothers to disprove stereotypes come at a high cost. An example from my research is the young woman who went straight back into full-time education after her six-week post-natal check-up. When Clare started college, she continued with her job so she would not be on benefit, was the primary care-giver for her baby, lived independently and did the cooking, cleaning and shopping this entailed. She had to be very well organised about when different people looked after her son, when she did her grocery shopping and housework and when she studied. She later regretted returning to full-time education so soon and wondered if it might have been better for her son if she had delayed going back to college until the following term. Lisa, on the other hand, made a conscious decision to delay returning to education until her second child was one year old. She prioritised motherhood over education and thus risked being viewed as an irresponsible citizen for not being in EET.

Both young women were in the no-win situation faced by all teenage mothers in the UK. They risked being judged by some people as neglectful or irresponsible parents if they prioritised education or work – and by others, as irresponsible citizens if they prioritised their mothering role (Kidger, 2004). The government rhetoric about the importance of family and parenting appears to be inconsistent with the expectation for young mothers to be in EET.

Thirdly, the wider social and economic context is one that fails to recognise women as society's childbearers. When both men and women are expected to be economically active, motherhood becomes an inconvenience to be fitted around paid work. This creates tensions for those who wish to combine motherhood and employment (Lee and Gramotnev, 2006; Luker, 1996). As Kelly (2000) argued, 'today's economy does not easily accommodate women of any age who combine childbearing and paid work' (p60).

Curiously, older women who need fertility treatment are not demonised in the same way as teenage mothers are, and the increasing trend for these later-in-life births is not represented as a national epidemic. The fact that these pregnancies result from expensive, publicly funded medical interventions and that their babies are at greater risk of poor neo-natal and subsequent health and developmental outcomes related to multiple and premature births does not receive the same degree of negative public attention as do births to teenagers (Edin and Kefalas, 2005).

I use the phrase 'same degree of negative attention' intentionally because it seems that any woman who does not take the 'correct' path to motherhood comes under public scrutiny. Hadfield *et al*'s (2007) media analysis of motherhood identified three different groups of women who are publically stigmatised because of their motherhood choices: older mothers, many of whom need fertility treatment to conceive; teenage mothers, who are responsible for the next generation of underclass; and women who choose not to become mothers, who are selfish. All of these women step outside the accepted norms of motherhood. However, even a cursory analysis of media representations reveals that teenage mothers receive a disproportionate amount of this negative public attention. The unspoken difference is that many more teenage mothers than older mothers are financially dependent on the state, at least for a time. The Rational Economic Man assumptions implicit in policy means that there is no easy place for childbearing. This is an exclusively female dilemma.

The beneficial but unpaid domestic, caring, voluntary and community work undertaken primarily by women is also unrecognised. Devaluing this work through non-recognition means that valuable opportunities are missed to build positive identities as worthwhile citizens. Kidger (2004) touches on this in her analysis of a project that involved young mothers as peer educators. Based on the 'moral inclusion' they felt as a result of their involvement in the project, she argues for a broader conceptualisation of social inclusion that goes beyond the current policy focus on formal education, training or employment. Positive recognition of their volunteer work in schools seemed to work as an antidote to the shame that the young women in her study had internalised about

being young mothers. These contributions remain unrecognised and unvalued in a system that officially records these youngsters as NEET.

Finally, policy does not recognise that there are different perspectives on what constitutes a good mother. The young mothers and the professionals in my study spoke about the tensions that result when policy assumptions do not match lived realities. For some of the young women, the desire to be a stay-at-home mother did not sit easily with the expectation to be in EET. People's views on the relationship between paid work and motherhood vary considerably from one community to another and from one time to another. In some neighbourhoods, paid work and motherhood are seen as incompatible and people who do both are frowned upon (Edwards and Duncan, 1996). This may explain why the young mothers in Harris *et al*'s (2005) study were reluctant to put their babies into childcare. Other mothers in other communities see financial provision through employment as part of their moral responsibility towards their children. These class and value based differences are not recognised in the Rational Economic Man assumptions prevalent in current social policy (Alldred and David, 2007; Edwards and Duncan, 1996).

We have considered how pregnant teenagers and teenage mothers are recognised as different from their peers. They are recognised as too young to be sexually active, too young to respond appropriately when they become pregnant, and too young to be good mothers. They are also constructed as irresponsible for being 'mother' rather than 'career' focused. We have seen how this leaves a number of important influences on adolescent sexual behaviour and subsequent choices unrecognised, and that this lack of recognition creates additional stressors with which older mothers do not have to contend. The examples referred to show how stigmatised representations can themselves influence thoughts, feelings and behaviour in ways which stigmatise still further.

Table 2 summarises the combination of recognition and non-recognition of difference that played out in the young women's daily interactions in unhelpful ways. It shows how feeling negatively judged by teachers, health professionals, the public at large and sometimes also family members was a pervasive and everyday part of their lives. This

Unhelpful recognition	Underlying assumptions	Effects on young people	Unhelpful non-recognition
Youthful Sex	Developmental deviance or moral deficiency	Feelings of embarrassment and shame; hiding of sexual activity; access to contraception is impeded	Many young people are sexually active; social disapproval is concentrated on pregnant teenagers who are highly visible; a wide range of factors not just sexual knowledge, influence adolescent sexual activity
Youthful pregnancy	Results from ignorance, foolishness or deviance	Shame; denial and late confirmation of pregnancy; limited uptake of antenatal services	It is women who are expected to take responsibility for contraception; many contraceptives have unwanted side-effects; there are gender-based dilemmas and double binds for young women in relation to sexuality; denial of pregnancy is a rational response given stigmatised representations; women at the older end of the fertility spectrum are not demonised in the same way
Youthful motherhood	Signifies an irrational choice and/or social irresponsibility	Internalisation of shame; fear of public scrutiny	It is women who are society's childbearers

134

Unhelpful recognition	Underlying assumptions	Effects on young people	Unhelpful non-recognition
	Teenage mothers are too young to be 'good' mothers while older mothers are 'naturally' better	Undermining of confidence in mothering ability; limited uptake of public services such as mother and baby groups or childcare; reluctance to seek advice and support	Some women prioritise motherhood over participation in the labour market
			There are different beliefs about what constitutes a 'good mother' (ie a stay-at-home mother versus a 'working' mother)
	Motherhood does not constitute 'work'	Returning to education very soon after birth of baby to 'prove every-body wrong'	The unpaid domestic and voluntary work undertaken primarily by women is not socially valued
		The effects of stigma and the associated shame are not recognised yet they perpetuate negative stereotypes	

Table 2: Unhelpful recognition and non-recognition in dominant representations of teenage pregnancy and motherhood

was often conveyed through disrespectful treatment. The young women and professionals spoke about the intrusive questions asked by health professionals, the very direct and public comment of 'slappers' made to Rebecca, the less direct disapproving stares, sideways glances and comments whispered behind backs. There was insistence that a bus seat be vacated; derogatory comments about young mothers were broadcast on a popular local radio station; and there was heavy surveillance by social services. These very public interactions conveyed clear messages about their pregnant and mothering status. These were messages about being less worthy, respectful and deserving citizens. This is the wider social context within which schools operate.

Pre-pregnancy disaffection: good students and 'other' students

This section examines young women's educational experiences. In Chapter 4 we saw that disaffection from school arose well before pregnancy. The issues that were raised in relation to curriculum, teaching and learning, interpersonal relationships and institutional structures were not specific to teenage pregnancy or motherhood but reflect those of any disaffected pupil, boy or girl.

Unhelpful recognition of difference: 'other' students

Most of the young women in my research were implicitly recognised by their school as 'other' students rather than 'good' students. Unlike 'good' students, they did not bring certain knowledge, attitudes, interests and ways of being with them to school (McLeod and Yates, 2006; Thomson, 2002). They were invariably low achievers, their attendance was poor, some were non-compliant and many had difficult relationships with staff or peers. As 'other' students, they were recognised as disaffected, lacking in motivation, having the wrong attitudes or aspirations, and as being difficult, troubled or troublesome.

There is evidence in my research and in other studies that being recognised in these ways has a detrimental impact on students. Being thus recognised influenced the students' thoughts, feelings and behaviour towards school in ways that work against their learning and well-being. They have feelings of failure, of not being good enough and this undermines their confidence in their ability to succeed academically (Kellett

and Dar, 2007) and their belief that school might offer something positive (Horgan, 2007), so they are no longer interested in formal education (Archer and Yamashita, 2003). Consequently they act out, truant, and do not comply with school expectations and this behaviour is interpreted as proving their lack of motivation, ambition or ability – thus reinforcing notions of 'otherness'. Meanwhile, important factors that contribute to students being seen as 'other' remain unrecognised.

Unhelpful non-recognition of difference: socio-cultural factors

For present purposes I focus on the non-recognition of one particular difference; that of social class. The young women in my study were all recognised as 'other' because they did not conform to the unquestioned middle class expectations of the good student. Other scholars have also found this. The pregnant schoolgirls in Kelly's Canadian study were considered 'different from the unstated norm of mainstream schooling by virtue of being poor or working class or academically unprepared' (Kelly, 2000:6).

Research on the relationship between social class and educational achievement reveals high levels of disaffection among working class students (Cassen and Kingdon, 2007; Reay, 2006; Smithers, 2005; Walkerdine *et al*, 2001) and shows how a 'good' student identity is not equally available to all (McLeod and Yates, 2006; Thomson *et al*, 2005). Thomson's (2002) two semi-fictional characters whose virtual school-bags contain 'roughly equal but different knowledges, narratives and interests' illustrate how some student identities and ways of being are privileged while others become liabilities. Non-middle class orientations to education make it harder for some students to succeed.

Although some research shows otherwise, non-recognition of the impact of class on educational outcomes is enduring and powerful. Policy continues to attribute educational failure to personal shortcomings such as lack of motivation and aspiration. A pupil who does not succeed at school is seen as a 'feckless, parasitic individual who has failed to grasp the opportunities open to them' (Francis and Hey, 2009:227). Research with young people from deprived communities, however, seldom support the individual deficit assumptions that pervade policy. Rather it suggests that many young people have realistic aspirations

given their circumstances and are often doing the best they can with what is available (Finlay *et al*, 2010; St Clair and Benjamin, 2011).

Differences of ethnicity, race and gender also remain largely unrecognised within policy. Feminist analyses make it clear that understanding the poorer educational achievement of particular groups of boys and girls requires recognising the complex intersectionality of all these differences for girls (Epstein *et al*, 1998; Plummer, 2000; Reay, 2006).

Table 3 shows that recognising some students as 'other' is based on inaccurate and pathologising assumptions which fail to recognise the impact of broader cultural, social and economic inequalities on educational outcomes. This mix of recognition and non-recognition has a detrimental effect on young people's learning and well-being. Rather than attributing disaffection from school to individual deficits, it could be viewed as an unsurprising outcome in light of these less widely acknowledged influences on young people's educational outcomes.

	Underlying assumptions	Effects on young people	Issues left unrecognised in these representations
'Other' students	They do not value education	Feelings of failure, rejection, loss of confidence and motivation	The effects of class, gender and ethnicity on educational outcomes
	They lack motivation and aspiration		The normalisation of middle-class values
	They are troubled and troublesome	Truancy, non-compliance, disruptiveness, having 'an attitude'	The role played by schools in reinforcing meritocratic myths and individualised discourses
	They will not succeed academically and will achieve little in their lives	Disengagement from formal education	

Table 3: Pre-pregnancy disaffection and the unhelpful recognition and non-recognition of difference

Responding to the difference of teenage pregnancy and motherhood: schools

We have seen that school responses to a pregnant pupil varied greatly and ranged from blatant prejudice and a belief that a pregnant school-girl has no place in mainstream school, to a non-judgmental acceptance of pregnancy simply as one more difference to be accommodated. Analysing which differences a school recognised, or not, and whether this was helpful or otherwise to students, provides important insights into the sorts of practices that can help or hinder good educational outcomes.

Helpful non-recognition of difference

Four schools in my study adopted a stance of non-recognition towards a pregnant pupil and this supported educational continuity and well-being. Shae, for example, was encouraged to stay in mainstream school-ing despite being pregnant. By treating her pregnancy as irrelevant to her education, Shae's school conveyed a clear message that her educa-tion was important and that she still belonged in mainstream educa-tion. Interestingly, this message was conveyed even when Shae began attending the pupil referral unit late in her pregnancy and was therefore no longer physically present in her school – highlighting that belonging or not belonging is not simply a matter of physical location. Neither her difference as a pregnant pupil nor her difference as a pupil who was educated off-site were recognised in ways that prevented her feeling part of her school. The regular contact, clear communication about coursework, and her return to school for examinations and the school prom all exemplify a helpful non-recognition of the difference of teen-age pregnancy and supported her status as a valued school member.

This was also the case for Rebecca and Mia throughout their preg-nancies, and for Libby upon her return to school as a young mother. Being treated no differently from their non-pregnant and mothering classmates was helpful. Although pregnant or a mother, they were ex-pected to continue their education, attend regularly, complete necessary coursework and sit their examinations. Libby's absences, for example, were followed up by a phone-call from the school, just as they were for any other pupil. This was sometimes a source of stress but it also con-veyed that the school cared about her education and had high expecta-tions of her.

Helpful recognition of difference

Other differences were recognised. These schools responded to the physical changes of pregnancy and health and safety concerns through simple accommodations such as flexibility over their movement around the school, seating arrangements, uniform requirements and access to toilet facilities. Sadly, not all pregnant pupils are offered these reasonable, common sense accommodations (Alldred and David, 2007; Harris *et al*, 2005). There were other examples of flexibility. Mia received home tuition late in her pregnancy; her tiredness and physical discomfort were recognised. Libby continued her education part-time when she returned to school as a young mother, in recognition of the additional responsibilities and demands of motherhood. These accommodations, based on recognising specific ways in which these pupils were different from their non-pregnant or mothering classmates, engendered positive attitudes towards school and promoted educational continuity and achievement.

Table 4 summarises the range of responses the young women spoke of and the messages that were conveyed through these actions. Some involved equal treatment while others involved different treatment but all were helpful.

Unhelpful non-recognition of difference

Even in these largely inclusive schools, there were examples of unhelpful non-recognition of difference. Rebecca, Shae and Mia all wanted to be treated the same as their non-pregnant classmates, and valued such treatment when they received it, but they sometimes found non-recognition unhelpful. They felt a tension between wanting to be treated the same and also differently from their classmates. Shae encapsulated this: 'They didn't really treat me any different. That's what I liked. But it was hard some days'. Ignoring fluctuating energy levels and emotional sensitivities associated with pregnancy were aspects of school that the students found difficult, and Mia would have liked an occasional inquiry about her well-being.

Treating pregnant pupils the same as their classmates was based on a view that school is for education, regardless of being pregnant. Shae expressed this as, 'any problems and they just see it like you shouldn't be pregnant anyway'. In many respects such non-recognition was helpful

Helpful non-recognition	Message conveyed/assumption made
Encouragement to stay in mainstream despite pregnancy	Pregnancy is irrelevant; you still belong here
Access to the same curriculum as other pupils	Pregnancy is irrelevant; completing your education is still important
The same coursework expectations as other pupils	Pregnancy is irrelevant; you are still capable of completing your education
A phone-call home after more than one day of absence – just like any other pupil	Pregnancy is irrelevant; we expect all our students to attend regularly
Helpful recognition	
Arrangements to move between classes a few minutes early to avoid the crowds	We recognise that you have to take care moving around the school
Provision of a toilet pass	We recognise your need to use the toilet more frequently
Modified school uniform requirements	We recognise that you will outgrow your school uniform
Home tuition provided in latter stages of pregnancy	We recognise your tiredness and physical discomfort but want you to continue your education
Part-time timetable arrangements for a school-aged mother	We recognise that you have other responsibilities as well as school
Extra help from a teacher after an absence	Your education is important and we expect all our students to succeed

Table 4: Helpful recognition and non-recognition of the difference of teenage pregnancy and motherhood in mainstream schools

in supporting the young women's education and well-being but in other respects it was not. There is no simple solution to this dilemma but one response that students found helpful was being consulted about what they did or did not need, and being given some control over what happened and when. Shae for example, appreciated being able to move between classes a few minutes before the other students. Rebecca, on the other hand, chose to move between classes with her friends.

Unhelpful recognition of difference

Unlike the schools Shae, Mia, Rebecca and Libby went to, other schools responded to pregnancy or motherhood as a difference that could not, or should not, be accommodated within mainstream education. Removing pupils off site and out of sight was justified using health and safety concerns or views that their needs would be better met elsewhere. Comments such as 'we can't have you in school while you are pregnant' convey a strong message that there is no place in school for a pregnant pupil.

Teachers ignored requests for help with schoolwork or non-completion of coursework, thus conveying an indifference to a pupil's achievements and an assumption that a pregnant pupil's education is no longer important. A complete lack of process or of any genuine input into the processes to which they were subjected, made the young women feel they no longer counted. Aimee, for example, thought that she had no choice other than to go to the pupil referral unit. Her school recognised her pregnancy as a difference that could not be accommodated in school. The disparaging comments directed at Rebecca and Clare, and the less obvious slurs directed at other students, further exemplify a stigmatised and thus unhelpful recognition of the difference of teenage pregnancy.

The effects on young women of these different recognitions

The pattern of recognition and non-recognition influenced students' thoughts, feelings and behaviour. The negative teacher attitudes, lack of encouragement and the lack of formal process experienced by some students reinforced feelings of shame and exacerbated feelings of alienation, thus demotivating them. This sometimes led to self-exclusion and non-completion of work, which in turn reinforced assumptions by the school that a pregnant pupil was an educational lost cause. Students in

Unhelpful recognition	Message conveyed/assumption made
'We can't have you in school whilst you are pregnant' comment	You do not belong here anymore
Lack of process when pregnancy revealed to school – no meeting, no discussion, no follow-up of absences	We do not deal with pregnant pupils
Requests for help with schoolwork ignored by teacher	Your education is no longer important
Non-completion of coursework ignored by teacher	Your education is no longer important
Work not provided to the home tutor	Your education is no longer important
Disparaging comments made behind students' backs but in front of other staff and students	You are no longer worthy of our respect
'Slappers like you don't belong in this school' comment	You are morally contagious and other students need protection from you
Unhelpful non-recognition	
Ignoring fluctuations in energy levels or emotional sensitivities	It is your fault getting pregnant so do not expect special treatment
Lack of flexibility with regard to coursework deadlines	It is your fault getting pregnant so do not expect special treatment

Table 5: The unhelpful recognition and non-recognition of the difference of teenage pregnancy and motherhood in mainstream schools

143

other schools were treated in more respectful ways and encouraged to stay in school, conveying a belief that these young women could continue their education *and* be a teenage mother. These expectations were reinforced by a range of practical, common-sense accommodations. The inclusive schools supported these students' motivation and achievement by recognising some differences in non-stigmatising ways and ignoring others. This differentiated recognition of difference was largely successful in dealing with the dilemma of difference.

Responding to the difference of teenage pregnancy and motherhood: the specialist educational alternatives

The students who attended the educational alternatives all spoke highly of them and identified factors that enhanced their academic achievement or enabled them to re-engage in education. Just like staff in the inclusive schools, staff in these programmes supported students' learning and well-being by adopting a differentiated recognition of difference.

Helpful non-recognition of difference

A non-stigmatising recognition of the difference of teenage pregnancy and motherhood was integral to the young women's positive experiences in these centres. Staff were non-judgmental about how students became pregnant and about their decision to continue with their pregnancy at their age. This contrasted with the negative responses they received from schools, medical professionals and the general public. Spending time with other young women who had similar experiences of stigma and oppression was equally important and seemed to work as an antidote to the shaming and shameful ways they had been treated in other contexts. Staff in these institutions made it clear that they expected students to attend regularly, undertake formal qualifications and progress to further education or employment – and were capable of doing so, even when pregnant or a teenage mother.

Helpful recognition of difference

Staff in these institutions responded flexibly to differences related to the embodied nature of pregnancy or the additional responsibilities of motherhood. The students had unquestioned access to toilet facilities, and Phoenix provided a small restroom with a couch for pupils who

Helpful non-recognition	Message conveyed/assumptions made
Encouragement to continue/ re-engage in education by attending one of these alternatives	You are pregnant/a teenage mother but you can still continue with your education
Expectation of regular attendance and follow up if this does not occur	You are pregnant/a teenage mother but regular attendance is also important
Expectation to undertake formal qualifications	Your education is important and you are capable of succeeding academically
Expectation that students will progress on to a formal college course or employment	You are a young mum but you can still do other things as well
Expectation that students can make mature and responsible decisions for themselves	It is your life and we know that you are capable of looking after yourself and your child

Table 6: The helpful non-recognition of the difference of teenage pregnancy and motherhood in the educational alternatives

needed a short break during the day. Stepping Stones recognised the need to use a toilet more frequently when pregnant and Phoenix recognised the additional tiredness and physical discomfort of being heavily pregnant. Its on-site nursery made it easier for the young mothers who might have been reluctant about it, to leave their baby with someone they did not know. Staff at Stepping Stones encouraged regular attendance but also accepted occasional non-attendance or late arrival when the responsibilities of motherhood had meant a sleepless night or when other engagements, such as medical appointments, were needed. By recognising these differences in non-stigmatising ways, the professionals supported the young women's education and conveyed the respect and care that had been absent in their schooling experiences.

Staff also recognised differences that were unrelated to being pregnant in non-stigmatising ways and these, too, contrasted with young women's

schooling experiences. All three specialist alternatives had a low teacher-to-student ratio and provided flexible, tailored programmes of learning and additional academic support for those who needed it. These learning environments were also characterised by closer, less formal and more trusting relationships with staff than the schools had done. As Table 7 shows, the messages conveyed through these arrangements conveyed: 'we recognise that past educational experiences may not have been positive', 'we recognise that some of you may have learning gaps or need additional support with your learning' and 'we recognise that not all students learn and progress at the same pace'. Academic success and progression for all students were implicitly assumed.

As was the case in the inclusive mainstream schools, non-stigmatising forms of recognition and non-recognition increased the students' educational confidence and motivation. It is little wonder that they believed they achieved more in these alternative education settings than they would have if they had stayed at school.

Helpful recognition	Message conveyed/assumptions made
Provision of an on-site nursery (Phoenix)	Being able to see your child during the day may make it easier for you to stay in school
Small restroom with couch available for short breaks (Phoenix)	We recognise that some days you will be more tired and uncomfortable because you are pregnant
On-site visits from midwives, health visitor, school nurse and Connexions adviser (Phoenix)	Access to these professionals is important and it is easier and less disruptive to your education if they come to the PRU
Ready access to toilet facilities	We recognise that your pregnancy means you need to use the toilet more frequently
A curriculum which included content that was directly related	We recognise your current or imminent status as mothers and

Helpful recognition	Message conveyed/assumptions made
to pregnancy and motherhood (Phoenix, YMTB)	wish to support you in this
Small group teaching, access to a differentiated curriculum, additional learning support	We recognise that you may have gaps in your learning and that you may feel unsure about your ability to succeed academically
Flexible, individually tailored programmes	We recognise that class members have different interests, needs, starting points and rates of progression
Flexibility in relation to attendance, pace of achievement and progression	We recognise that the demands of motherhood mean that it may take you longer to achieve the same outcomes as non-parenting students
Group discussions about teenage motherhood (Stepping Stones)	We recognise that not all representations of teenage motherhood are accurate or fair
Encouragement to use the centre's computer, phone, fax, printer and internet to support EET applications	We recognise that you are financially stretched and not everyone has access to these facilities at home
Close and trusting relationships with staff and an educational environment that is emotionally and academically supportive	We recognise that past educational experiences may not have been positive but here it is different
	We care about you and are interested in all aspects of your life
	You are capable of succeeding academically

Table 7: The helpful recognition of the difference of teenage pregnancy and motherhood in the educational alternatives

Unhelpful recognition of difference

The young women's accounts also revealed examples of unhelpful re-cognition of difference. The parenting advice students received from staff and visiting professionals at Phoenix and Young Mums To Be was not always appreciated. Although students valued curriculum content about pregnancy and motherhood which would not have been pro-vided in their mainstream schools, some of the young women found it patronising. This further illustrates the dilemma of difference and the difficulties inherent in providing both special and equal treatment. The message some of the young women internalised through parenting advice was 'you are too young to be a good mother'. This was not speci-fic to Phoenix; Tracy pointed out that all adults in her life assumed that parenting advice was needed. At the same time, experiences of stigma and the desire expressed by many of the young women to 'prove every-one wrong' made it difficult for them to seek support or request help when they needed it.

One way of dealing with this dilemma is to encourage more equal power relationships by giving young people more say about what they are offered and in what form. Research shows that young people want and value the pastoral as well as the learning support that is typically offered in educational alternatives (Vincent *et al*, 2007). But it is the nature of the support that determines how it is perceived; young people want to be cared for but not in an adult-child way (Pomeroy, 2000). The teenage pregnancy midwives achieved this by conveying assumptions of competence, and staff at Stepping Stones gave the young women res-ponsibility for the supports that were put in place. Adults who work with teenage mothers can help reduce the pressure some of them feel to 'prove themselves' in ways that exclude seeking support by recognis-ing the difference of teenage pregnancy in non-stigmatising ways, con-veying assumptions of competence, and giving young women more say about what they need and want.

Unhelpful non-recognition of difference

There were other differences that remained largely unrecognised by these institutions yet have a detrimental impact on pregnant and mothering teenagers. By taking an uncritical view of the relationship be-tween educational qualifications and future employment, all three

institutions reinforced rather than challenged the policy assumption that qualifications are the route to social and economic salvation and that motherhood on its own is not a real or valued occupation. This view fails to recognise the intertwined and deeply rooted connections between gender, class, race, educational outcomes and subsequent employment and income. The hairdressing, beauty therapy and social care courses the young women took or planned to take were unmistakably gendered and the OCNs and NVQs they acquired will facilitate access to further education, but not higher education. Both outcomes will lead the young women toward low paying, insecure employment with limited opportunities for progression. Lisa could not have been clearer in her statement about her choice of hairdressing: 'I mean, I would like to do other stuff, but like that's all I know really'.

The failure to recognise these broader social differences means that large social problems are presented as individual ones. If these young women have to struggle to provide adequately for themselves and their children in the future, it will be attributed to their own poor choices or lack of motivation or ambition. No recognition will be given to the host of social structural inequalities that constrained and shaped those choices. The gendered career trajectories of the young mothers in her research led Kelly (2000) to observe: 'Nobody puzzled over the institutional barriers that prevented women from entering certain occupations or discussed collective (versus individual) strategies that might overcome these barriers' (p142).

Other commentators have taken up this issue. American researchers Lesko (1990) and Pillow (2004) acknowledge the positive aspects of the special provision made for the pregnant teenagers in their studies but highlight some important limitations. The aim of these programmes was to help pregnant and mothering schoolgirls be responsible, good mothers and to strive for self-sufficiency through completing their education. As Lesko noted, there was no discussion, however, of the disparity between men's and women's wages, or guidance on helping girls to consider non-traditional occupations with better salaries, or discussion of the gendered inequalities in romantic relationships or the division of labour in the home. So rather than create opportunities to question their status as a public problem, the schools helped students

to fit unquestioningly into a society which oppressed them by virtue of their gender, class and race, as well as their youthful motherhood.

The on-going impact of class and gender on educational and employment outcomes has been the focus of extensive sociological research. It shows that gendered subject choices continue to determine subsequent labour force participation (David *et al*, 2000; Tinklin *et al*, 2005) and that despite more women entering paid employment, they still experience inequality in terms of positions of responsibility, status and pay (Leathwood, 2006; Walkerdine *et al*, 2001). My research confirms Leathwood's (2006) finding that although women now achieve more NVQs than men, these are mostly in hairdressing and other traditional low-paid women's work. Other research shows that the on-going concerns about the underachievement of boys masks the underachievement of working class girls (Collins *et al*, 2000; Epstein *et al*, 1998; Reay, 2006).

Walkerdine *et al*'s (2001) oft cited psychosocial analysis of 'growing up girl' adds an additional layer of complexity to our understanding of the interface between class, gender and educational trajectories. They reject explanations of high teenage pregnancy rates among working class girls as simply a rational choice in the absence of other career ambitions. Instead, they attribute the decisions made by the high achieving working class girls in their research to continue with their pregnancy to the psychosocial costs that a shift to the unfamiliar and uncomfortable territory of higher education involves. This is not the case for middle class girls, who are expected and encouraged from a young age to progress to higher education. There seems little doubt that issues of class, gender and race continue to shape the choices and possibilities that are open to young people (Nayak and Kehily, 2008), yet these differences remain largely unrecognised. Stepping Stones broached wider social issues to some extent, but the non-recognition of class and gender at Phoenix and YMTB meant that they continued to perform the same normalising function as the young women's schools, supporting meritocratic myths that locate success or failure entirely within the individual.

Staff at Stepping Stones drew attention to another unrecognised difference when they spoke, with some frustration, about how they were audited. Pregnant teenagers will inevitably need some time out of edu-

cation late in their pregnancies and immediately after birth – and as shown in Libby's case, full-time education may not be appropriate or desired by a student who is also caring for a baby. Completing qualifications and progressing to further education or employment will therefore take longer for these young women than for those who are not mothers. Policy that recognised this would evaluate the success of programmes such as Stepping Stones over a longer time-frame and use more flexible criteria than immediate progression to EET. It would also recognise other outcomes such as increased personal and academic confidence, without which progression to EET would be highly unlikely anyway.

Unhelpful recognition	Message conveyed
Continual advice about pregnancy/ mothering from staff and visiting professionals (PRU)	You are too young to be a good parent (this may undermine confidence)
Unhelpful non-recognition	
An uncritical and primary focus on educational qualifications and future employment	Qualifications and employment are your route to social and economic salvation Motherhood, on its own is not a real or valued occupation

Table 8: The unhelpful recognition and non-recognition of the difference of teenage pregnancy and motherhood in the educational alternatives

The recognition and non-recognition of difference: implications

So how might schools increase the responses in the left hand side of the grid and decrease those on the right? Several points may be taken from my work.

	Helpful	Unhelpful
Recognition of difference		
Non-recognition of difference		

All three educational alternatives and the schools which practiced helpful non-recognition of difference took a non-stigmatising view of teenage pregnancy and motherhood. Students were seen firstly as students and only secondly as pregnant and mothering teenagers. In addition, assumptions were made about educational continuity and progression irrespective of pregnancy or motherhood and students were treated as valued and respected members of their institutions. A rejection of dominant stigmatising discourses underpinned this helpful non-recognition of teenage pregnancy and motherhood.

These institutions also demonstrated helpful recognition of difference. Sensible, practical accommodations were made to pregnancy or motherhood, such as ready access to toilet facilities, flexibility over uniform, reduced curriculum expectations and support with childcare. The difference of teenage pregnancy or motherhood was viewed simply as one more difference to be accommodated. Such simple actions, based on a non-stigmatising recognition of difference, partially fulfil the somewhat vague policy wording that schools and local authorities provide a 'suitable' education. They should be happening in all educational institutions but this was not the case in some schools, as my research showed.

The educational alternatives recognised additional differences in ways that were slight or non-existent in the young women's mainstream schooling experience. All three educational alternatives offered flexible and individually tailored programmes characterised by more small-group work, a greater range of teaching and learning strategies, and ready access to additional learning support. Differences resulting from learning gaps, learning styles and pace of progression were recognised in non-stigmatising ways and students were assumed to be able to achieve. The institutions provided safe and welcoming environments where students clearly felt wanted and valued. It seems likely that this combination of features contributed to the more satisfying relationships between staff and students that the students reported.

Although such qualities are harder to provide within the systemic constraints of mainstream schooling, the evidence from my research suggests that some accommodation is possible. Exactly what makes the difference for a pupil is not easy to identify. The support that Shae felt from staff in her school provided a sense of belonging that continued

even after she began attending the PRU late in her pregnancy. This highlights that educational inclusion is not defined by a pupil's physical location. Good relationships with caring professionals who were committed to inclusive education appeared to be important.

The young women's experiences of pregnancy, motherhood and education were made more difficult because certain differences were recognised while others were not. This shaped their thoughts, feelings and behaviour in ways which contributed to stigmatising discourses and were not conducive to their well-being. My analysis shows that the differences that were recognised in unhelpful ways were linked to youthfulness while those related to gender, class and sexuality went largely unrecognised. But some professionals adopted a pattern of recognition and non-recognition of difference whereby the young women were supported. Pregnant and mothering teenagers will have affirming experiences only when recognition is appropriately targeted. Differences need to be recognised in non-stigmatising ways and greater attention needs to be paid to differences resulting from gender and class.

7

Inclusive policy and practice:
moving forward

This book offers a glimpse into the lives of fourteen adolescents who became mothers when they were expected still to be in school. It has aimed to deepen understandings about their educational experiences, their perspectives on their own lives, and how they position themselves and negotiate the social context in which they find themselves. I used the concept of difference as a central analytic theme to explore how the difference of teenage pregnancy is represented within policy, how it is responded to by institutions and the individuals within them, and with what effect.

I was struck by young women's experiences of stigma, double standards and double-binds and by the way so much remained unrecognised and shrouded in silence. The shock and denial associated with realising pregnancy; the dilemmas of abortion versus motherhood at their age; the silence and stigma surrounding adolescent, particularly female adolescent sexual desire and pleasure; and the sexual double-standards in relation to both sexual activity and contraception all featured in their stories, yet are largely absent from popular conceptualisations of teenage pregnancy. The gendered and classed influences on their educational outcomes and career choices remain largely unrecognised. It was made impossible for some young women to be both a 'good mother' and a 'good citizen'.

The prevailing non-recognition of vital matters means, firstly, that false stereotypes are rarely questioned and, secondly, that the role played by social-structural factors with regard to teenage conception, school and college subject choices, and their future employment are rarely acknowledged. This book has highlighted the less visible and less talked about aspects of young women's experiences and tried to show the complex, multi-dimensional and situated nature of their lives. This is important not just because such accounts are largely missing but also because they challenge the dominant stigmatising discourses. These young women's stories break silences and expose the dominant views about intentionality, fecklessness and ignorance to be wrong.

In this concluding chapter I return to some of the issues raised by my work to highlight how they develop what is already known and understood about teenage pregnancy, motherhood and education and consider the implications for policy and practice. We saw that the assumptions upon which policy is based are questionable; that the stigmatising representations of pregnant teenagers and teenage mothers are unhelpful; and that policy regarding the education of pregnant and mothering schoolgirls is not reflected in practice. The young women's views and experiences gainsay the assumptions underpinning policy and the stigmatised representations of teenage motherhood within it.

Policy and difference of teenage pregnancy

Policy is well-intentioned and has some useful aspects. It is right to promote and encourage educational continuity. The requirement that schools and local authorities provide a 'suitable' education, and that health and safety issues are not to be used as a reason for exclusion from school, is a useful basis for inclusive practice. Similarly, assistance with childcare through the Care To Learn initiative is a tangible, practical way of supporting educational continuity. The young women in my research could not have stayed in education without this funding. However, the limitations of policy have undesirable consequences for the young women concerned.

Unfounded assumptions

Policy that is based on what are unfounded assumptions is unlikely to meet policy aims effectively. This may partially explain why the Teenage

Pregnancy Strategy failed in its aims to halve teenage conception rates and increase the number of young mothers participating in EET to 60 per cent. My focus on difference helps sheds light on what differences have to be recognised if policy is to be more effective.

Research, my own included, does not support the view that teenage pregnancies result primarily from ignorance and that better SRE is therefore a realistic solution to high teenage conception rates. It is clear that a wide range of factors influence adolescent sexual behaviour. Competing risks, different meanings attached to sexual encounters, gender-based power dynamics within relationships, and gender in-equalities such as responsibility for contraception falling primarily on women are all significant. A more positive and accepting recognition of adolescent sexuality generally, and of gender-based differences would contribute to less stigmatising representations of adolescent sexuality and of the adolescents who have babies.

The policy focus on education as the solution to social exclusion is also questionable. My research suggests that the disaffection with school of some students is directly related to the poor educational outcomes noted in research about pregnant teenagers. Many have been recognised within their schools as 'other' rather than 'good' students. As scholarly critiques reveal, neo-liberal discourses that focus on internally located concepts such as aspiration and motivation (Bullen *et al*, 2000; Francis and Hey, 2009), or on narrowly defined concepts such as social inclusion (Gillies, 2007; Lister, 2001), or which use gender-neutral terms such as 'parenting' (David, 2003) neglect broader issues of inequality and the relationship between 'good' students and a host of other differences.

The findings from my research confirm that there needs to be greater recognition of the relationship between class and educational out-comes. Discourses about aspiration marginalise and alienate certain pupils from an education system that is represented within policy as the solution to poverty and social inequality. My work supports the analyses of those who argue that the relationship between teenage motherhood and education needs to be understood in relation to the wider contexts of gender and class (Alldred and David, 2007) and this demands better understanding of different meanings and values attached to mother-hood and to particular ways of being a mother.

Stigmatised representations

Teenage pregnancy is represented in pervasive and powerfully stig-matising ways as a social and health problem that is costly to both the individual and the state. The individualised, pathologised discourses render alternative understandings and social structural inequalities all but invisible.

The young women's experiences of pregnancy, motherhood and edu-cation were made difficult by their stigmatisation, more than by their pregnancy or motherhood. Policy which purports to support pregnant and mothering teenagers but which is based on unfounded assump-tions and which ignores the ways in which class, gender and race shape. choices and possibilities, effectively reinforces negative stereotypes. Stigmatised representations work against policy intent and contribute to the negative outcomes associated with teenage pregnancy. Pregnant and mothering teenagers would be better supported if the stigma were lifted and the needs of girls and women properly addressed. The classed and gendered influences in the lives of young women have to be recog-nised. A differentiated recognition of difference and the analytic frame-work developed in the previous chapter present different understand-ings about teenage motherhood.

A differentiated recognition of difference would broaden conceptua-lisations of social inclusion to include those who are not economically active but who contribute to society through their mothering, caring and domestic work (recognition of unpaid labour, gender inequalities and mothering responsibilities). It would broaden the concept of social exclusion to include those who are economically active but face finan-cial difficulties due to low wages, part-time work or under-employment (recognition of labour market inequalities). Many young women fall into both categories because of their care-giving responsibilities and career choices.

Policy makers need to recognise the different life choices and values placed on motherhood and the timing of motherhood in non-stigma-tising ways, and to reconsider the implications for educational con-tinuity. Instead of putting pressure on young mothers who wish to care for their own children to take up training or employment opportunities immediately, they could improve young mothers' employment pros-

pects by supporting education and training opportunities for those who wish to return to study in their early twenties (recognition of mothering responsibilities and the tensions created by competing roles).

Policy formation should actively involve young women in decision-making that affects them and take heed of their choices. The young women in my research talked about trying to decide where to continue their education (viable alternatives, including those such as Pheonix therefore need to be maintained); when to return to education after having their baby (this might be longer or shorter than the six weeks after giving birth currently specified in policy for those of compulsory school age); which qualifications they would like to pursue (both academic and vocational routes need to be available); and whether they continue their education on a full-time or part-time basis.

Schools and the difference of teenage pregnancy

A key finding emerging from young women's mainstream school experiences was the mismatch between policy and practice and the unwillingness of some schools to support a pregnant pupil to remain in mainstream education. Policy requires all schools to respond positively and flexibly to accommodate and include a pregnant schoolgirl but the experiences of the young women in my research clearly showed otherwise.

Some schools excluded a pupil by making dubious claims on grounds of health and safety or insisting that 'her needs are better met elsewhere'. They justified the exclusion by highlighting the ways in which a pregnant pupil was different from her peers, while ignoring the ways in which she was similar.

However, other schools adopted a differentiated recognition of difference, recognising some differences while disregarding others. They took a pragmatic approach of 'treat them the same' and 'treat them differently'. They were flexible about school uniform, movement around the school, seating arrangements, access to toilet facilities, part-time study and additional support with learning. But they also conveyed non-recognition of difference through holding the same expectations of pregnant pupils to continue their education, attend school regularly and complete their course work. This seemed to work well for the pupils.

The underlying beliefs and assumptions that a pregnant pupil did still belong in school, wanted to achieve educationally and was capable of doing so that the schools conveyed by their actions were helpful. The implicit messages made the young women feel cared about and valued as members of their schools and motivated them to achieve. So the non-recognition of some differences alongside the recognition of others mediated an inclusive experience; the adoption of a differentiated recognition of difference dealt constructively with the dilemma of difference.

From policy to practice

My research showed that instances of inclusive practice were due to the caring responses by individual teachers rather than to management-led implementation of school policy. If Shae had attended her neighbouring school she might have been less fortunate. Her head-of-year was instrumental in convincing the staff and Shae herself that pregnancy did not necessarily mean the end of a pupil's mainstream education. Similarly it was Rebecca's head-of-year who advocated to school management on her behalf although Rebecca had to manage some awkward situations because the school did not have a clear policy on how to respond to a pupil pregnancy but merely supported the principle of inclusion. In her school, Libby received additional support when she missed classes from one teacher but none from her other two subject teachers.

The support a pregnant pupil receives should not depend on which school she attends or which teachers she has. Schools should have a staff-developed policy that specifies how the difference of teenage pregnancy and motherhood will be responded to. All staff would then know what is expected of them and individual teachers would not be obliged to advocate on behalf of a pregnant pupil. Many local authorities offer sensible advice on such policy and the sorts of inclusive strategies reported in this book (see for example Cambridgeshire County Council, 2011).

Importantly though, policy on its own is unlikely to be enough. Bhopal's (2011) research on teacher attitudes towards Gypsy and Traveller pupils showed even in schools that had an inclusive ethos and followed 'good practice', policy had little impact on some of the teachers who con-

tinued to display negative attitudes towards these pupils. She makes the point that inclusive practice is best supported when all the members of staff adopt principles of inclusion. The schools in her research were helped to become more inclusive by staff from the Traveller Education Service. The schools came to understand and appreciate Gypsy and Traveller culture in new ways – once they were made aware of the unhelpful nature of their recognition and non-recognition of difference.

Bhopal's work highlights the value of staff development activities that challenge deeply rooted and stigmatising views about certain pupils and this would be equally true for pregnant and mothering teenagers. The assumptions about youthful pregnancy being a disaster or caused by irresponsible or irrational choices make no allowance for the possible reasons for the decisions taken. The view that young mothers are too immature to care for their children should be challenged. Attention should be drawn to the gender and class-related factors that influence young people's educational trajectories, sexual activity, views about motherhood and career choices. Creating opportunities for teachers to analyse their own long established beliefs and to consider these differences can move them to less stigmatising understandings about pregnant teenagers and more accepting attitudes towards those who remain in their schools or return to them, thus facilitating educational continuity.

At Stepping Stones some of these issues were discussed in the educational programmes, so they were recognised by the pregnant students themselves. Students can be encouraged to critique their own assumptions about the gendered division of childcare and domestic labour, about gender inequalities in the labour market, and about their status as a public problem. They can be encouraged to consider non-traditional courses of study and occupations and to recognise the value of the unpaid contribution they make to society by caregiving and other domestic work. Developing such understandings might reduce the feelings of shame and the stigma of being a young mother and help develop positive and respected identities instead.

SRE and difference

Policy places emphasis on improving SRE and sexual health services. Young women in my study viewed SRE as important but their personal experiences had, on the whole, been unsatisfying. They suggested how

SRE could be improved to meet their needs by providing a balance between knowledge and skills in the curriculum, more group work and discussions, and greater emphasis on the emotional aspects of relationships. They recommended that SRE be delivered by people who know the subject and are comfortable working with young people. I would add that activities in SRE should also promote greater recognition of gender differences and gender-based inequalities in relationships.

Lessons on contraception should progress from talking about what is available and their relative merits and disadvantages, to discussing the factors that influence the use or non-use of certain contraceptives in particular situations. A lesson on the practicalities of using a condom could also explore the pupils' feelings about a girl carrying condoms, for example, and the different meanings attached to either males or females who are prepared with contraceptives. The gender differences involved in heterosexual encounters should be discussed, along with the communication skills and assertiveness that can develop more empowering relationships between young people. SRE is represented as primarily about sexual health but should incorporate the concepts of desire and pleasure.

Educational alternatives and the difference of teenage pregnancy and motherhood

The existence of alternative provision such as Phoenix and Stepping Stones rubs against the grain of inclusive education. They remind us that schools do not work well enough for every pupil and that our educational institutions have a long way to go before they become inclusive. But at the same time they remind us that there is more than one way of educating and including. Until all schools become more inclusive it is wise to maintain alternatives such as those described in this book.

The young women were all enthusiastic about the alternative provision they had attended, and identified which of this provision had re-engaged or motivated them in their education. Much of what they said applies to disaffected students generally and reinforces findings from other research about the importance of respectful relationships, a flexible, tailored curriculum, greater academic support and an emotionally and physically safe environment within which students feel valued and cared for.

The programmes and processes (see Chapter 5) of these educational alternatives helped to build the students' academic confidence and achievement. This was particularly important for those who had left school with few formal academic qualifications or who felt they had failed. The alternative settings provided supportive, nurturing environments for the students and appeared to help them rebuild their moral integrity. Their early pregnancies and motherhood were wholly accepted, with no stigma attached. Stepping Stones held discussions about stereotypes, and all three settings helped the young women to shape their identities and feel better about themselves. The shame some had internalised about becoming pregnant as teenagers diminished and their expectations rose about what else they might achieve in their life along with motherhood.

There are lessons for mainstream schools. They need to recognise the many ways in which students are marginalised and what might prevent students becoming alienated. Widening participation goes beyond the easily measured formal credentials such as NVQs, OCNs or GCSEs. As shown in Chapter 5, less tangible outcomes such as improved personal confidence, identity and expectations are important steps towards educational achievement

Pregnancy will inevitably necessitate some time out of education so the longer time it will take to reach particular educational milestones should be factored into evaluations of the programme's success and its funding arrangements. A differentiated recognition of difference is needed about how such alternatives are judged. Post-secondary providers such as Stepping Stones need to be more appropriately and flexibly audited.

Other differences and inclusive education

The research presented in this book has focused on those who become pregnant while still at school but the findings and analysis speak also to those with a general interest in inclusive schooling. Parallels may be drawn between institutional responses to pupils who become pregnant and pupils with other differences. Those who do not fit, for whatever reason, are seen as not belonging and are effectively excluded from mainstream education in one way or another. Exclusion is justified on grounds that certain individuals have needs which are better met outside the mainstream system. In this scenario, the schools are seldom

asked what they could do to become more inclusive places; difference is managed by fitting the student to the school or sending them elsewhere. Little thought is given to changing institutional structures or systems to accommodate difference and individual deficit discourses are used to define those who do not fit as being a troubled or troublesome 'other'.

There is another way. If conceptualisations about who is the same and who is different are broadened, it would be recognised that many pupils would benefit from greater flexibility in what is offered educationally, variations in and questions of how, when and where education is offered would develop. Importantly, it would be understood that what is most helpful for one pupil might not be most helpful for another. Sonia wanted to be able to do the GCSEs she missed through her disrupted schooling at Stepping Stones, but the options were not available, whereas other students wanted to undertake vocationally orientated qualifications. So better outcomes will be promoted if students are offered viable alternatives of equal value and given access to a range of curricula, qualifications and support. The student and school should share responsibility for planning responses to difference through a transparent and agreed process. Inclusion is not primarily about physical location or even the amount of time spent in school. Rather, it encompasses a broad set of criteria about student choice, participation, feeling valued and having a sense of belonging within an educational community.

Throughout the book I have drawn attention to the dilemma of difference and the perennial question of whether justice is best served by responding to pupil difference with equal treatment or different treatment. The young women revealed in their accounts their desire to be treated both the same and differently. This may appear to be contradictory but a differentiated recognition of difference goes some way to resolving the dilemma of difference. What matters is which differences to recognise and in what ways. Moving from an *either/or* response to the dilemma of difference towards a *both/and* response, opens up possibilities for creative and flexible responses which can effectively help pupils whose difference leaves them culturally devalued or educationally marginalised.

The study of this sample of young women shows clearly that it is not difference that creates exclusionary or inclusionary schooling experiences but how educators and educational institutions respond to it. Recognising the many differences that pupils bring into school, without stigmatising them, should drive both policy and practice. Account should be taken of the many ways in which one pupil is similar to and different from another and this should determine which differences need to be worked with. Only when they acquire the understanding this will bring them can educators develop appropriate and affirming provision for all pupils, whatever their difference.

References

Abel, G and Fitzgerald, L (2006) 'When you come to it you feel like a dork asking a guy to put a condom on': Is sex education addressing young people's understandings of risk? *Sex Education* 6(2) p105-119

Ainscow, M, Dyson, A, Goldrick, S, and West, M (2011) *Developing Equitable Education Systems.* London: Routledge

Alldred, P, and David, M (2007) *Get Real About Sex: the politics and practice of sex education.* Milton Keynes: Open University Press

Allen, I and Bourke Dowling, S (1998) *Teenage Mothers Decisions and Outcomes.* London: Policy Studies Institute

Allen, L (2004) Beyond the birds and the bees: constituting a discourse of erotics in sexuality education. *Gender and Education* 16(2) p151-167

Allen, L (2005) 'Say everything': exploring young people's suggestions for improving sexuality education. *Sex Education* 5(4) p389-404

Allen, L (2007) Denying the sexual subject: schools' regulation of student sexuality. *British Educational Research Journal* 33(2) p221-234

Archer, L and Yamashita, H (2003) 'Knowing their limits'? Identities inequalities and inner city school leavers' post-16 aspirations. *Journal of Education Policy* 18 p53-69

Audit Commission (1999) *Missing Out: LEA management of school attendance and exclusion.* Northampton: Belmont

Ballard, K (1999) International voices: an introduction In K Ballard (ed), *Inclusive Education: international voices on disability and justice.* London: Falmer Press

Baraitser, P, Dolan, F, and Cowley, S (2003) Developing relationships between sexual health clinics and schools: More than clinic nurses doing sex education sessions? *Sex Education* 3(3) p201-213

Barrett, G, and Wellings, K (2002) What is a planned pregnancy? Empirical data from a British cohort. *Social Science Medicine* 55, p545-557

Bhopal, K (2011) 'This is a school, it's not a site': teachers' attitudes towards Gypsy and Traveller pupils in school in England, UK. *British Educational Research Journal* 37(3) p465-483

Bonell, C, Allen, E, Strange, V, Copas, A, Oakley, A, Stephenson, J, *et al* (2005) The effect of dislike of school on risk of teenage pregnancy: testing of hypotheses using longitudinal data from a randomised trial of sex education. *Journal of Epidemiology and Community Health* 59(3) p223-230

Booth, T and Ainscow, M (1998) *From Us to Them*. London: Routledge

Brindis, C, Llewelyn, L, Marie, K, Blum, M, Biggs, A, and Maternowska, C (2003) Meeting the reproductive health care needs of adolescents: California's Family Planning Access, Care and Treatment Program. *Journal of Adolescent Health* 32(supplement) p79-90

Bullen, E, Kenway, J, and Hey, V (2000) New Labour, social exclusion and educational risk management: the case of the 'gymslip mums'. *British Educational Research Journal*, 26(4) p441-456

Buston, K, Wight, D, Hart, G, and Scott, S (2002) Implementation of a teacher-led sex education programme: obstacles and facilitating factors. *Health Education Research Journal* 17(1) p59-72

Buston, K, Wight, D, and Scott, S (2001) Difficulty and diversity: the context and practice of sex education. *British Journal of Sociology of Education* 22(3) p353-368

Cambridgeshire County Council (2011) Access to Education for Pregnant Schoolgirls and School Aged Parents Guidance Cambridge: Cambridgeshire County Council; www.cam bridgeshiregovuk/childrenyoungpeople/socialcare/teenpreg (September, 2011)

Carabine, J (2001) Constituting sexuality through social policy: the case of lone motherhood 1834 and today. *Social and Legal Studies* 10(3) p291-314

Cassen, R, and Kingdon, G (2007) *Tackling low educational achievement*. York: Joseph Rowntree Foundation

Cater, S and Coleman, L (2006) *'Planned' teenage pregnancy Perspectives of Young Parents from Disadvantaged Backgrounds*. Bristol: Polity Press for Joseph Rowntree Foundation

Coleman, J and Dennison, C (1998) Teenage parenthood Research review. *Children and Society* 12(4) p306-314

Collins, C, Kenway, J, and McLeod, J (2000) Gender debates we still have to have. *Australian Educational Researcher* 27(3) p37-48

Corcoran, J, Franklin, C, and Bell, H (1997) Pregnancy prevention from the teen perspective. *Child and Adolescent Social Work Journal* 14(5) p365-382

Cronin, C (2003) First-time mothers – identifying their needs, perceptions and experiences. *Journal of Clinical Nursing* 12(2) p260-267

Crozier, J and Tracey (2002) Falling out of school: a young woman's reflections on her chequered experience of schooling. In A Lewis and G Lindsay (eds), *Researching Children's Perspectives*. Buckingham: Open University Press

David, M (2003) Teenage parenthood is bad for parents and children. In M Bloch, K Holmlund, I Moqvist and T Popkewitz (eds) *Governing Children, Families and Education* p149-171. New York: Palgrave Macmillan

David, M, Weiner, G, and Arnot, M (2000) Gender equality and schooling, education policy-making and feminist research in England and Wales in the 1990s. In J Salisbury and S Riddell (eds) *Gender, Policy and Educational Change Shifting Agendas in the UK and Europe* p19-36. London: Routledge

Davies, L, McKinnon, M, and Rains, P (2001) Creating a family: perspectives from teen mothers. *Journal of Progressive Human Services* 12(1) p83-100

Dawson, N and Hosie, A (2005) *The Education of Pregnant Young Women and Young Mothers in England*. Bristol: University of Bristol

Daycare Trust (2002) *Exploring the Childcare Needs of Young Parents. Final Report.* London: Daycare Trust

Dench, S, Bellis, A, and Tuohy, S (2007) *Young Mothers Not in Learning: a qualitative study of barriers and attitudes.* Brighton: Institute for Employment Studies, University of Sussex

Department for Children Schools and Families (2007) *Teenage Parents Next Steps: Guidance for Local Authorities and Primary Care Trusts Improving Outcomes for Teenage Parents and their Children.* Nottingham: DCSF

Department for Education and Employment (2000) *Sex and Relationship Education Guidance.* Nottingham: DfEE Ref 0116/2000

Department for Education and Skills (2006) *Teenage Pregnancy: accelerating the strategy to 2010.* Nottingham: DfES

DfE (2011a) *Statistical First Release GCSE and Equivalent Attainment by Pupil Characteristics in England.* London: DfE

DfE (2011b) *Statistical First Release Permanent and Fixed Period Exclusions from School and Exclusions Appeals in England.* London: DfE

Duncan, S (2007) What's the problem with teenage parents? And what's the problem with policy? *Critical Social Policy* 27(3) p307-334

Duncan, S, Edwards, R, and Alexander, C (Eds) (2010) *Teenage Parenthood: What's the Problem.* London: Tufnell Press

Dunne, M, and Gazeley, L (2008) Teachers, social class and underachievement. *British Journal of Sociology of Education* 29(5) p451-463

Durant, C, Thomas, R, and Manning, R (2005) *Each One Teach One! Returning Young Parents to Education, Employment and Training.* Leicester: Leicestershire Connexions and Sure Start Plus Leicester

Edin, K, and Kefalas, M (2005) *Promises I Can Keep. Why Poor Women Put Motherhood Before Marriage.* Berkeley: University of California Press

Edwards, R and Duncan, S (1996) Rational economic man or lone mothers in context. In E Bortolaia Silva (ed) *Good Enough Mothering.* London: Routledge

Epstein, D, Elwood, J, Hey, V, and Maw, J (1998) *Failing boys? Issues in gender and achievement.* Buckingham: Open University Press

Fine, M (1992) *Sexuality, schooling and adolescent females: the missing discourse of desire. In Disruptive Voices: the possibilities of feminist research.* University of Michigan: Ann Arbor

Finlay, I, Sherdan, M, McKay, J, and Nudzor, H (2010) Young people on the margins: in need of more choices and more chances in twenty-first century Scotland. *British Educational Research Journal* 36(5) p851-867

Formby, E, Hirst, J, and Owen, J (2010) Pathways to adulthood: reflections from three generations of young mothers and fathers. In S Duncan, R Edwards and C Alexander (eds) *Teenage Parenthood: What's the Problem.* London: Tuffnell Press

Foucault, M (1976) *The History of Sexuality, volume 1.* London: Penguin

Francis, B, and Hey, V (2009) Talking back to power: snowballs in hell and the imperative of insisting on structural explanations. *Gender and Education* 21(2), 225-232

Fraser, N (1997) *Justice Interruptus. Critical reflections on the 'postsocialist' condition.* New York: Routledge

Gilbert, J (2007) Risking a relation: sex education and adolescent development. *Sex Education* 7(1) p47-61

Gillies, V (2007) *Marginalised Mothers Exploring Working Class Experiences of Parenting.* Abington: Routledge

Hadfield, L, Rudoe, N, and Sanderson-Mann, J (2007) Motherhood, choice and the British media: a time to reflect. *Gender and Education* 19(2), 255-263

Hall, S (1997) *Representation. Cultural Representations and Signifying Practices.* London: Sage

Halstead, M, and Waite, S (2003) 'Love and trust': making space for feelings in sex education. *Education and Health* 21(2) p23-28

Hampshire, J (2003) Sex education: politics and policy in England and Wales. *Education and Health* 21(2) p29-34

Hanna, B (2001) Negotiating motherhood: the struggles of teenage mothers. *Journal of Advanced Nursing* 34(4) p456-464

Harris, J, Howard, M, Jones, C, and Russell, L (2005) *Great Expectations. How realistic is the government target to get 60 percent of young mothers in education, employment or training?* Oxford: YWCA

Hawkes, D (2010) Just what difference does teenage motherhood make? Evidence from the Millinneum Cohort Study. In S Duncan, R Edwards and C Alexander (eds), *Teenage Parenthood: What's the Problem?* London: Tuffnell Press

Hey, V (1997) *The Company She Keeps: an ethnography of girls' friendship.* Buckingham: Open University Press

Hobcraft, J and Kiernan, K (1999) *Childhood Poverty, Early Motherhood, and Adult Social Exclusion. Analysis for the Social Exclusion Unit, CASE paper 28.* London: London School of Economics

Hock, E, McBride, S, and Gnezda, T (1989) Maternal separation anxiety: mother/infant separation from the maternal perspective. *Child Development* 60(4) p793-802

Hoffman, S (1998) Teenage Childbearing is Not so Bad After All ... Or is it? A review of the new literature. *Family Planning Perspectives* 30(5) p236-243

Hoggart, L (2003) Teenage pregnancy: the government's dilemma. Capital and Class 79 p145-165

Holland, J and Ramazanoglu, C (2002) Coming to conclusions: power and interpretation in researching young women's sexuality. In M Maynard and J Purvis (eds), *Researching Women's Lives from a Feminist Perspective.* London: Taylor and Francis

Holland, J, Ramazanoglu, C, Sharpe, S, and Thomson, R (2000) Deconstructing virginity – young people's accounts of first sex. *Sexual and Relationship Therapy* 15(3) p221-232

Horgan, G (2007) *The impact of poverty on young children's experience of school.* York: Joseph Rowntree Foundation

Hosie, A (2007) 'I hated everything about school': an examination of the relationship between dislike of school, teenage pregnancy and educational disengagement. *Social Policy and Society* 6(3) p333-347

Ingham, R (2005) 'We didn't cover that at school': Education against pleasure or education for pleasure? *Sex Education* 5(4) p375-388

Jewell, D, Tacchi, J, and Donovan, J (2000) Teenage Pregnancy: whose problem is it? *Family Practice* 17(6) p522-528

Kehily, M J (2002) *Sexuality, Gender and Schooling: Shifting Agendas in Social Learning.* London: Routledge

Kehily, M J (2005) The trouble with sex: sexuality and subjectivity in the lives of teenage girls. In G Lloyd (ed) *Problem Girls. Understanding and Supporting Troubled and Troublesome Girls and Young Women.* Abingdon Oxon: RoutledgeFalmer

Kellett, M and Dar, A (2007) *Children researching links between poverty and literacy.* York: Josepth Rowntree Foundation

Kelly, D (2000) *Pregnant with Meaning. Teen Mothers and the Politics of Inclusive Schooling.* New York: Peter Lang

Kidger, J (2004) Including young mothers: limitations to New Labour's strategy for supporting teenage parents. *Critical Social Policy* 24(3) p552-559

Kiernan, K (1995) Transition to Parenthood: young mothers, young fathers – associated factors and later life experiences, *Welfare State Programme Discussion Paper 113.* London: London School of Economics

Kitzinger, C (1987) *The Social Construction of Lesbianism.* London: Sage

Kubler-Ross, E (1973) *On Death and Dying.* London: Routledge

Lawlor, D and Shaw, M (2002) Too much too young? Teenage pregnancy is not a public health problem. *International Journal of Epidemiology* 31(3) p552-559

Leathwood, C (2006) Gender equity in post-secondary education. In C Skelton, B Francis and L Smulyan (eds) *The SAGE Handbook of Gender and Education.* London: Sage

Lee, C and Gramotnev, H (2006) Motherhood plans among young Australian women Who wants children these days? *Journal of Health Psychology* 11(1) p5-20

Lee, E, Clements, S, Ingham, R, and Stone, N (2004) *A Matter of Choice? Explaining National Variation in Teenage Abortion and Motherhood.* York: Joseph Rowntree Foundation

Lesko, N (1990) Curriculum differentiation as social redemption: the case of school-aged mums. In R Page and L Valli (eds) *Curriculum Differentiation Interpretive Studies in US Secondary Schools.* Albany: University of New York

Lister, R (2001) New Labour: a study in ambiguity from a position of ambivalence. *Critical Social Policy* 21(4) p425-447

Lloyd, G and O'Regan, A (1999) Education for social inclusion Issues to do with the effectiveness of educational provision for young women with 'social, emotional and behaviour difficulties'. *Emotional and Behavioural Difficulties* 4(2) p38-46

Luker, K (1996) *Dubious Conceptions The Politics of Teenage Pregnancy.* Massachusetts: Harvard University Press

Luttrell, W (2003) *Pregnant Bodies, Fertile Minds. Gender, Race, and the Schooling of Pregnant Teens.* London: Routledge

MacDonald, R and Marsh, J (2005) *Disconnected Youth? Growing up in Britain's Poor Neighbourhoods.* Basingstoke: Palgrave MacMillan

Macvarish, J and Billings, J (2010) Challenging the irrational, amoral and anti-social construction of the 'teenage mother'. In S Duncan, R Edwards and C Alexander (eds) *Teenage Parenthood: What's the Problem.* London: Tufnell Press

McLeod, J and Yates, L (2006) *Making Modern Lives Subjectivity, Schooling and Social Change*. Albany: State University of New York

Meade, C and Ickovics, J (2005) Systematic review of sexual risk among pregnant and mothering teens in the USA: pregnancy as an opportunity for integrated prevention of STD and repeat pregnancy. *Social Science and Medicine* 60(4) p661-678

Measor, L (2006) Condom use: a culture of resistance. *Sex Education* 6(4) p393-402

Measor, L, Tiffin, C, and Miller, K (2000) *Young People's Views on Sex Education: education, attitudes and behaviour*. London: RoutledgeFalmer

Minow, M (1990) *Making All the Difference: Inclusion, Exclusion and American Law*. New York: Cornell University Press

Mitchell, W and Green, E (2002) 'I don't know what I'd do without our Mam' – motherhood, identify and support networks. *The Sociological Review* 50(1) p1-22

Nayak, A and Kehily, M J (2008) *Gender, Youth and Culture Young Masculinities and Feminities*. Basingstoke: Palgrave Macmillan

Office for National Statistics (2011) *Under 18 conception data for top-tier Local Authorities (LAD1), 1998-2009*. Newport: Office for National Statistics

Office for National Statistics and Department of Health (2008) *Statistical Bulletin Abortion Statistics, England and Wales 2008* http://www.dh.gov.uk/en/Publicationsandstatistics/Statistics/index.htm (January 2011)

Office for Standards in Education (2002) *Sex and Relationships*. London: Ofsted

Osler, A and Vincent, K (2003) *Girls and Exclusion. Rethinking the Agenda*. London: RoutlegeFalmer

Phoenix, A (1991) *Young Mothers?* Cambridge: Polity Press

Pillow, W (2004) *Unfit Subjects Educational Policy and the Teen Mother*. New York: RoutledgeFalmer

Plummer, G (2000) *Failing Working Class Girls*. Stoke-on-Trent: Trentham

Pomeroy, E (2000) *Experiencing Exclusion*. Stoke-on-Trent: Trentham

Reay, D (2006) Compounding inequalities: gender and class in education. In C Skelton, B Francis and L Smulyan (eds) *The SAGE Handbook of Gender and Education*. London: Sage

Rhamie, J (2007) *Eagles Who Soar*. Stoke-on-Trent: Trentham

Rolfe, A (2005) There's helping and there's hindering: young mothers, support and control. In M Barry (ed) *Youth Policy and Social Inclusion Critical Debates With Young People*. London: Routledge

Rubie-Davies, C, Hattie, J, and Hamilton, R (2006) Expecting the best for students: teacher expectations and academic outcomes, *British Journal of Educational Psychology* 76(3) p429-444

Schultz, K (2001) Constructing failure, narrating success: rethinking the 'problem' of teen pregnancy. *Teachers College Record* 103(4) p582-607

Seamark, C and Lings, P (2004) Positive experiences of teenage motherhood: a qualitative study. *British Journal of General Practice* November, p813-818

Selman, P (2003) Scapegoating and moral panics: teenage pregnancy in Britain and the United States. In S Cunningham-Burley and L Jamieson (eds) *Families and the State: Changing Relationships*. Basingstoke: Palgrave

REFERENCES

Shacklock, G, Harrison, L, and Angwin, J (2005) 'Methodology in action': some dilemmas about researching pregnant and parenting young people and their educational participation. *Melbourne Studies in Education* 46(1), 73-90

Sieving, R, Eisenberg, M, Pettingell, S, and Skay, C (2006) Friends' influence on adolescents' first sexual intercourse. *Perspectives on Sexual and Reproductive Health*, 38(1), 13-19

Smithers, A (2005) Education. In A Seldom and D Kavanagh (eds) *The Blair Effect 2001-5*. Cambridge: Cambridge University Press

Snow, T (2006) Pregnant pause for teenage mums. *Nursing Standard* 20(40) p14-15

SEU (Social Exclusion Unit) (1998) *Truancy and Social Exclusion*. London: Cabinet Office

SEU (Social Exclusion Unit) (1999) *Teenage Pregnancy*. London: SEU

St Clair, R and Benjamin, A (2011) Performing desires: the dilemma of aspirations and educational attainment. *British Educational Research Journal* 37(3) p501-517

Stenner, P, Bianchi, G, Popper, M, Supekova, M, Luksik, I, and Pujol, J (2006) Constructions of sexual relationships: a study of the views of young people in Catalunia, England and Slovakia and their health implications. *Journal of Health Psychology* 11, 669-684

Stevens-Simon, C, Kelly, L, Singer, D, and Cox, A (1996) Why pregnant adolescents say they did not use contraceptives prior to conception. *Journal of Adolescent Health* 19(1) p48-53

Stone, N and Ingham, R (2003) When and why do young people in the United Kingdom first use sexual health services? *Perspectives on Sexual and Reproductive Health* 35(3) p114-120

Strange, V, Forrest, S, Oakley, A, Stephenson, J, and the RIPPLE study team (2006) Sex and relationship education for 13-16 year olds: Evidence from England Sex Education. *Sex Education* 6(1) p31-46

Tabberer, S, Hall, C, Prendergast, S, and Webster, A (2000) *Teenage Pregnancy and Choice: abortion or motherhood: influences on the decision*. York: Joseph Rowntree Foundation

Teenage Pregnancy Unit (2005) *Teenage Pregnancy Strategy Evaluation: Final Report Synthesis*. London: Teenage Pregnancy Unit

Thomson, P (2002) *Schooling the rustbelt kids*. Stoke on Trent: Trentham

Thomson, P, McQuade, V, and Rochford, K (2005) 'My little special house': re-forming the risky geographies of middle school girls at Clifftop College. In G Lloyd (ed), *Problem Girls Understanding and supporting troubled and troublesome girls and young women*. London: RoutledgeFalmer

Tinklin, T, Croxford, L, Ducklin, A, and Frame, B (2005) Gender and attitudes to work and family roles: the views of young people at the millennium. *Gender and Education* 17(2) p129-142

Trussell, J (2004) Contraceptive failure in the United States. *Contraception*, 70(2) p89-96

Turner, K (2004) Young women's views on teenage motherhood: a possible explanation for the relationship between socio-economic background and teenage pregnancy outcome? *Journal of Youth Studies* 7(2) p221-238

Vincent, K and Ballard, K (1997) Living on the Margins: Lesbian Experience in Secondary Schools. *New Zealand Journal of Educational Studies* 32(2) p147-161

Vincent, K, Harris, B, Thomson, P, and Toalster, R (2007) Schools collaborating for collective gain. *Emotional and Behavioural Difficulties* 12(4) p283-298.

Walkerdine, V, Lucey, H, and Melody, J (2001) *Growing up girl: psychosocial explorations of class and gender.* Basingstoke: Palgrave Macmillan

Wedell, K (2005) Dilemmas in the quest for inclusion. *British Journal of Special Education* 32(1) p3-11

Wellings, K, Nanchahal, K, Macdowall, W, McManus, S, Mercer, C, Johnson, A, *et al* (2001) Sexual behaviour in Britain: early heterosexual experience. *The Lancet,* 358 p1843-1850

Wellings, K, Wadsworth, J, Johnson, A, and Field, J (1996) *Teenage sexuality, fertility and life chances. A report prepared for the Department of Health using data from the National Survey of Sexual Attitudes and Lifestyles.* London: Department of Health

Wiggins, M, Oakley, A, Austerberry, H, Clemens, F, and Elbourne, D (2005) *Teenage Parenthood and Social Exclusion: a multi-method study.* London: Social Science Research Unit, Institute of Education, University of London

Wight, D and Buston, K (2003) Meeting needs but not changing goals: evaluation of in-service teacher training for sex education. *Oxford Review of Education* 29(4) p521-543

Wilkinson, R (2007) *The Impact of Inequality. How to Make Sick Societies Healthier.* London: Routledge

Wilson, H and Huntingdon, A (2005) Deviant (m)others: the construction of teenage motherhood in contemporary discourse. *Journal of Social Policy* 35(1) p59-76

Worden, J W (1995) *Grief Counselling and Grief Therapy.* London: Routledge

Young, I M (1990) *Justice and the Politics of Difference.* Princeton, New Jersey: Princeton University Press

Zachry, E (2005) Getting my education: teen mothers' experiences in school before and after motherhood. *Teachers College Record* 107(12) p2566-2598

Index